John Hedgecoe's

NEW

INTRODUCTORY

PHOTOGRAPHY

COURSE

John Hedgecoe's

NEW
INTRODUCTORY
PHOTOGRAPHY
COURSE

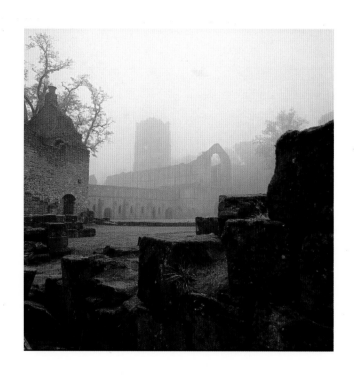

MITCHELL BEAZLEY

**John Hedgecoe's New Introductory
Photography Course**

First published in Great Britain in 1996
by Mitchell Beazley
an imprint of Octopus Publishing Group Ltd.
2–4 Heron Quays, London E14 4JP

Reprinted 1997, 1998, 2001

Contributing Editor **Chris George**

Art Director **Gaye Allen**
Executive Art Editor **Janis Utton**
Executive Editor **Judith More**
Project Art Editor **Emma Boys**
Designer **Tony Spalding**
Project Editor **Anthea Snow**
Production Controllers **Juliette Butler,
 Kate Thomas**
Indexer **Ann Barrett**

A CIP catalogue record for this book is available
from the British Library

ISBN 1 85732 836 1

Set in Frutiger
Produced by Toppan Printing Co., (H.K.) Ltd.
Printed in China

Contents

Introduction

Photography is a medium for artistic expression, just like painting and sculpture. A photograph can be considered as art, as decoration, or as a means of communication – a vehicle for expressing ideas and feelings. The art of photography is about making informed choices, because there is no single way of taking a picture.

The once complicated techniques of photography have now lost most of their mystique. Many have been taken over by the camera and film manufacturers, and the remainder have been reduced almost to a straightforward routine. Good photographers are all around us. Their skill lies in being able to concentrate on taking pictures without having to worry about how to handle the camera. And as cameras become easier to operate, achieving excellent results becomes possible for more and more people.

The emphasis in this book is on learning how to become a good photographer through hands-on experience. The freedom of knowing that most of your photographs will turn out satisfactorily can only be gained by practising the basic skills until they become automatic. While you are mastering the practical side, you will also be developing your visual sense – an awareness of why you are taking a particular picture. Without this sense of purpose, the result is likely to be dull, no matter how technically correct.

Selection and interpretation play a major part in any good photograph. This book shows you how to develop these perceptual skills through a series of projects which you can undertake yourself, much as a student would on a formal photography course. These structured exercises will enable you to make faster progress than if you were taking photographs at random. My purpose, both in the projects and in the opening section, which discusses how to use a camera, is to make you aware of the range of possibilities that any scene can offer. Working through the book will help you to appreciate the enormous improvements that you can make in your photographs by exercising conscious and careful choice over the elements you include, the emphasis you give them, and the vital moment at which you press the shutter.

Nearly all the photographs I have included were taken with equipment that is easily available to the amateur. For most, I used a medium-priced single-lens reflex camera with three interchangeable lenses.

The most powerful photographs are the ones that have an element of surprise in them – the ones that do not give up their secret at the first glance, but reveal it slowly after the initial response. This book will help you to take such photographs; and in the course of the hard work and exploration that go into learning how to "see" a picture, you will find yourself taking great enjoyment in acquiring the skills and in developing a distinctive personal style.

John Hedgecoe

How to use a camera

The simple camera

In comparison to the other pieces of technology we use in everyday life, the camera is a very simple device. The most popular type is the point-and-shoot compact, which is both portable and convenient but also limited in scope for the creative photographer. The first step in gaining control over your pictures is to get hold of an SLR camera.

All cameras are essentially light-tight boxes in which a light-sensitive material can be housed in darkness. To take a picture, a small hole is opened for a short amount of time. The action of the light on the film inside leaves an invisible trace, called a latent image, which is later chemically transformed into a visible image.

You can make a simple camera out of a cardboard box into which you place a sheet of photographic paper or film at one end. At the other end you make a small hole, which you cover until the picture is taken. The primitive "pinhole" camera has no lens to focus the image, so produces a fuzzy picture.

The most basic commercially-produced camera is the disposable camera. This contains a simple lens to focus the image, and an elementary shutter for opening the aperture (the hole through which light enters) for a set period of time. The unit is pre-loaded with a roll of film that is retrieved by the processing laboratory. The rest of the camera is then thrown away.

The point-and-shoot camera, or compact camera, is more sophisticated. It is primarily designed for portability and ease of use, and has a shutter mechanism situated behind the lens. The image is viewed not through the lens itself but via a separate window, which approximates what the lens is "seeing". A built-in flash, automatic shutter speed selection, and motorized

◁ **Disposable, or single-use, cameras** are principally designed for emergency use, when you have forgotten your camera or when you do not want to risk damaging expensive photographic equipment – such as on a sandy beach. They work best in bright conditions outdoors, although some models have a built-in flash for indoor use.

▷ **Simple point-and-shoot compact cameras** offer motorized film advance, automatic exposure and a built-in flash. They generally have a fixed, wide-angle lens, which is good for shots of buildings and landscapes, but is not ideal for portraits.

◁ **Top-of-the-range compact cameras** have built-in zoom lenses, giving you a range of image magnifications to choose from. As well as a wide-angle end for use with landscapes or architecture, there are telephoto settings, which are particularly useful when taking pictures of people. However, these cameras are unable to give you any real control over the exposure settings (see the box below).

THE PROS AND CONS OF COMPACT CAMERAS

Portability The compact is easy to slip into a pocket or bag.
Ease of use Fully automatic control makes using these cameras simply a matter of pointing and shooting.
Built-in lens Although many now have zoom lenses, the choice of lens setting is always limited. Close-ups of timid animals or racing cars in action, for instance, are almost impossible.

Automatic exposure This facility, which dictates how much light will enter the camera, works well in some lighting conditions, but is not foolproof – high-contrast subjects can be problematic. Also, lack of choice in the size of aperture means that you have no control over how much of the picture is in focus (see page 20). With no control over shutter speed, you cannot

guarantee that moving subjects will be captured sharply, nor can you convey them using artistic blur (see page 16).
Direct-view viewfinder This gives a slightly different image from the one recorded on film. The discrepancy increases the closer the subject is to the camera. Furthermore, the viewfinder gives no indication of how much of the picture will be in focus.

film advance are all common features. More expensive models offer a choice of lens settings or zooms, so that the camera can home in on distant subjects without the photographer having to move forward.

Despite the fact that compacts continue to become more complex, (adding longer zooms, for instance) there are still important functions that these pocket cameras cannot perform in creative photography.

THE ADVANTAGES OF THE SLR CAMERA

The single-lens reflex camera, or SLR, remains the basic workhorse for both the enthusiast and the professional photographer because it has capacities far beyond those available with a compact camera:

Interchangeable lenses These give the photographer complete control over image magnification at any distance. Lenses can be attached (using a bayonet mount) and removed while the film is loaded in the camera.

Lens variety A huge range of lenses is available for most SLRs. Standard types can be chosen to suit the subject and your pocket; there are also specialist lenses for applications such as sport or wildlife photography, and for larger-than-life magnifications.

Spring-loaded mirror and prism These allow you to view the image through the lens itself, so that the image you see through the viewfinder is the same as the one recorded on the film.

Shutter speed control Manual control of the shutter speed gives you a variety of ways to tackle a moving subject, and prevents camera shake from appearing in your pictures (see page 16).

Depth of field control This gives you manual control over how much of the picture is in focus (see page 20).

◁ **The lens range** of a compact camera is always limited, even if the camera has a zoom. In this shot, I have not been able to get close enough to the subject using my point-and-shoot camera. With an SLR, extremely powerful telephoto lenses are available for taking close-up shots of distant subjects.

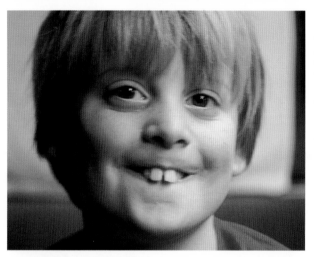

◁ **Depth of field** control is not possible with a compact camera, and therefore although some parts of this boy's face are sharp, others are slightly out of focus. An SLR, on the other hand, allows you to decide how much of your shot will be sharp.

◁ **Simple frontal lighting** and landscape views suitable for a wide-angle lens are what a compact camera deals with best. This type of shot places few demands on the exposure and focussing system of a camera, and could even be taken with a single-use model.

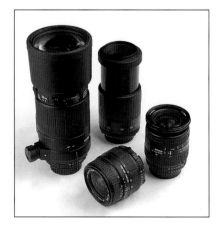

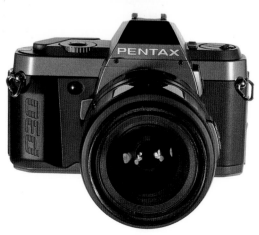

◁ **Most SLR cameras** have an interchangeable lens system, which enables you to choose a lens to suit the type of pictures that you want to take. As well as zooms, lenses with fixed focal lengths are also available.

▷ **A single-lens reflex camera** provides complete creative control over the shutter speed and aperture settings – and because you look through the lens, you get an accurate view of what you are shooting, even at close distances.

The SLR camera

The SLR camera gives you greater control over your photographs, but it is not very much more difficult to use than a pocket compact. Many automatic, labor-saving devices are incorporated into modern SLRs, so that they can be used in a point-and-shoot fashion, leaving you the choice of when and how to add your own creative input.

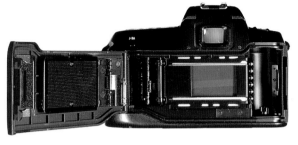

△ **Advanced SLR cameras** have automatic film transport mechanisms to advance the film between shots, and to rewind it after the film is finished. They also have DX contacts, which automatically read and set the film speed of the emulsion that you are using. These devices make an SLR easier to operate.

△ ▷ **Viewing the image** with an SLR camera is more accurate – the user actually looks through the lens while composing the picture instead of looking through a separate viewfinder window. The image is formed on a screen in the roof of the camera, and is seen the right way up by the photographer viewing it through a five-sided prism. The mirror, which reflects the image upward onto the screen, moves upward when the shutter is fired, clearing the pathway of the light to the film.

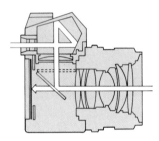

◁ **An LCD information panel** on the top of advanced SLRs gives you a full read-out of the settings in use. The shutter speed, aperture, film speed and exposure compensation setting can all be displayed, as can the frame number, autofocus mode, exposure mode, advance mode (single or continuous), and any other special effects feature currently engaged.

VIEWING THE IMAGE

Although several other types of camera allow you to change lenses and give you full control over shutter speed and depth of field, the SLR is unique in allowing you to see the scene you are shooting through the lens itself, and without having to remove the film.

This is possible because of a mirror that is angled at 45° behind the lens, which reflects the image onto a glass or plastic screen immediately above it. The image on this screen (and the one that is recorded on the film behind the mirror) is upside-down and laterally reversed (what is on the right appears to be on the left and vice versa). Because of this, the screen is not viewed directly, but is seen through a pentaprism – a multi-sided piece of glass that reverses and rotates the image, and then delivers it to the viewfinder window, through which you see an accurate rendition of the image.

As the screen is the same distance from the lens as the film, it can be used

as a visual guide to focussing the lens – only the parts of the picture on which you have focussed appear sharp.

MAKING AN EXPOSURE

The hole through which the picture is taken is a diaphragm within the lens. This is left fully open while the picture is composed and focussed, so that you see the brightest possible image.

When an exposure is made, three things happen:
• The mirror is raised out of the way of the light·path, so that the light can reach the film.
• The lens diaphragm is closed down to the aperture size selected for the shot.
• The light-proof curtains in front of the film are opened. This focal plane shutter is made up of two blinds. One opens to start the exposure, the other follows to block out the light again. For the shortest exposures, the curtains are never fully open – the second blind begins to close before the first has completed its path.

AUTOMATIC SYSTEMS

At one time, using an SLR required you to set the shutter speed, aperture and focus for every shot. When the picture had been exposed, the film needed to be wound on manually and the focal plane shutter reset. Today, most SLR cameras have a number of labor-saving devices, including:

DX-coding This communicates information about the type of film being used from the film canister to the camera, including the number of exposures on the roll, the film's sensitivity to light – its speed (see page 12) – and whether it is slide film or print film.

Programmed exposure This automatically chooses both the aperture and the shutter speed, depending on the type of subject being photographed and the ambient light level (see page 22).

Autofocus This adjusts the lens so that the central part of the image in the viewing screen is sharp. The best of these systems can even focus on moving

△ **A high-speed shutter setting** was selected to ensure that this fast-moving subject was not blurred.

△ **A small aperture** was necessary here to make sure that everything from the tree to the horizon was sharp.

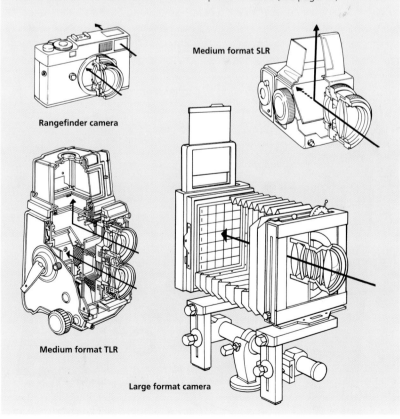

△ **The precise focussing of an SLR** made sure that the eyes of this girl appeared pin-sharp in the portrait.

OTHER TYPES OF CAMERA

Rangefinder cameras The rangefinder is the ancestor of both the SLR and the compact. Twin windows create a double image of the subject in the viewfinder. To focus the image, a ring around the lens is turned until the two images coincide. The absence of the moving mirror makes these cameras very quiet and compact. Leica's M-series of 35mm rangefinders, which have interchangeable lenses, still has many followers among both amateurs and professionals. Medium-format rangefinder cameras are also available.

Medium format SLRs Although the majority of SLRs use the 35mm and APS "miniature" formats, some are also designed for use with roll film (see page 13). This offers larger frame sizes, giving more picture detail. Some of these cameras have interchangeable backs, allowing a variety of formats to be used. Polaroid film backs can often be fitted, too, so that you can check exposure and composition before recording a shot on standard film. These cameras are usually held at waist level. The ground-glass focussing screen is viewed through a magnifier and hood that can be folded down when the camera is carried. The image is upright but reversed from left to right. Pentaprism viewfinders can sometimes be fitted to give a correct view, and to allow the camera to be used at eye level.

Medium format TLRs Most of the advantages of the SLR are offered by the mechanically simpler twin-lens reflex, or TLR. The image is viewed through a second lens, not through the taking lens, so a moving mirror is not required. The two lenses have the same angle of view and move in unison as the image is focussed. The image in the viewfinder is not identical to that seen by the main lens, but it is only for very close subjects that this difference becomes important. It uses a waist-level viewing system similar to that of a roll-film SLR. Not all TLRs offer the facility to interchange lenses.

Large format cameras Also known as "technical cameras", these offer the greatest degree of control, albeit with a loss of operating speed and convenience. They use individual sheets of film measuring 5 x 4in (12.7 x 10.2cm) or 10 x 8in (25.4 x 20.3cm). A front panel carries the lens and a rear panel carries the film holder or focussing screen. These are joined by a light-proof, folding bellows. The panels (or standards) can be moved back and forth along a monorail, and raised, lowered and tilted, giving control over linear perspective and the plane of focus (see page 19).

subjects and allow for any movement between when the distance calculation is made and when the shutter opens.

Motorized film transport The film is wound on automatically to the first frame when loaded. It is then advanced, and the shutter cocked, after each shot. The film is rewound when all the available frames have been used.

Built-in flash Many SLR cameras have a built-in flash unit, similar to those found on compact cameras. These can often be set up to fire automatically in low light. The option is still open to attach bigger or specialized flashguns by using a separate hotshoe interface.

Matrix metering This is a sophisticated exposure measuring system in which light readings are taken from many areas across the image. These are compared to idealized exposure settings stored in the camera's memory in order to estimate a suitable shutter speed and aperture combination however difficult the lighting conditions (see page 15).

Rangefinder camera

Medium format SLR

Medium format TLR

Large format camera

Films and formats

Color or black and white? Print or slide? 35mm or APS? ISO 400 or ISO 100? Film is available in a variety of different formats, types, lengths, and speeds – offering an immense, and at times bewildering, choice. There are also differences in grain structure and color saturation, depending on the brand. Each type, however, has its uses.

FILM FORMATS

Film is usually packaged in one of four ways: cartridges, cassettes, rolls or sheets. The sort you need depends on the type of camera you intend to use.

The format – the size and shape – of picture given by a camera is determined primarily by the width of the film. The popular 35mm film format usually gives images that are 36 x 24mm (1¼ x 1in). It is said to have an aspect ratio of 3:2 (in other words, one side is one and a half times longer than the other). Other formats have squarer or more panoramic aspect ratios (see the table opposite). Some cameras allow you to choose the ratio while shooting, by flicking a switch or changing the film back.

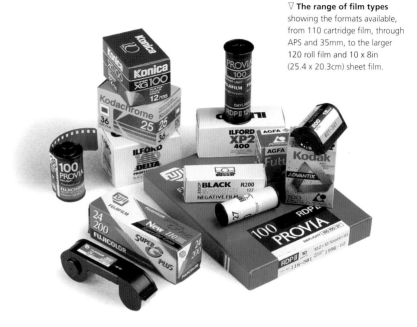

▽ **The range of film types** showing the formats available, from 110 cartridge film, through APS and 35mm, to the larger 120 roll film and 10 x 8in (25.4 x 20.3cm) sheet film.

FILM SPEEDS

Film is available in a variety of speeds, which are determined by its sensitivity to light. The higher, or faster, the film speed, the greater its sensitivity. Faster film needs less exposure to yield an image and so can be used in poorer light. Slower films are less light sensitive and have a lower film speed rating.

Film speed is generally measured on the ISO scale. This is an arithmetic scale on which a film that is rated at ISO 200 is twice as fast as one rated at ISO 100,

thereby requiring only half as much light to produce a similar picture. Standard films have speeds from ISO 100 to ISO 400, but fast films are available with speeds of up to ISO 3200, and slower films with speeds of ISO 25–64.

There is a price to be paid for faster film, as this gives a grainier image and duller colors. As a rule, the slower the film, the better the picture quality.

SLIDE AND PRINT FILM

There are two different types of film. Negative film is intended solely for making prints; reversal film is primarily intended for producing transparencies, which are usually mounted in holders and viewed as slides. However, it is not difficult to make prints from slides.

Once developed, a reversal film becomes a set of transparencies. With negative film, though, the developing is just the first step toward producing a print. The chemical development produces a negative that must then be printed onto photographic paper to give a positive image.

Most people find prints more convenient, but many professional photographers prefer to use slide film as it gives them greater control over the final image. Negative film requires a second exposure stage, when printing, and more decisions to be taken about how the picture should look. Unless you are making the prints yourself, you have to leave the decisions to a technician or an automated machine. Slide film, therefore, provides the photographer with more consistent results – with more reliable color saturation and exposure.

▽ **Film is available in two main types** – negative film, which produces prints, and reversal film, which produces slides or transparencies.

△ **Slow-speed color slide film** (ISO 25–100) gives the best detail and color saturations.

△ **Medium-speed color slide film** (ISO 100–400) is the all-round choice for outdoor, hand-held use.

△ **Fast slide films** (ISO 800 and above) are designed for shooting moving subjects in low light.

△ **Slow black and white film** – the grain is not visible even when the print is blown up.

△ **Medium-speed black and white film** – the grain is visible only when enlarged.

△ **Fast black and white film** – the grain is visible in any size of print, but allows you to do without flash.

There is an unwelcome aspect to slide film: it is far less forgiving to inaccuracies in exposure. Print film can be grossly overexposed, or reasonably underexposed, and you can still achieve a relatively good result at the printing stage. Slide film has far less exposure latitude, and such mistakes cannot be corrected at a later stage.

Color slide film must also be carefully balanced to the type of light, as the color cannot be corrected at the printing stage. It can be bought ready balanced for average daylight or for tungsten bulb lamps, but corrections for other types of light must be made using filters.

BLACK AND WHITE FILM

This film is used less and less in commercial settings, but still retains its appeal elsewhere. Most significantly, black and white print film is simple to print and process yourself, giving you complete control over the final image (see pages 179–92). The darkroom brings another creative stage to your photography, allowing you to manipulate the content of your pictures to shift emphasis, add mood, and correct mistakes made at the shooting stage.

OLD AND NEW FILM FORMATS

35mm (or 135) This is the most commonly used format for both SLRs and compacts. The cassette-loaded film has sprocket holes along each edge and usually gives 36 x 24mm images. Some cameras offer a panoramic format, with an image area 36 x18mm. "Half-frame" cameras give a 17 x 24mm image.

120 roll film This is the film used by medium format cameras. It is 6cm (2¼in) wide and provides a number of different formats, most commonly 6 x 4.5cm, 6 x 6cm and 6 x 7cm. 120 film is a fixed length, so the number of shots you get per roll depends on the format used (15 shots for "645" format, 12 shots for the "square" format, 10 shots for the "67" format). The film is wound onto a second spool as it is used, and when finished the empty spool is transferred to the other side ready for the next roll. Each roll is protected from light during handling by a layer of backing paper.

APS The Advanced Photo System is the newest film format. This sprocketless cassette offers drop-in film loading where the film itself is never seen by the user. It stays inside the cassette until the film has been placed in the camera. The processed negatives are returned in the cassette. An indicator system tells you whether or not the film has been used. The standard image area is 30.2 x 16.7mm, but you can choose from two other formats when shooting: panoramic (3:1 ratio) and classic (3:2 ratio). The format selected is invisibly marked on the film on a magnetic layer, later read by the processor. Other data can also be stored, such as titles, date and time, and exposure details.

110 and 126 These are cartridge film formats found on older compact cameras. 126 film gives negatives that are 26 x 26mm, and the 110 format gives 17 x 13mm negatives.

Sheet film This is loaded by the user into holders, called dark slides, that hold two sheets (one on each side). Usual sizes are 10 x 8in and 5 x 4in.

See also page 198 for data on formats.

Exposure metering

Getting the exposure right is one of the fundamental jobs of a photographer. In many situations, the camera can do all the hard work. At other times, the photographer must intervene as there is not always one "correct" exposure. The nature of film may mean choosing a compromise between revealing detail in the shadows or the highlights.

△ **Aperture: f/2. Shutter speed: 1/250sec**
The first in this bracketed sequence shot on slide film is overexposed. The clouds and the buildings are burnt out with hardly any detail.

△ **Aperture: f/2.8. Shutter speed: 1/250sec**
To decrease the amount of light reaching the film, the aperture of the lens is closed down by one stop, but the shutter speed remains the same as before.

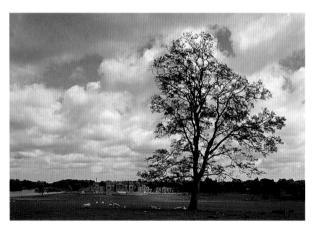

△ **Aperture: f/8. Shutter speed: 1/250sec**
With the sun starting to break through, this exposure is starting to do more justice to the color of the sky, which becomes brighter as exposure decreases.

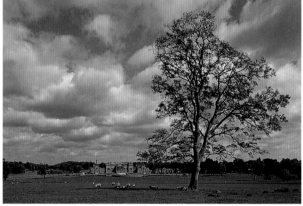

△ **Aperture: f/11. Shutter speed: 1/250sec**
With the sunlight bathing the tree and the building, the contrast between the sky and land decreases, helping to make this the best exposure of the sequence.

WHAT IS EXPOSURE?

Exposure is the amount of light needed to produce a picture on the film – and as brightness varies from scene to scene, the camera must compensate for these variations. Most cameras have two controls over the amount of light that reaches the film – shutter speed and aperture (see pages 16–17 and 20–21).

To understand this relationship, think of film being exposed to light as a cup being filled with water from a tap or faucet. How the cup is filled depends on:
• how much you turn on the tap (which is the aperture of the lens) and
• how long you leave on the tap (which

is the shutter speed being used). The more you turn the tap, the shorter time you need before the cup is filled.

The same applies to film: the wider the aperture, the shorter the shutter speed. However, there are other factors:
• the size of the cup used (the speed of the film used – see page 12) and
• water pressure (the intensity of the light being reflected from the subject).

To avoid having to consider all these variables every time you take a picture, most cameras have a built-in meter. The film speed is either set automatically using the DX-coding system (see page 10), or you set it manually. The camera

takes readings from across the scene to find out the intensity of light.

However, even the most sophisticated metering system cannot guarantee you the results you want every time as the intensity of light is not even throughout the scene. Unfortunately, taking an average value will not suffice.

The main reason for this is that the human eye is much more sensitive to extremes of light than film. A scene where the brightest areas are much brighter than the darker parts is difficult to expose well on film without making the dark areas black or the bright areas featureless. A compromise is needed.

TYPES OF EXPOSURE METER

Center-weighted average metering This metering system is found on most older SLR cameras. It takes readings from across the whole frame but concentrates on the middle of the picture. While not foolproof, it is easy to predict.
Matrix metering Found on more recent SLRs, this meter takes readings from several dozen areas across the frame.

It compares these with references stored in the camera to work out the type of lighting and picks an exposure value to suit. A clever system, but its mistakes are hard to predict.
Spot metering This takes an average reading from a very small area of the picture. It requires practice to handle effectively, but is very useful in difficult lighting conditions.

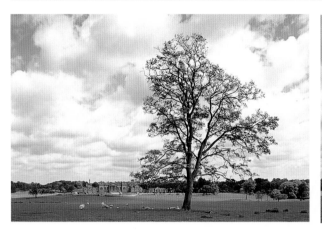

Aperture: f/4. Shutter speed: 1/250sec
In this shot, the exposure has not only been decreased, but the lighting has changed subtly too, as the clouds have cast a shadow over the building.

Aperture: f/5.6. Shutter speed: 1/250sec
With the building and tree now in shadow, this exposure does justice to both these two main elements of the landscape, but the sky still looks too light.

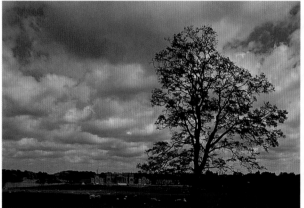

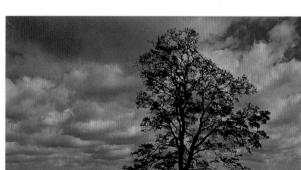

Aperture: f/16. Shutter speed: 1/250sec
Although the front of the house is still in direct sunlight, the tree is now in shadow. The exposure is now making the sky predominate.

Aperture: f/22. Shutter speed: 1/250sec
Using the smallest aperture available on the lens, the whole foreground and bottom half of the picture look far too dark. However, the sky looks fine.

EXPOSURE COMPENSATION

The type of metering system varies from camera to camera (see the box above) – and some even give a choice between two or more types. Each system can suggest different readings for identical scenes, so they can not, of course, all be right all of the time.

One factor determining how precise the meter reading needs to be is the type of film you are using. Print films are far more tolerant of errors than slide films.

By studying your results, you will learn in which lighting conditions your camera is going to have problems producing the exposure you want. You can then compensate by increasing or decreasing the overall exposure in each situation by adjusting one of these three:
The manual exposure mode With this facility (see page 23), the shutter speed and aperture are set independently of any built-in meter and you can change the overall exposure by altering just one of these settings.
The compensation dial This allows you to change the exposure value (EV) by a certain number of stops (see page 20), often broken up into half- or third-stop intervals. Use a negative number if you want less light to reach the film or a positive value for a brighter image.

The film speed setting You can lower this to make the camera think that you are using a slower film than you are. Conversely, if you want a darker image, increase the film speed setting.

BRACKETING

In difficult lighting conditions, such as when the contrast in the scene is very high, it is worthwhile repeating the shot with a wide variety of different exposure values. This is known as bracketing and is carried out in a systematic fashion. In a sequence of near-identical shots, some are too dark and some are too light – but the exposure of at least one is perfect.

Shutter speed

The length of time the shutter is open is one of the factors that dictates the amount of light reaching the film – the exposure. It also determines whether or not your photograph will be blurred. You need to select a fast enough shutter speed not only to "freeze" moving subjects, but also if you are to avoid camera shake.

There are two main factors that should be taken into consideration when choosing the shutter speed for a shot:

Camera movement If a camera is being hand-held then, however hard you try to keep it steady as you take the picture, there is always a small amount of shake, caused by the involuntary movement of your muscles. The action of firing the shutter will also cause small vibrations, particularly in an SLR, where the mirror swings out of the way before the focal plane curtains open.

Subject movement If you are photographing a cyclist pedaling at 20 miles (32km) per hour, the subject will travel about 30 feet (9m) per second. If you use a shutter speed of 1/30sec, your subject will have moved a whole foot (30.5cm) during the exposure. This might show in your picture as a blurred image – an effect that you might want to create deliberately to give an impression of movement, or one that you might wish to avoid, to get a sharp, "frozen" image.

AVOIDING CAMERA SHAKE

First, you need to learn how to hold the camera correctly for hand-held shots:

△ **The correct way to hold a 35mm SLR** is to grip the side of the camera with the right hand, while using the palm of the left hand to support the weight of the lens. In this way, your right forefinger covers the shutter release trigger, and the left thumb and forefinger can focus the lens when necessary. Elbows should be tucked into the sides of the body.

• Stand with your feet slightly apart, so that they are directly below your shoulders, and keep your legs straight.
• Grip the camera firmly, but not too tightly, with your right hand.
• Use your left hand as a support underneath the camera. With an SLR camera, you can position this hand under the lens, so that your forefinger and thumb can still operate the zoom and focus controls, when necessary.
• Keep your elbows tucked in.
• Just before you take the picture, take a deep breath and immediately press the shutter release button. Don't stab at it – gently squeeze it until the camera fires.

SHUTTER SPEED AND LENSES

Once you have perfected the technique for hand-holding, the shutter speed you select depends largely on the type of lens you are using. The longer the focal length of a lens – such as in a telephoto lens – the bigger the magnification of the image, and the faster the shutter speed required. The shorter the focal length – such as in a wide-angle lens – the less the image bobs around the viewfinder, and the slower the shutter speed required.

As a general rule, the slowest shutter speed you should use with any lens, when hand-holding, is 1/30sec. If the setting is any slower, you should use an extra support (see the table below). However, to allow for longer lenses there is a simple rule of thumb for calculating shutter speeds, which works with most

EXTRA SUPPORT

The following accessories and strategies can be employed when you want to use a slower than usual shutter speed:

Tripods A good tripod gives you a completely solid platform, allowing you to use shutter speeds that are seconds or even minutes long. As a general rule, the heavier and bulkier the tripod, the more stable it is. Features worth looking out for are an extendible central column, which allows you to raise the camera without adjusting all three legs, and a 3-way pan-and-tilt head for precise compositional changes, and to allow vertical shots.

Monopods The monopod is a one-legged relative of the tripod, which gives extra support when hand-holding

a camera. It is particularly useful for sporting events, or in other crowd situations, where a tripod is impractical.

Pistol grips A wide variety of often eccentric-looking camera supports can be found in a good photographic store. Shoulder braces, pistol grips, beanbags, spikes and clamps all give extra solidity to your camera.

Impromptu supports Bracing your back against a wall or tree will give you extra support in an "emergency", as will leaning your elbows on a fence or car roof. Resting the camera on a table or other flat surface, and then using the self timer to fire the shutter, is another tactic for low-light photography when you do not have a tripod available.

cameras. This says that the minimum shutter speed in seconds should be the reciprocal of (or "one over") the focal length in millimetres. In other words, when using a lens with a focal length of 250mm, you should use a shutter speed of 1/250sec, or faster. When the exact shutter speed you need is not available on your camera, go for the closest faster setting. For instance, when using a 100mm lens, choose a shutter speed of at least 1/125sec. With a zoom lens, use the focal length setting you have chosen for the shot when making your calculation – so the lowest shutter speed will vary within the zoom's range.

SHOOTING MOVING TARGETS

When photographing moving subjects, it is not the speed at which they are traveling that is important, but the speed at which the image moves across the viewfinder. The shutter speed needed to "stop" the movement depends on the size of the subject in the frame and its direction of movement, as well as its speed. These three factors must be taken into consideration together:
• The bigger the image magnification, the faster the shutter speed you need. If the subject is at a distance, or you are using a lens with a short focal length, you can use a slower speed than if the

subject is close to the camera or you are using a long lens.
• If the subject is moving across the frame, you will need a faster shutter speed than if the subject is moving toward the camera.
• Take into account the subject's speed. To get a pin-sharp shot of a sprinter moving across the frame, you will need a faster shutter speed than for a walker.

When you have mastered the art of selecting the correct shutter speed to give a sharp image, you can then begin experimenting with slower shutter speeds to add creative blur to your action shots.

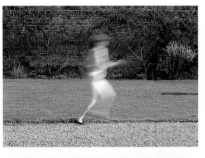 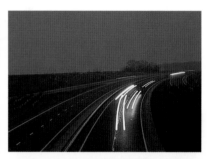

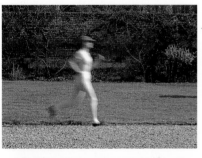 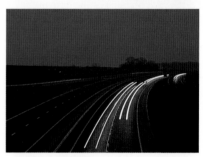

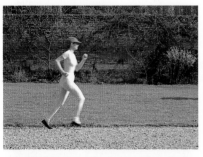

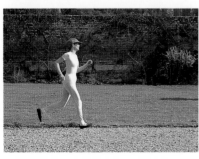 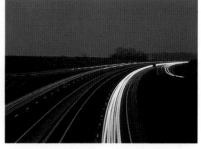

△ **Movement across the frame** – varying shutter speeds of 1/30sec, 1/125sec, 1/250sec and 1/1000sec, from top to bottom, were used to shoot a runner. As the movement is across the frame, only the exposure taken at 1/1000sec gives a completely sharp picture; all the others show different degrees of blur.

△ **Movement toward the camera** – the car was shot with shutter speeds of 1/30sec, 1/125sec, 1/500sec and 1/1000sec. Although it is traveling faster than the runner, at 45mph (72kmph), because it is approaching the camera only slight movement can be seen even in the shot taken at 1/30sec.

△ **Creating blur** – when photographing the lights of the cars traveling along a fast road, choose a deliberately slow shutter speed. Here shutter speeds of 2sec, 4sec, 15sec and 30sec (from top to bottom) were used. The longer the shutter speed the better the effect you achieve.

Focal length and focussing

The lens houses one of the most important controls, the focussing ring, and the SLR's ability to take different lenses – and therefore to offer a wide range of focal lengths – is one of its strongest assets. To squeeze more of the surroundings into your shot, or to home in on a detail in the distance, you can simply change the focal length.

THE LENS AND FOCAL LENGTH

All photographers find that there are subjects that they cannot photograph satisfactorily because they are unable to get close enough for the subject to fill the frame sufficiently, or because they cannot stand far enough back to include the whole scene in the shot. In both cases, changing the lens provides the simplest answer.

Different lenses produce images of varying sizes. The longer the focal length, the bigger the image magnification the shorter the focal length, the wider the angle of view.

The focal length of a lens is considered "normal" if it approximates to the field of vision of the human eye (excluding periphery vision). This focal length is roughly equivalent to the diagonal measurement of the camera's picture format.

Therefore, for the 35mm format SLR, a focal length of 50mm is considered usual. For other camera formats, the "normal" focal length figure changes (although the angle of view remains the same). For a 645 medium-format camera the normal lens is a 75mm, while for an APS camera it is a 35mm (see also the table on page 198).

WIDE-ANGLE AND TELEPHOTO LENSES

Lenses with significantly shorter focal lengths than usual are known as wide-angles, because of their wide angle of view. Lenses with significantly longer focal lengths are known as telephotos. For the 35mm format SLR, any focal length from 100mm upward is considered to be telephoto, while a

AUTOFOCUS MODES

Single shot AF Once the focus has been set with this mode it remains locked until after the shutter is fired. It is the best for stationary subjects.
Continuous AF This autofocus system continues to change the focus until the shutter is fired and is suitable for slow-moving subjects.

Predictive AF This is a refinement of continuous autofocus, in which the camera predicts where a moving subject will have moved to during the time between its last measurement (when the shutter is fired) and when the shutter begins to open – about 1/5sec. It is ideal for moving subjects.

△ **A 24mm wide-angle lens (35mm format) shot**

△ **A 35mm wide-angle lens shot**

△ **A 50mm standard lens shot**

△ **A 100mm telephoto lens shot**

△ **A 150mm telephoto lens shot**

△ **A 250mm telephoto lens shot**

◁ **To focus on the swimmer** I had first to compose the shot with the subject in the middle of the frame. Once focussed, the subject could then be repositioned to the side of the picture.

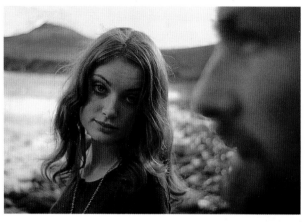

△ **When shooting close-ups** of people or animals it is important to make sure that you focus on the eyes – if these are sharp in your picture, it does not matter if other features are out of focus.

▷ **Autofocus systems** focus on whatever is in the middle of the frame. In this shot, the result is that the man on the right is out of focus.

focal length of 35mm or under is considered to be wide-angle.

However, few lenses for the 35mm format have only one focal length. Most are zoom lenses, in which the focal length can be altered by moving the positions of the lens elements using a rotating or sliding collar. And zooms that have both wide-angle and telephoto settings are increasingly common.

FOCUSSING

One of the SLR's most important controls is found on the lens: the focus ring. Turning the ring allows you to select which part of a subject will appear sharp in your picture. As you focus, what you see through the viewfinder is the image formed on the focussing screen, below the pentaprism. This screen is made of a coarse-surfaced glass or plastic that helps to accentuate the areas that are out of focus. Two further focussing aids are sometimes also found on the screen:
• A microprism area that gives you a clear view of your subject only when the focus is correctly set.
• A split prism area that causes straight lines to appear broken if incorrectly focussed.

All cameras with interchangeable lenses have the focus ring control, but an increasing number also have a system that makes this adjustment automatically:
Autofocus Even if your camera has an autofocus system, it is still important to

make sure that it focusses on the area of the picture you want to be sharp. An autofocus system tends to focus on the subject nearest to the middle of the viewfinder, and where there are two or more subjects in this area, on the one nearest to you. If you do not want this to be the focus of your picture, you need to focus manually, or to use the focus lock by moving the target over your main subject, locking the focus and then recomposing the shot as you prefer it.

Two other issues also need to be taken into account when focussing:
Focal plane A camera only allows you to focus precisely on one plane at a time – the one that runs parallel with the film in the camera. More of the picture may

appear acceptably sharp, due to the effects of depth of field (see page 20), but in front of and beyond the focus plane, circles rather than points of light are recorded on the film. The further away a part of the picture is from the focus plane, the more it is out of focus.
Three-dimensionality Most subjects are three-dimensional, so there is more than one plane to concentrate on. Choosing what to focus on can be difficult (especially if you have inadequate depth of field). For portraits, always make sure that the eyes are the sharpest part of your picture, because this is where the viewer looks first. With other subjects you have more freedom, as the viewer usually looks first at whatever is sharpest.

THE PROS AND CONS OF SLR AUTOFOCUS

• In good light, an autofocus (AF) system is often more accurate and quicker than focussing manually.
• Older photographers find autofocus compensates for failing eyesight.
• The autofocus system on SLRs works on the principle that the sharper the picture the higher its contrast. Subjects with no contrast variation, such as plain-colored walls, prove a problem for the AF system.
• SLR autofocus systems do not work well in low light.

• The best systems can focus on subjects moving at a moderate image speed, but poorer systems fail even with slow-moving targets.
• Autofocus systems select an area to focus on, but the photographer must still check that this is the area they want to appear sharpest.
• Autofocus SLRs often have inferior focussing screens and focus rings, which makes manual focussing difficult on the occasions when the autofocus system fails.

Aperture and depth of field

The aperture on a camera not only regulates how much light reaches the film, but also has a significant effect on how much of the picture is in focus. The ability to control depth of field, as this is known, is one of the most important creative tools that photographers have at their disposal.

The aperture is an adjustable hole through which light passes to form an image on the film. By varying the size of the aperture (in conjunction with setting the shutter speed) you can control the amount of light reaching the film.

The aperture on most cameras is an iris diaphragm made up of overlapping blades that can be moved to form a polygonal hole of varying size. It remains fully open until the picture is taken, to make focussing easier and to provide a bright image in the viewfinder.

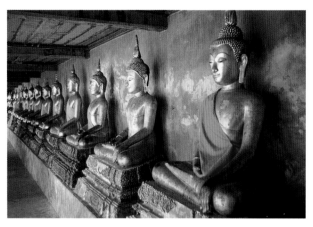

◁ **By shooting at f/32** with a wide-angle lens, I tried to make sure that as many as possible of these statues of Buddha were completely sharp. This meant focussing the lens on a spot part-way along the row in order to maximize the depth of field available.

F/STOPS

Apertures are described in terms of "f/stops". Confusingly, the larger the aperture the smaller the f/stop number, so f/2 is a large opening while f/16 is a small one. This is because the number represents a fraction of the focal length of the lens. When a 50mm lens is set to f/2, the diameter of the aperture is 25mm (50mm divided by two). At f/16 this lens's aperture diameter is 3.125mm.

The sequence of f/stop numbers on a lens runs as follows: 2, 2.8, 4, 5.6, 8, 11, 16, 22. The scale is such that by closing the lens by one stop you let in half the amount of light. Changing the aperture from f/8 to f/4 (opening up the lens by two stops) will, therefore, let in four times as much light (providing the shutter speed remains constant).

The reason why the f/stop series is so important is that each change in aperture by one stop can be compensated for by a one-stop change in shutter speed. If an exposure setting of 1/125sec at f/8 is correct, an exposure of 1/60sec at f/11 will also be correct. Similarly, 1/500sec at f/4 could be used.

CONTROLLING DEPTH OF FIELD

Besides influencing exposure, the aperture has another, more important, use: it affects how much of the picture is in focus. Although you can only focus on one plane at a time, a certain amount of the picture in front of and behind this plane also appears sharp. This zone of sharpness is known as the depth of field. It is greater in front of the point of focus than behind it.

Three main factors affect how much of the scene will appear sharp and therefore determine the depth of field: the aperture, the focal length of the lens, and the distance from the film to the point of focus:

Aperture Depth of field increases when you reduce the aperture.

Focal length The longer the focal length of the lens, the less depth of field you have to play with. A wide-angle lens will typically allow you to keep everything sharp from a few feet away to the horizon. However, with a long telephoto lens setting depth of field can be limited to just a few inches in front of and behind the point of focus.

Focussed distance The closer the subject is to you, the less depth of field you have to work with.

Control over depth of field is one of the SLR's main advantages, as you can use all three of the above factors to decide what will appear sharp. They can be manipulated to allow you to throw distracting backgrounds and intrusive foreground material so far out of focus that it is unrecognizable. Not everything that is out of focus will appear equally blurred, though. The further away an object is from the zone of focus, the more unrecognizable it will be.

6ft (2m)

135mm 50mm 28mm

◁ **The wider the aperture** and the longer the focal length, the shallower the depth of field. This diagram shows the depth of field provided by three lenses of differing focal lengths when focussed on a subject about 6ft (2m) away with an aperture of f/4.

∞

6ft (2m)

135mm 50mm 28mm

◁ **The narrower the aperture** and the shorter the focal length, the greater the depth of field. With an aperture setting of f/16, the 28mm lens makes everything appear sharp from about 3ft (1m) to infinity (the technical term for the distant horizon).

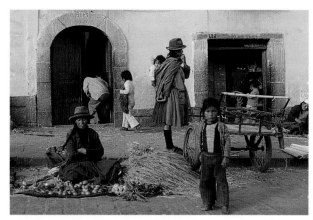

◁ **The closer you are to the subject,** the shallower the depth of field. Even with an aperture of f/8, the zone of focus does not include the full diameter of the bottle.

▽ **With two areas of interest** in this shot, an aperture of f/16 was needed so that they both appear sharp.

△ **Shot at f/2** it was more important to keep the shutter speed fast, rather than to worry about depth of field, hence some of the figures on the street are slightly out of focus.

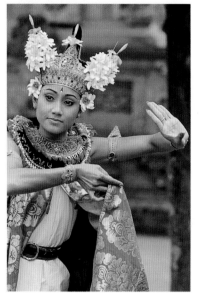

◁ **A wide aperture of f/4** helps to throw the distracting background out of focus in this shot.

▷ **An aperture of f/22** was selected to make sure that the church in the distance and the gondolier in the foreground were both in focus when taking the shot with a telephoto lens.

METHODS OF CHECKING DEPTH OF FIELD

Depth of field preview What you usually see in the viewfinder is the depth of field you would have if you selected the widest aperture for that lens. A good SLR, however, has a lever that allows you to "stop down" the aperture to the set value before taking the shot, to see how much of the image is sharp. As less light now reaches the viewfinder, this feature only provides a rough idea of depth of field.

Depth of field scale Some, but not all, lenses are marked with a range of aperture numbers next to the scale that tells you the focussed distance. Each of the apertures is marked twice. The distances shown next to these refer, respectively, to the distance of the nearest and farthest points in the picture that will be in focus.

Unfortunately, these scales do not mark every possible aperture, so are less than exact. However, they do, allow you to calculate the hyperfocal distance for a particular aperture. This

is the point at which to focus the lens to get maximum depth of field while ensuring that the horizon (known as infinity, or ∞) is also sharp.

Auto depth mode A few autofocus SLRs have a clever system whereby you

point the camera in turn at the two parts of the picture that you want to be the extremes of your depth of field. The camera then calculates and sets the necessary aperture and focus for the focal length used.

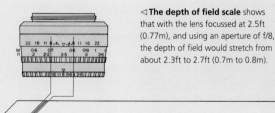

◁ **The depth of field scale** shows that with the lens focussed at 2.5ft (0.77m), and using an aperture of f/8, the depth of field would stretch from about 2.3ft to 2.7ft (0.7m to 0.8m).

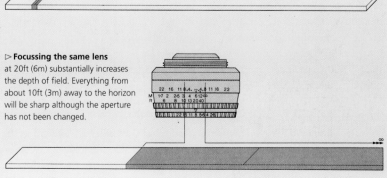

▷ **Focussing the same lens** at 20ft (6m) substantially increases the depth of field. Everything from about 10ft (3m) away to the horizon will be sharp although the aperture has not been changed.

Exposure modes

The great beauty of the SLR camera is that when setting the exposure for each shot you are free to choose the shutter speed or aperture – and any combination is possible. How you take advantage of this breadth of choice, and achieve a well-exposed shot, depends on the range of exposure modes that your camera offers you.

The art of photography depends on the choices you make – about what to include in the picture, what to highlight in the frame, and what effect to use. Two of the most important factors to consider before you press the shutter release are the aperture and the shutter speed.

However, you do not usually have a free choice with both of these. Select a particular shutter speed because, for instance, you want to avoid subject movement, and you will be restricted to a single aperture – unless, of course, you want to alter the overall exposure, or can change film speeds (see page 15). In short, when you select one setting, the other falls into place. Inevitably there are times when you have to compromise between the two. Low light may mean, for instance, that you have to use a wider aperture than you would want ideally in order to avoid camera shake.

Many SLRs give you a wide variety of ways in which to input these two figures, while keeping in line with the overall exposure suggested by the camera's built-in meter. These methods, or "exposure modes", vary from the completely manual approach to the totally automatic.

THE DIFFERENT MODES

The exposure modes that you are most likely to come across are as follows:
Metered manual With older equipment, simpler medium-format cameras, or large-format models, you are likely to find a true manual mode, where the photographer inputs both the shutter speed and aperture without any help from the camera. However, in more modern cameras, even the manual model works in conjunction with the built-in metering system. You put in a particular shutter speed and aperture combination, and the camera will tell you in the viewfinder whether or not it estimates the exposure to be spot on. This read-out may even tell you how far out it estimates you to be. In either case, you can use this mode for the most troublesome lighting conditions, when

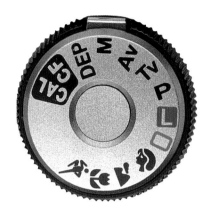

⊲ **A typical exposure mode dial** – each of the settings represents a different way to select the aperture and shutter speed. The icons of the runner, flower, mountains and woman correspond to special program modes. The "P" corresponds to either program or program shift mode, depending on the model of camera. "Av" and "Tv" are common abbreviations for, respectively, aperture priority and shutter priority modes. The "M" stands for metered manual, and the "L" is the camera lock. The green spot setting converts all the functions to automatic, for point-and-shoot photography, and "DEP" refers to the auto depth mode (see page 21).

you need to correct the metered exposure for many of your shots. This mode works you hard, and using it is a good way to gain experience of problems with exposure, without relying too heavily on the camera.
Program mode At the other extreme of exposure modes is the completely automatic setting, in which the camera sets both the aperture and the shutter speed for a particular lighting intensity. Of course, the camera does this without taking into account what you are shooting – so it may, for instance, select f/11 at 1/250sec even if your photograph would look better if those buildings in the distance were put out of focus by using a wider aperture. The straightforward program setting is little better than using a point-and-shoot compact and has no use in creative photography.
Special programs A slight improvement are the program modes that are specifically designed for particular picture-taking circumstances. Some cameras may even have half a dozen of these exposure modes covering such subjects as portraits, sports, landscapes and close-ups.

The rationale behind each of these is that you need a particular range of apertures or shutter speeds for particular subjects. A sports program, for instance, might make the assumption that you need a fast shutter speed, and will keep it above 1/500sec until the light is too low to enable this. The disadvantage of this approach is that a fast shutter speed

is not necessary for all sports pictures – sometimes depth of field is more important. These settings work for some shots, therefore, but fail for others.
Program shift This is by far the best of the do-it-all exposure modes because with this facility you have the opportunity to override the camera's automatic settings using a single dial, if you think the camera has got it wrong.

Mid-range apertures and mid-range shutter speeds can be fine for many pictures, but if you see that your shot needs a faster shutter speed, or limited depth of field, you can alter the combination to suit – shifting the exposure settings so that you get the shutter speed or aperture that you desire.

In short, the camera does the work, but you keep creative control. A full read-out of the settings in the viewfinder is needed to make best use of this mode.
Aperture priority This is a semi-automatic mode, in which you set the aperture you want and the camera sets the necessary shutter speed for the prevailing lighting conditions. A shutter speed read-out is given in the viewfinder, which will usually advise if the speed is too low for the camera to be hand-held. This mode can be particularly useful when you want to maximize (or minimize) depth of field over a series of shots.
Shutter priority This works in the opposite way to aperture priority. You set the shutter speed you want, and the camera works out the appropriate aperture for the metered light level and sets this automatically.

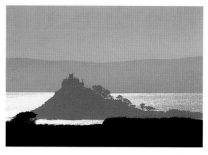

◁ △ **The exposure mode** that you use can be a matter of personal preference. In the shot on the left, the important setting was the aperture – to make sure that there was enough depth of field. Aperture priority was therefore the obvious mode to choose. However, in the shot above the shutter speed was more important – to avoid camera shake as a result of using a hand-held telephoto lens, and so I used shutter priority in this instance.

▽ **Manual modes,** because they are harder to use, are best employed in difficult exposure conditions. In the shot immediately below, the frontal lighting caused no problems for the meter, so I used a straightforward program shift mode. However, the picture at the bottom presented more problems because a delicate balance had to be found between the color of the sky, and the darkness of the silhouettes. The manual mode allowed me to take several shots quickly at slightly different exposures.

The direction and quality of light

Contrary to popular opinion, a sunny day does not guarantee good pictures. The art of photography depends on the quality of light, not the quantity. It is the direction of light that counts, and how much it is diffused – how shadow falls on a subject, how the light affects the intensity of its colors, and the level of detail that the light reveals.

There is more to photography than getting right the exposure, focus, shutter speed and aperture for a subject. One of the most important lessons to learn is how different types of lighting can affect the look and feel of your pictures.

The amount of light falling on a subject is often unimportant. You can allow for dimmer illumination with wider apertures, faster film, or slower shutter speeds. Conversely, it does not always follow that bright sunlight will produce good results. More important is the quality of the light. A picture of a famous landmark taken with the midday sun behind you can look like a lifeless cardboard cut-out, but caught by a single ray of light after a winter storm it can look majestic and golden.

The way you see an object depends on the angle at which light falls on it, and the way in which the light is reflected toward you. It is not just the parts of the object that are well lit that give us information about it; we learn as much from the areas in shadow, and so can work out the object's color, shape, texture and form.

The permutations in which sunlight can light an object are limitless – it can vary in direction, strength, and the amount it has been diffused by cloud cover or other obstacles. However, light can be divided into four principal types.

THE FOUR PRINCIPAL TYPES OF LIGHT
Frontal lighting Until quite recently, the standard instruction given to

photographers was to stand with the sun behind them. The reason why this advice was given, is that this form of lighting often gives the best colors, and provides an even illumination. It also means that there are few shadows, and so the scene has a low contrast ratio, which does not tax the camera's exposure meter.

The main disadvantage of this lighting is that, because most of the shadows fall behind the subject, out of view, there is little information about depth. The result is a flat picture that tells you little about the texture and depth of your subject.
Backlighting With the sun in front of the photographer, the subject is bathed in shadow. The result can be a high-contrast scene where you can not expose correctly for the subject as well as for the

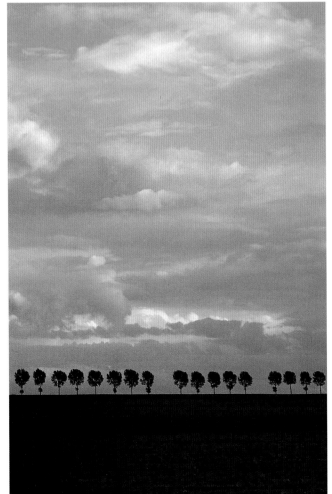

◁ **Backlighting** – with the sun in front of the camera, this line of trees in a French landscape appears as a row of silhouettes. Although backlighting is good for emphasizing shape, it gives little information about form, color and texture.

△ **Sidelighting** – with the sun low in the sky, this woman's face is only lit on one side; the other side is thrown into deep shadow. Sidelighting is good for emphasizing form because the shadow helps to convey the missing third dimension in a photograph.

sky behind it. If you expose for the sky, then you would expect to end up with a silhouette, which gives no information about the subject's color or its three-dimensional form and texture. All that is shown is the shape of the subject.

However, in practice there is always some light reflected toward the subject, from buildings, the ground, and even the sky (see below). This can make backlighting successful for some subjects, provided that you are prepared to have the background burn out. The subtle colors and lack of shadow variation offered by this lighting can look particularly attractive.

The other occasion when backlighting comes into its own is when shooting translucent subjects. Leaves, petals, and stained glass often look their best with the light behind them.

Sidelighting An object lit from the side becomes a mass of highlights and shadows. Parts of the subject that are facing the light source are caught in the light and seen in full color. Areas facing directly away from the light source are bathed in shadow and show no color at all. The parts of the subject in between, such as those facing the camera, are seen with their texture exaggerated, as any small bump creates its own shadow.

With simple shapes and easily recognizable subjects, sidelighting works well because there is an amplified sense of three-dimensionality. With more complex subjects, the picture can become a confusion of shadows.

Diffused lighting In direct sunlight, the shadows cast by a subject are clear and distinct. This is known as hard lighting. However, light is not always direct. Sometimes it is diffused by cloud cover or dust in the atmosphere. At other times, it is reflected off buildings or the ground. It can even be reflected by the sky, bouncing off particles in the atmosphere to create a bluish light known as skylight.

Areas in the shade are, of course, not lit by direct sunlight, but neither are they completely dark as they are lit by this indirect, or diffuse, sunlight.

Diffuse light casts very little shadow because it has been scattered by whatever it is reflecting off – so it strikes the subject from many different directions. It therefore tends to give less information about depth and form than direct light, and the subject's coloring appears more subtle. It works particularly well when you want to reveal intricacies and detail, such as in a person's face.

△ **Frontal lighting** – shooting with the sun behind you produces photographs with the best color saturation. However, the low-contrast, even illumination can make objects appear like cardboard cut-outs, as there are no visible shadows.

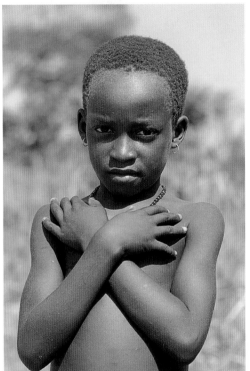

◁ **Frontal lighting** – this is not recommended for portraits because the sun creates unsightly shadows under the nose and around the eyes. Subtler lighting must be used for such subjects, to help suggest the form of the face and the texture of the skin.

▽ **Diffused lighting** – light bounced off buildings, or diffused by clouds, produces a low-contrast effect that is ideal for showing intricate detail, such as the lines on this old woman's face.

Flash lighting

Flashguns are not only used to increase illumination levels in dark conditions, they also change the quality of light. As flash lighting is of such brief duration, the way that the exposure is metered and the aperture/shutter speed is set is different from other picture taking. New skills, therefore, have to be learned when using flash.

The simplest way to avoid using slow shutter speeds, wide apertures and fast film when shooting in low light is to use a flashgun. This device is fitted as standard to many SLRs, although more powerful models are available as accessories and connected to the camera with a hotshoe, or via a simple connector known as a PC socket.

The power of a particular flash unit is indicated by a guide number – the higher the number, the greater the maximum output. Guide numbers are usually quoted in feet (or meters), in relation to ISO 100 film. The exposure setting for a particular guide number can be calculated using the following formula: aperture equals guide number divided by flash-to-subject distance. So, if you are using a flashgun with a guide number of 60 (ft/ISO 100), (or 20m/ISO 100), and your subject is 15 feet (5 meters) away, then the aperture required is f/4 when using ISO 100 film. Corrections need to be made when using other film speeds.

You will notice that no shutter speed is given in this exposure calculation. This is because when the flash is used in low light, the shutter speed has little effect on exposure. However, you do not, have a free choice of shutter speed. The focal plane shutters on SLRs only completely open the film curtains at slower speeds. At faster speeds, the film is exposed

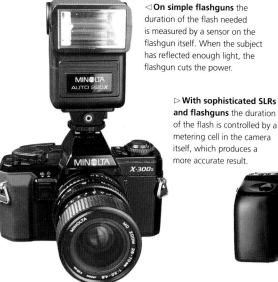

◁ **On simple flashguns** the duration of the flash needed is measured by a sensor on the flashgun itself. When the subject has reflected enough light, the flashgun cuts the power.

▷ **With sophisticated SLRs and flashguns** the duration of the flash is controlled by a metering cell in the camera itself, which produces a more accurate result.

through a moving slit. The fastest shutter speed in which the curtains are fully open at some point during the exposure is known as the flash synchronization speed, or synch speed. This varies from 1/30sec to 1/250sec depending on the model and is the fastest shutter speed that can be used with flash. It is often marked in a different color on the shutter speed dial (or labelled "X").

FLASH METERING

Most flashguns have automatic modes that can work out some, or all, of the calculations and settings for you. On more basic cameras and flashguns, the shutter speed may automatically be set to the synch speed. A small sensor on the flashgun can be used to control the duration of the flash burst, cutting the power when enough light has been reflected by the subject. However, the aperture may have to be set manually for the distance range of the subject.

On more sophisticated cameras, the exposure can be measured by the camera using a system called through-the-lens (TTL) metering. The reading takes into account the focal length of the lens being used, and the reflectivity of the principal subject. If communication between the gun and the camera (known as dedication) is good, the aperture can set itself automatically, and the shutter speed can vary itself automatically to suit the ambient light.

THE QUALITY OF FLASH LIGHTING

Having a single flashgun mounted on a camera is convenient, but this set-up does not give the best results. Flash is a hard light source, and, as with other frontal lighting, it can cause problems in the following areas:
Form The light is directed straight at the subject, giving little information on form.
Shadow If the subject is standing against a wall, hard shadow shows around it.

▷ **A typical studio flash unit** – these are mains-powered, and have a higher output than hand-held flashguns. The quality of the light can be controlled by fitting accessories – such as an umbrella, which produces bounced flash.

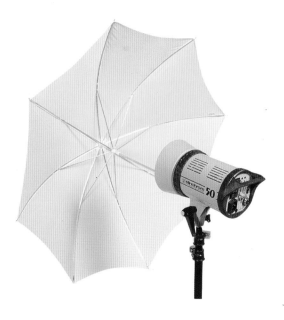

△ **Fitting a diffuser over a flash head** placed to the side of the composition has provided sidelighting that helps to accentuate the cylindrical form of the jug and cups.

◁ **The inverse square law** is illustrated in this shot. Although the women wrestlers are adequately lit by a flashgun, the background of the arena and spectators is lost in darkness because of its distance from the flash. This has helped to simplify the composition, but the effect can at other times make your pictures look unnatural.

Lighting intensity All light obeys what is known as the inverse square law, in which the further away an object is from the light source, the less light it receives. The amount of light reaching the object is inversely proportional to the square of the distance. When you are shooting in sunlight, this law has no significance as the distance to the sun is so great. When using flash, the law is fundamental because if your scene has any depth the variation in lighting intensity throughout it will be enormous. An area of the scene that is twice as far away as another area, will receive a quarter of the light (a full two stops difference in exposure). In a flash-lit picture, therefore, the background appears very dark if it is far behind the main subject.

Red eye Portraits can suffer from red eye – a phenomenon in which the flash reflects off the retina of the subject, showing up the blood vessels in the eye. The effect is made worse by decreasing the angle between the camera, the eyes and the flash, and therefore by having the flashgun and camera close together. For the same reason, the effect becomes worse the further away the camera and flash are from the subject.

These problems can be minimized by a variety of techniques including:
• Placing the flash unit well to the side of the camera (on a bracket, for example), to angle the light slightly and give slight shadows to suggest form and texture.
• Diffusing the flash to make the light softer, by covering the flash with a diffusing material or angling the unit so that it bounces off a surface (such as a wall or ceiling) before hitting the subject.
• Decreasing the shutter speed of the camera below the synch speed, to increase the effect of any ambient light and so make the background lighter.

FILL-IN FLASH

Flashguns are not only useful after dark, they are also handy in daylight, providing "fill-in" flash – so called because ambient light still has a significant effect on the picture. It has the following uses:

Backlit subjects With subjects lit from behind, it reduces contrast, illuminating the dark subject in the foreground. It only works for subjects that are close to the camera.

Dull weather The diffuse lighting of an overcast day can produce shots that lack color intensity and contrast. Flash increases the directionality of light, putting some of the punch in your pictures. This is an essential technique for news and wedding photographers, who cannot wait for the light to change. Again, it only works for close subjects.

Freezing movement with flash

Electronic flash has an extremely short duration, lasting often just a fraction of a millisecond, so it can be used to photograph moving subjects and to capture a single moment of action that is happening too fast for the human eye to see, and which it would not be possible to catch with the normal shutter speed range of a camera.

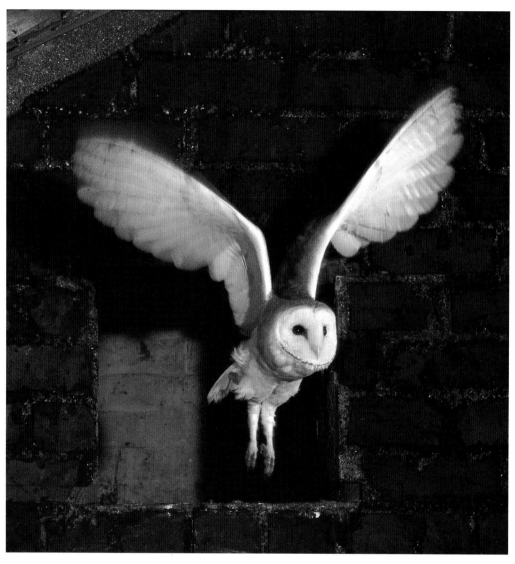

◁ **A barn owl** leaves its nest in search of food. Having observed the flight path of the bird, I was able to set up my camera and flashguns in exactly the right spot to catch the image on film. All but the tips of the owl's wings are frozen by the flash, which was used at full power and gave an effective shutter speed of about 1/500sec, although the camera was set to its flash sync speed of 1/60sec.

A flashgun works by charging a capacitor with electrical current from batteries (or the mains, in the case of studio flash). When the shutter release is triggered, this storage tank of electricity discharges itself through a gas-filled tube, producing an instant, high-intensity flash of light.

The length of time of this flash varies depending on the type of gun, and on the flash-to-subject distance, but it rarely lasts longer than 1/1000sec. Often, with higher-powered guns used for short distances, the duration can be as short as 1/40,000sec.

When a flashgun is used in low light, the duration of the flash effectively becomes the shutter speed for the shot.

With such high speeds, it is possible to capture on film fast-moving subjects that the eye never sees. Such subjects can also be recorded in freeze frame on film.

A sugar lump falling into a cup of tea, for instance, can be photographed so that every droplet of liquid is "frozen" in your picture. Similarly, a bullet leaving the barrel of a gun can be shown seemingly hovering in the air. As the picture above shows, the technique can also be used to capture insects and birds in flight, which has revealed previously unknown characteristics about their locomotion.

The main difficulty with this type of photography lies in being able to synchronize the moment when you press

the shutter release with the moment when your subject is in the frame. You can prepare for the shot by setting up the focus and exposure beforehand, but human reactions are not quick enough to capture the fastest moving objects – such as insects and bullets. For these subjects you can use a special triggering device in which the subject indirectly takes its own picture, by firing the trigger as it crosses and breaks a continuous beam of infra-red light.

Larger subjects, with set patterns of behavior (such as the owl shown above) are easier to shoot manually, as are repeatable shots, such as a sugar lump dropping into tea.

Projects

Color

Of all the elements of a photograph, it is color that draws the greatest emotional response from the viewer. It is for this reason that it must be used with great care – the photographer must decide which elements to include and which to emphasize in the picture. Some colors attract the eye more than others. Primary colors – particularly red – are seen instantly by the viewer even when they cover a small area of the image. Other colors – notably blues – tend to retreat in the picture, and do not command as much of the viewer's attention.

The way in which colors are combined in an image will change the overall effect. Some colors clash, creating a discordant image, whereas others blend together well, creating a feeling of harmony. The appearance of a particular color will largely depend on the type of lighting. Frontal lighting will often give the strongest colors, but the resulting image can be so bright that the effect is dissipated. A mass of seemingly clashing colors, for instance, will tend to harmonize in subtler lighting. The truest colors are often produced on a clear day at noon, but the most suitable colors for your picture may be produced at other times of the day or in overcast weather.

△ **Similar colors tend to harmonize** in a picture. Here the turquoise of the net and the blue of the rope blend to make an interesting abstract photograph.

△ **Balance is the key** when dealing with color. The kaleidoscope of color provided by the flower seller's boat is balanced by the large expanse of water.

▷ **The bright blue dress** of this woman contrasts against the dark tones of the stone wall behind. The difference between these two colors helps to emphasize the shape of the main subject.

▽ **A sunset is essentially** a monochromatic picture where the only real color is provided by the varying shades of orange produced by diffraction of the sun's rays. The shapes in the picture – such as the silhouetted figure – are rendered in a colorless shade of grey or black.

△ **Even a small splash** of a bold, primary color will become the main focal point in a picture. In the shot above, although the straw-colored corn fills most of the frame, it is the bright red poppies that immediately catch your eye when you look at the photograph.

▷ **The colors of nature** invariably work together. When in shadow, and lit indirectly by diffuse sunlight, the full beauty and variation of the turquoises and browns can be seen to the full.

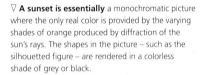

▷ **Bold primary colors tend to dominate** a photograph. Here the red flowers, and the yellow flowers in the distance, grab the attention of the viewer – almost to the exclusion of everything else in the frame.

Shape

Shape is the most fundamental and the most economical of all the compositional elements. The simple outline of an object is often enough to enable you to recognize it. People, for example, can often be identified from silhouette portraits in which nothing is visible but the profile. Details such as the texture of the skin, the form of the features, or the color of the hair play a less important part in recognition than the basic shape of the face. Therefore, the classic way to show the shape of a subject alone is to use backlighting, and then to expose for the background – turning the subject into an underexposed, black silhouette. However, this approach often leads to dull-looking pictures that tease rather than inform.

A better technique is to stress the shape by using sidelighting, and, most importantly, by choosing the camera position carefully so that the outline of the subject is clearly visible against the background. A low camera angle, for instance, will allow you to frame a subject against the sky, providing a neutral backdrop to shoot against. In the studio, the shape of a subject can be accentuated by using a plain white or colored roll of paper. A further technique is to underexpose the subject slightly (by up to a stop), thereby emphasizing the shape at the expense of other picture elements, such as form and color or tone.

▽ **Even with just the outline** to go by, there is no mistaking the shape of New York's Empire State Building and the Brooklyn Bridge. This classic early-morning shot has used backlighting to simplify the image. However, the misty conditions have produced a photograph that is more than a mass of silhouettes. The diffraction and diffusion of light by dust and water particles in the atmosphere has created a multi-toned picture with a feeling of depth.

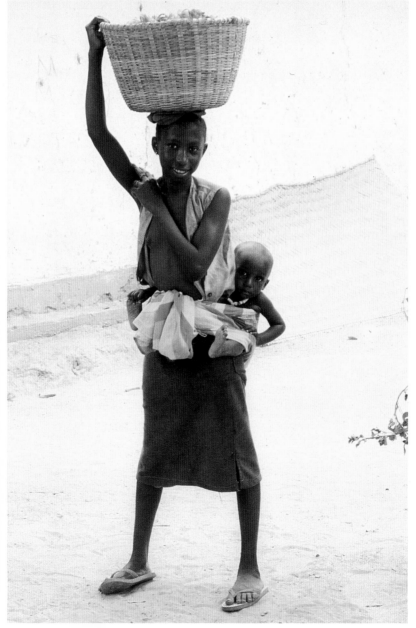

△ **Although there is information** about color, texture and form, this picture of the Egyptian pyramids is dominated by shape – not only that of the pyramids, but also of the camel and driver and the donkey and its rider. But rather than use the pyramids themselves as the focal point, I carefully chose a camera angle that made the best of the shapes of the man on the camel, and the donkey rider. By moving around I found a viewpoint from which each of these elements was distinct and did not appear on top of each other in the frame.

◁ **It is the contrast** between the slightly burned-out background and the dark but correctly exposed young girl that helps to emphasize shape in this portrait. This is a proud picture, in which the girl's firm stance says much about this family's way of life. But it is not purely an exercise in shape. Rather, the use of a featureless, white backdrop has simplified the overall composition of the picture. As there is no unnecessary information and detail, the viewer can concentrate exclusively on looking at the main subject, her baby passenger, and her basket.

Texture

Texture in a photograph is like an adjective in a sentence – its purpose is descriptive. A photograph taken with the right camera angle and lighting can accentuate the texture of a subject so that the viewer can imagine exactly what the surface would feel like if it were touched.

Everything, animate or inanimate, has surfaces that can be very expressive. The peeling paint of a wall, or the wrinkled brow of an old man, for instance, can tell us about the age of the subject. Even a highly polished surface, if photographed with severe lighting and high magnification, will reveal facets of its texture that are not readily visible to the naked eye.

To exaggerate texture, sidelighting is often the best technique to use. The mass of shadows and highlights that results throws the surface into relief, showing up every bump, furrow and spot. The more the light is angled so that the rays follow the surface of the object, the more pronounced the effect.

However, texture is not always a welcome addition to a photograph. Commercial portraiture, for instance, aims to flatter the customer – not to show up every wart and wrinkle. So sometimes such angled lighting must be avoided at all costs, and the opposite approach is taken to smooth out the ravages of time!

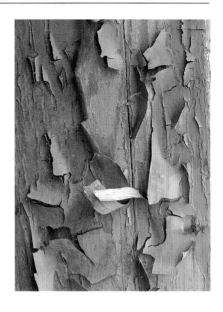

△ **Peeling paint** might not seem the most photogenic of subjects, but simplifying the composition and using sidelighting has turned the surface into an abstract, three-dimensional design. The subtle lighting was sufficient to accentuate the texture without creating harsh shadows.

▷ **Photographers are frequently told** to avoid working with the midday sun. However, I found that overhead sunlight was the only way to show the full detail of these Egyptian hieroglyphics. The extreme lighting has also made a focal point of the similarly carved brow of the guide, as much of the rest of his face has been thrown into shadow.

◁ **Texture need not always be exaggerated.** Here diffuse lighting is enough to reveal the exfoliation and decay on this rusty piece of metal. Because sidelighting has been avoided, the color too can be seen in all its richness.

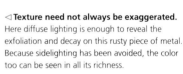

▷ **Sidelighting is generally avoided** for portraits, unless the photographer wants to show every hair and blemish on the face. Here, however, gentle sidelighting reveals the delicate quality of the girl's complexion. Soft focus has also been used to complement this approach.

▷▷ **A person's skin** tells you about the life that they lead – whether they live and work in a harsh environment, for instance. In the picture on the far right, the weathered face of this man says much about its owner's lifestyle and age. You can imagine that behind every one of his crow's feet there is a story of hardship and toil.

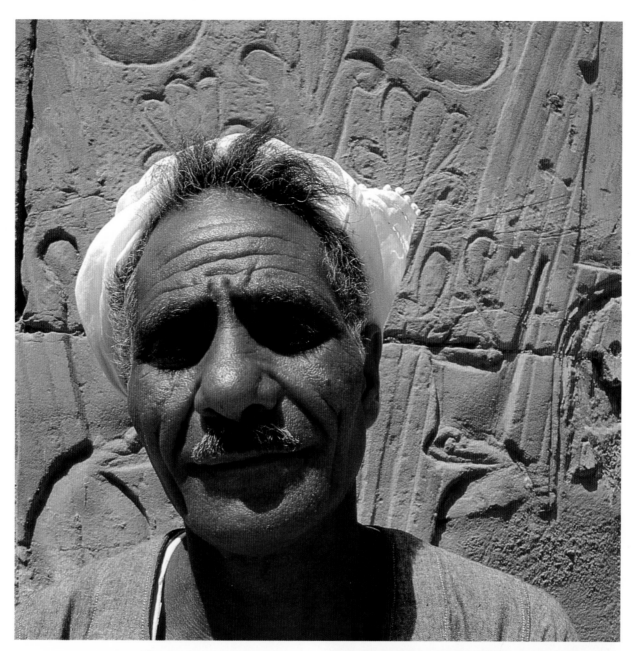

Form

Photography is a two-dimensional medium describing a three-dimensional world. Because of this, the photographer has to find ways to suggest the missing information about depth to the viewer in every picture that he or she takes.

 The shape of the outline is, as we have seen on pages 32–3, sufficient to identify the object, but the outline tells nothing about the "roundness" of the object. It is essential to suggest, therefore, that an apple can be picked up – that it is more than a cardboard cut-out. It is the gradations of light and shade that reveal the form of a subject. In this respect, form is closely related to texture. However, instead of the raking light that emphasizes texture, subtler sidelighting is used to accentuate the modelling of a subject. The gradual variations in tone and hue that are obtained in this way are enough to depict the subject as three-dimensional and therefore real.

▷ **Correct exposure** is often of the utmost importance in suggesting depth. In order to show the subtle changes in modelling, the exposure must reveal as many midtones as possible between the areas of shadow and highlights. Here a soft light to the side of the camera has revealed this tonal range, and an average reading from the model's skin has determined the shutter speed and aperture combination. Notice how this angled lighting also reveals the texture of the woman's skin.

▷ **A bowl of fruit** is the classic subject to use for your own experiments to find the best lighting to suggest the three-dimensional nature of small objects. By moving the studio lights, or by changing the camera position relative to a window, you can find how strong the sidelighting needs to be. A reflector can be used to fill in the shadows on the darker side of the fruit if necessary. In this shot, the main light source has been placed slightly to the side and above the bowl of peaches.

▽ **Bright sidelight** provides enough modelling in this shot to suggest that the trunks of these trees are cylindrical in shape – rather than being cuboid or cardboard cut-outs. Notice the variation in tone and form between the areas of bark which are highlighted by the sun, and the central trees in the shadow area, which are only lit by diffuse, reflected light. The gradation from highlights to shadow and separation of tones suggests form.

Pattern

Patterns can be found in almost anything that you photograph. In nature, they are particularly abundant, be it a pile of similarly shaped leaves, or the intricate lattice-work of a spider's web. Manmade patterns also surround us – in the bricks that make a wall, or in a stack of tins on a supermarket's shelves.

Photographs based purely on pattern are little more than decorative, but by isolating it from other elements you show a geometrical order to the subject of which you may not always be aware. The novelty of seeing a pattern in the most ordinary of objects has a curious pulling power.

The most suitable viewpoint for taking pictures of patterns is usually from a straight-on, frontal position, or at an angle with the lens stopped down to give good depth of field. Pictures of pattern can look very flat – as if it were wallpaper you were photographing rather than three-dimensional objects. Although diffuse lighting might help accentuate the pattern, it is better to use soft, directional lighting, which will help suggest form and color.

To shoot patterns you do not even have to leave your home. You can arrange identical or similarly shaped objects and photograph them so as to emphasize the pattern they form – such as a dozen identical empty bottles, taken from above.

▷ **A photograph of the decorative topiary** in this garden would do little more than record the skill of the gardeners who made it. However, the inclusion of the person in the foreground added interest, focus and context to the picture.

▽ **The intricate lattice-work of a bridge** is highlighted by isolating the cables in the frame with a telephoto lens. With no color in the picture, and little information about depth, the viewer can concentrate on exploring the patterns formed by the wires, arches and balustrade.

△ **A carefully arranged pile of pears** on an Egyptian stall, combined with the decorative wheel, offers an interesting scene. The desire for order, color and beauty is a fundamental wish in most of us.

▷ **By choosing a head-on view** and excluding the box itself, I accentuated the pattern made by the fruit and the purple dividers, which isolate each color area and allow you to examine each apple. Although the primary elements in this picture are pattern and design, the lighting has also given sufficient information about form and color for the viewer to know that these apples are three-dimensional objects.

Framing

There is a very straightforward maxim to use when composing a photograph: the simpler the picture, the stronger the picture. By eliminating all unnecessary detail from the foreground and background, you often improve the composition.

Part of the problem in simplifying a picture is the film format that you are using. Whether you are using 35mm, with an aspect ratio of 3:2, or the square 6 x 6cm (2¼ x 2¼in) format, there will be subjects that do not fit neatly into this shape. Although selective cropping enables you to change the picture's proportions at the printing stage, it is generally better to get the shot looking right from the beginning.

One way of hiding unwanted areas of the photograph is to use a frame within a frame. A window or arch, for instance, can be used as an opening through which to shoot, and forms a natural border to the picture. This technique also adds depth to the shot, as the viewer knows that this inner frame is in the foreground. Similarly, the branches of a tree can be used to isolate a building or landscape – the foliage covers either clutter or empty spaces in the frame. Areas of shadow can be used in a similar way, as the eye is naturally attracted to the lighter areas in a picture. It is often tempting to cut out these dark areas by zooming in, but if you leave them in they act as a handy compositional device, allowing you to give your subject more emphasis.

△ **The tall church spire** does not readily fit the 35mm frame. By shooting through the branches of a tree, a natural border is formed that fills the photographic frame.

▷ **In this classic frame-within-a-frame shot,** an archway has been used to simplify a study of the Taj Mahal in Agra, India. By shooting from behind the arch, I excluded some of the elements of this famous building – such as the minarets and gardens. A further benefit of the arch is that its shape is repeated in the building itself.

▽ **The window pane** adds a sense of mystery to this portrait. As you can not see clearly through the glass, because of the reflections, you have to peer at the picture to see the woman properly. The frame puts the photograph in context by making it obvious that we are looking through a window. As people do look out of windows all the time, this inner-frame technique is particularly suited to portraits and gives a sense of being both inside and outside.

◁**The inclusion of the dark clouds** and dark sea in this shot leads the eye to the skyline of this coastal town and the bright peach-colored expanse of sky. The picture could have been cropped tighter, to include less of the shadow areas, but this would not have given the same sense of openness and we would have seen less of the sprawling seaside buildings.

▽ **Light itself is the strongest element** in this almost abstract shot of high-rise office blocks. Again the eye is first led to the lighter area in the middle of the picture. But on closer inspection you can see that the buildings at either side of the picture are of the same design, and that a distinctive pattern is formed by the hundreds of windows. While pattern and light play important parts here, there is also a feeling of airiness and immense height. You can imagine the hundreds of desk-bound workers hidden behind the windows of the three towers.

Exploring possible shots

Any subject will offer more than one viewpoint that will give you exciting photographs. The combination of lens setting and camera position will provide an enormous choice as to what is, and what is not, included in the frame. But the possibilities do not end there – the time of day, the season and the lighting also have a bearing on how the picture will appear. Add to that the ways in which different apertures, focussing distances and accessories will affect the result, and you have an infinite number of pictures that you could take.

When visiting a new location, do not take just a couple of pictures and give up. After all it may well have taken you hours to get there, but even if you have not it is worth investing a little more time to search out the best camera angles. You might find that a wide-angle lens used close to the subject works best, but equally you might need a super-long telephoto, used from half a mile away, to get the shot you want. The challenge is always to try to bring out something that is not obvious to begin with. Patience is a vital attribute for any photographer. The lighting may not be ideal when you first visit a site, but waiting a couple of hours, or returning another day, will reap the reward that you are looking for. Photography is not just about turning up and pressing the shutter – you have to work at getting great pictures.

△ **Gray overcast conditions** are not suitable for all shots, but for close-ups of the mechanics of this Isle of Man water pump they were fine. I was able to tackle this picture as I waited for the sun to break through.

▽ **A shot worth waiting for** – eventually there was a slight break in the cloud cover. The resulting sidelight increases the contrast and drama in the scene, reveals the construction and form of the pump, and establishes its location.

◁ **The close-up of the Manx emblem** on this 19th-century water wheel proudly boasts its home, where it was once used to keep nearby lead mines free from water. The Isle of Man wheel, called the Lady Isabella, is the largest such structure in the world.

◁ **A similar shot to that on the opposite page** except this close-up was taken from the other side of the wheel, adding the further pattern of the railings. The mixture of straight and curved lines creates an abstract design well worth photographing.

▷ **The diffuse lighting** and the distant viewpoint combine to show the surroundings in which the Laxey wheel is situated, with the stream and surrounding countryside clearly in view.

◁ **By finding a high vantage point** at which the camera was at a similar height to the wheel, I was able to take well-balanced photographs, both from a distance and much closer to the subject.

▽ **A brief break in the cloud** was worth waiting for here, as it has helped to accentuate the color of the paintwork. The highlights and shadows have also helped to produce a feeling of dizzy height as your eye follows the rail down the spiralling staircase. Maximum depth of field was needed to achieve sharp focus throughout.

▽ **An abstract approach** shows the viewer just a section of the giant wheel. The picture was shot from ground level with a telephoto lens.

△ **This sequence** shows the way in which a subject can change when you vary subject distance and camera height. The shot above was taken with a wide-angle lens from eye level, creating strong diagonal lines. The pattern of the arches was stressed by including very little foreground detail.

△ **A distant view,** this time shot from above the Roman aqueduct, gives a completely different view. Here we see clearly how the structure spans the valley. A telephoto lens was used to increase the magnification, but the surrounding landscape was also included to help give context.

△ **Taken from farther down** the valley, this shot was also framed at eye level, and shows the river clearly, helping to add color to the picture. This time a standard focal length was used – and only part of the aqueduct was included in the frame, to simplify the photograph.

△ **Shot from ground level,** this wide-angle picture gives a worm's eye view of the entire aqueduct. The choice of a low camera angle has usefully filled the foreground with the outcrop of rock. The distinct areas in the shot – the rock, water, aqueduct, and sky – enhance the feeling of depth.

Selecting a viewpoint

By moving round a subject, you not only affect the angle at which the subject appears in the picture and the direction of lighting – you also change the role played by the foreground and background. Move the camera a short distance to the side, for instance, and what is seen behind the subject will completely change. This allows you, in many situations, to find a background that suits the subject. Sometimes this entails trying to exclude ugly buildings as a backdrop, and sometimes it requires the inclusion of something that adds to the picture, such as a beautiful landscape.

Similarly, by choosing a lower or higher camera position you can decide how much of the foreground you want to include. When using long lenses, you might want to forego all foreground detail, while with wide-angle lenses you will often be looking for something that will fill what would otherwise be an empty hole at the bottom of your composition.

△ **The church at Snaefellsnessi** is reputed to be the only black church in Iceland. Having travelled some distance to photograph it, I walked all round it in search of the most interesting viewpoints.

△ **I managed to exclude the nearby hotel** from the scene when taking this shot, but I was to find far better viewpoints to shoot from in my circumnavigation of this unusual building.

▽ **By using a telephoto lens,** I isolated the church against a small section of the mountains, thus accentuating its remoteness and isolation. Excluding the sky helped to keep the exposure balanced.

△ **The volcanic rocks** that litter this frozen landscape were used to fill the foreground in this distant shot of the church. To ensure adequate depth of field an aperture of f/22 was required.

◁ **Here the black lava** frames the church, leading your eyes to the building and almost suggesting that it is camouflaged to blend in with the landscape. The flowers in the foreground give a sense of distance and space.

▽ **This shot was framed** with the church in the central third of the picture, both horizontally and vertically. This composition is another way of conveying the church's isolation amid overwhelming landscape.

◁ **A rather different approach** from all the other pictures on these two pages, with a sand dune filling nearly all of the frame. This technique helps to keep the feeling of openness and remoteness without having to include large areas of the surrounding landscape. As with most of these shots, despite relatively bright conditions I was forced to use a tripod and ISO 100 slide film, so that I could use a small enough aperture to ensure that the whole frame was sharp.

△ **Shooting against the light** turned the church into a silhouette, allowing me to use the cloudy sky as a backdrop. The only problem with this shot is that the backlighting does not show the unique quality of the building – with no information about color, the viewer has no idea that it is black. In addition, the framing does not reveal the church's complete seclusion.

Covering every angle

The problem with stills photographs is that they are just that – still. If care is not taken over the composition, a shot will appear lifeless. However, the smallest adjustment to the camera angle can have a dramatic effect. Remember that just because you can not move mountains it does not mean that you can not change the way they appear in your photographs!

A simple device to use to make your pictures more dramatic is to introduce diagonal lines. While lines that run parallel to the borders of a shot look staid and motionless, diagonals are dramatic. The dynamic force that these diagonals cause by interacting with the frame makes the viewer's eye follow them, because they suggest movement. By moving round a subject, you will see how both horizontal and vertical lines become diagonals – simply because of a change in subject position. The key is to use a less straight view, moving slightly to the side of the subject. Then, by using a wider-angled lens close to the subject, rather than a telephoto lens from a distance, you will further exaggerate these dynamic diagonals. If there is just one diagonal line then the optimum angle to the side of the frame is 45°. If there are two or more lines, you should aim to prevent them appearing parallel to each other by keeping the angles between them and the borders as wide as possible.

△ **In this head-on view** the waterfall runs parallel to the sides of the picture, producing a shot that is more static than any of the others in this sequence.

△ **Moving closer** to the waterfall, and slightly to the side, makes the composition more dramatic and conveys the movement of the water.

△ **As I continue my 180° tour** round the Seljalandsfoss waterfall, in Iceland, the angle that it makes with the picture frame continues to increase.

△ **Taken with a longer lens,** this shot highlights the power of the water alone, leaving out the sky and the summit of the rock face.

△ **The droplets of water** act like a prism, diffracting the sun's rays to produce a rainbow of light across the picture, and creating another diagonal.

△ **Notice that as the camera** moves round, the top of the cliff forms a powerful diagonal – another dynamic path for the eye to follow.

△ **In such a high-contrast scene,** auto exposure fails, causing the main subject to appear overexposed. For the other shots I used a highlight meter reading.

△ **The camera is now positioned** at 90° to the side of the waterfall, capturing the force of the cascading water as it shoots over the cliff.

△ **Moving further round still,** I was now standing slightly behind the water. From here, it looks wider than it has appeared in the previous shots.

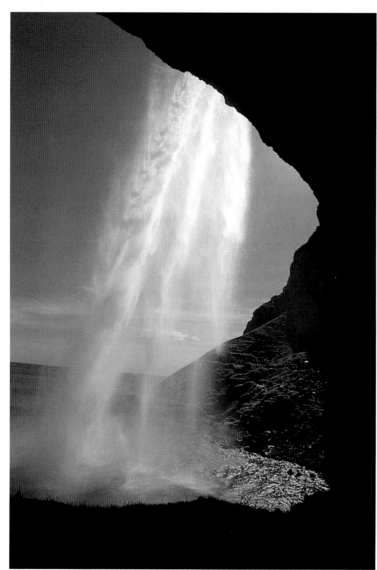

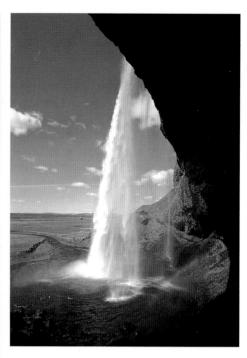

△ **Although the waterfall** is positioned almost vertically in this shot, its edges still form slight angles to the sides of the picture. Also, the overhang of the rock now forms a far more powerful diagonal line, adding drama to the composition.

◁ **With the main line of the waterfall** forming a 45° angle with the side of the picture, the backlit water and the additional diagonal lines formed by the overhang of the rock, this shot from behind the cascade is the most dramatic in this sequence of pictures.

▽ **An alternative way** of displaying the power and force of the water, this selective viewpoint focussed on the pattern formed by the millions of water droplets. You almost feel the cold water on your skin as you look at this picture.

Improving composition

Although the composition of a shot changes as you walk round the subject or change lenses, it is also possible to make substantial alterations to the way a picture looks by moving just a few feet – or sometimes without moving at all.

One of the most fundamental changes available with most cameras is to rotate the composition to give an upright, or portrait, shot, rather than a horizontal, or landscape, shot – although this change is not possible for those using square formats such as 6 x 6cm (2¼ x 2¼in). You can also tilt the camera slightly to include more, or less, sky in the shot. Usually the horizon is positioned about two-thirds of the way up the frame but this can be altered if it helps the picture.

Most people take pictures at normal eye level, but by bending your knees, lying down or standing on a wall you will radically alter the way you see the shot. A low-angle shot, for instance, often involves tilting the camera upward, which exaggerates the height of the subject. However, the main advantage of this tactic is that you can use it to exclude extraneous objects and so give greater emphasis to your subjects.

△ ▽ **In the shot above** the camera was held at eye level, but this has the effect of looking down on the boys, and means the background looks cluttered. By lying down on the ground for the low-angle shot below, I achieved a cleaner composition in which the boys are shown against the light sky.

▽ **The two pictures of the hillside church** below look very similar on first inspection. However, if you look closely you will see that the church in the picture at the foot of the page has moved, and now seems much closer to the two peaks in the distance. Such changes are produced simply by moving the camera to the left or the right of the original position – as you move, so the subject seems to move relative to the background.

△ ▷ **The same camera position** was used for these two pictures of Lake Traunsee, in Austria. The only change was that I tilted the camera slightly between the shots. In the picture on the right more of the sky is included, causing a bleached-out distraction from the main subject. In the shot above more of the lake is included, with the reflections of the buildings in the water adding interest to the photograph.

◁ △ **At first I thought** a vertical shot would best suit this spired church (above), but this format made it necessary to include more of the road in the foreground. Rotating the camera to a landscape format for the shot on the left, I was able to achieve a far more pleasing composition.

▷ **Shooting from ground level** made the vertical lines in the shot of the church immediately on the right appear to converge. However, when I shot the same scene (far right) from an upstairs window of a house across the road, the camera was at mid-height to the church and the sides of the building run parallel to each other once again.

A question of distance

Picture composition entails arranging the various visible subjects in an order of preference. The simple principle used to determine what goes where is that the photographer should communicate to the viewer what is the main interest of the picture. As a rule, there should be one main subject, and everything else in the frame should be subsidiary to it – or contribute to it in some way.

The main subject is positioned in the frame in such a way that other elements are included that help the design, or that help set the mood and atmosphere. The decisions that usually have to be made concern how much background and foreground are included. In some shots, the foreground, or background, may form the main subject of the picture. In others, the subject is isolated in the "middle-ground" with no appreciable or recognizable foreground or background. When the viewer looks at the picture, however, you want them to work their way through it gently. You do not want the punchline to be obvious, but want the eye to be drawn to the main subject naturally as it wanders through the whole frame. However, you will often have to arrange the picture to make the best of the elements available, and therefore when a suitable background or foreground is found the position of the subject in relation to it (or them) becomes obvious.

△ **The main subject**, the pottery, is in the foreground, where its shape, color and decoration can be seen clearly. However, the linear perspective and the warm light also lead the eye through to the background, to convey the setting and atmosphere.

△ **The eye is immediately** led to the figure of the boy in the foreground, but this figure in turn highlights the ruggedness of the Peruvian landscape, with its stony fields and the Andes in the background.

▽ **This windsurfer is isolated** in the "middle-ground". The blue and gray of the sky and sea contrast with the bright colors of the sailboard, which immediately grab the viewer's attention.

△ **Another shot with a dominant** "middle-ground". The shape of this Icelandic church is emphasized by its position against the stormy sky. The inclusion of so much foreground helps convey its lonely situation.

▷ **The ruined castle** is placed in the background but the foreground of trees, water, and the castle's reflection all help to convey the romantic feeling of the place.

◁ **By placing these bales** of straw in the foreground, I have not only shown the rural setting, but have given some idea of just how large the white horse, carved into the chalk hillside in the background, actually is.

▷ **The large granite rock** at the bottom of this shot helps to link the foreground to the background, drawing the eye through the valley to the hills in the distance.

▽ **The diminishing size** of the pillars, and the strong linear perspective, automatically force the eye to scan the whole picture area in this shot of the Dar al Glavi Palace in Marrakesh, Morocco. The human figure is included to give an idea of scale.

Perspective

Perspective is a crucial tool for the photographer in that it suggests the missing third dimension in a flat, two-dimensional picture. As you have seen in the project on form on pages 36–7, form can be conveyed by tonal modelling, providing light and shade that suggest volume in an individual object. Perspective, however, tells you that one object is further away from the camera than another. There are five types of perspective used by photographers.

Linear perspective is the most familiar. Lines that are parallel appear to converge as they recede into the distance. Closely allied to linear perspective is diminishing size, where objects appear smaller the further away they are from you. To exaggerate this type of perspective, use a wide-angle lens, which allows you to shoot from a point nearer to the subject in the foreground. Similarly, to minimize the effect of both these types of perspective, you need to increase your apparent distance from the foreground of your picture, which usually means using a longer lens.

Aerial perspective is caused by atmospheric haze, which makes distant objects appear less vividly colored and less sharply defined than those in the foreground.

The two other forms of perspective – overlapping forms and selective focussing – are described in the next project, Conveying Depth, on pages 54–5.

△ **Diminishing size** – as you know that these two rowing boats are in reality the same size, the fact that the one at the top of the picture appears smaller means that it must be further away from you.

◁ **Linear perspective** – you assume that the road is roughly the same width, even though in the picture it seems to get narrower as it disappears into the distance. By contrast, as each of the trees is exactly the same distance from the camera, they all appear exactly the same size in the picture.

◁ **Aerial perspective** – in this monochromatic landscape shot, you can see more than a dozen different layers of rolling hills, but those at the top of the picture appear less well defined and more colorless than those at the bottom of the frame. This suggests that they are further away from the camera. The effect is caused by tiny particles of water, or dust, in the atmosphere, which together diffuse and soften the light being reflected off these distant objects. Notice that each successive ridge appears less distinct than the one in front of it.

▷ **Subject distance and linear perspective** – in this photograph you are certain that the two rails are exactly the same distance apart. But the use of a wide-angle lens, in a situation where the foreground is only a couple of feet from the camera has increased the impression of perspective. The result is that the railway lines seem to converge at the horizon. However, linear perspective has nothing to do with focal length – it is only affected by the distance between camera and subject.

Conveying depth

While aerial perspective, diminishing size and linear perspective are ways of conveying depth used by both photographers and artists, the two other kinds of perspective are less widely used.

Overlapping forms is a perspective technique that is learned by painters, but rarely taught to photographers. Nevertheless, it can be a useful device for the latter. The theory behind overlapping forms is quite simple – if object A partly obscures object B in the frame, you make the assumption that A is closer to you than B. By arranging the subjects so that they overlap, you increase depth.

Selective focussing, on the other hand, is peculiar to photography alone. By adjusting the aperture and focussed distance, you can restrict depth of field – making some parts of the picture sharp and others out of focus. Because you assume that the two areas must be at different distances, you also assume that one is farther away from you than the other. Furthermore, "unsharpness" is not absolute – it increases with distance from the plane of focus.

In practice, these different forms of perspective are frequently used together, rather than in isolation. But sometimes the photographer deliberately avoids all of them, in order to make two subjects seem closer than they actually are.

△ **Overlapping forms –** because each boat partly obscures the next from view, you assume that the boats at the bottom of the frame are closer to you than those further away. The diminishing size of the Dutch windmills also increases the feeling of depth in this photograph.

△ **Other tricks can also be used** to increase the feeling of depth. Here the red rim of the boat stands out, while the blue of the sea and sky recedes (see pages 30–1). The use of a wide-angle lens close to the boat has exploited the principle of diminishing size, making it appear disproportionately larger than what you know are bigger vessels in the distance.

◁ **Overlapping forms** – the tree in this shot links together all the elements in the picture by overlapping the lake, the distant landscape, and the sky. Because of this, you know that the branches form the foreground of the picture and make everything behind them seem farther away.

▷ **Selective focussing** – by using a telephoto lens at its minimum shooting distance, and selecting the widest aperture available, I restricted depth of field as far as possible in this shot. In fact, it only extends a few millimetres. Everything in the distance is so far out of focus that it is unrecognizable. You make the assumption that these blurred areas are further away than the sharp ones, and this is reinforced by the fact that the subject partly obscures bits of the background.

Backgrounds: exterior

Although when shooting outside it is not possible to move buildings to get the background you require for a particular picture, you can still have a certain amount of control over what is, and what is not, included in the frame.

What is an ideal background? The word "background" says it all – it is, by definition, of less importance than the main subject. The background should not be allowed to dominate the picture. There are two types of backdrop that are guaranteed to work. First, you can choose a plain background so that the subject stands out clearly. This is particularly useful for complex objects, or where you want to emphasize shape. In many cases, using a low camera angle, for instance, makes it possible to frame your subject against the sky. If all else fails, by restricting depth of field you can throw the more distant elements in the picture completely out of focus.

The alternative approach is to choose a background that complements your subject. With immovable subjects, such as buildings, your options are limited to changing viewpoint, lens, and subject distance. However, with posed portraits, where you can move your subject, you can be more inventive. The background can be selected to tell the viewer something more about the person – by showing their immediate environment, for instance — but keep it simple.

△ **I thought this elaborate modern building** would complement the weird spikey suit worn by this man. In fact, it just makes it harder to see what he is wearing.

△ **A simplified background proves** far more successful for showing off the rubber suit. Again an ultra-modern building is used for the backdrop, but the man is isolated against the plain-colored column of the office complex. The Victorian power station reflected in the glass wall adds to the mystery of the image.

◁ **Complex backgrounds sometimes work.** Here the elaborate architecture is integral to the shot, as it helps reinforce the message about the luxury offered by this hotel. The carefully arranged table of food and the smartly dressed staff combine with the background to suggest accommodation fit for a king.

▷ **I shot this picture for the cover** of *The Sunday Times Magazine*. It features Father Simplicity, who grew giant vegetables and flowers in an English monastery. The garden in the background complements the subject matter well. I strengthened the composition by arranging the cabbage, flowers and master gardener to form a pyramid shape that leads the eye from the bright blooms to the face of the main subject.

Backgrounds: interior

Indoors, the photographer has far more control over backgrounds. Even when you are taking full length portraits, a backdrop that is just eight foot wide will suffice. Frequently, the subjects tackled are much smaller, and even less room will do.

Whether your studio is usually a room in your home or is purpose built, one of the main props that you will use is background paper. This is available in long rolls, and is suspended at about eight feet, so that the paper can be extended underneath the subject, forming both foreground and background. When a length becomes dirty or torn, more paper can be rolled out quickly and easily. A wide variety of hues is commercially available, but gray is the most versatile color because its tone can be lightened or darkened depending on how much light reaches the backdrop. It can even be colored by putting gels over the lights.

When a black backdrop is required, paper rarely looks dark enough in photographs. Instead black velvet is used, which reflects very little light and so gives a jet-black background.

Improvised backdrops are also worth looking out for. For example, pieces of weathered wood and slabs of slate are useful to have around. Alternatively, you can paint your own backdrops on canvas, which can be bought from theatrical suppliers.

△ **Rolls of white or gray paper** are the most common background used in a studio. Here the subtle colors of the uniform and tiger would be lost against a more elaborate backdrop, and the white has helped emphasize the subjects' shape.

△ **A piece of marble** forms a suitable backdrop for this overhead shot. Despite the elaborate patterns on the plate and napkin, the contours of the polished stone complement the subject, rather than compete with it. The combined effect is to accentuate the sense of luxurious dining.

◁ **To complement this rustic arrangement** I used two pieces of weathered wood whose color and texture produced a nostalgic atmosphere. The composition is lit by diffuse sunlight from a window above, and a silver reflector helped to fill in the shadow areas.

△ **To complement the feeling of fun** in this portrait, I blew up half a dozen party balloons, which were held in place behind the subject's head by the unseen hand of an assistant.

◁ **For this picture it was the background** that came first, and the subject later. The model has been purposefully made up and dressed to echo the appearance of the giant romanesque statue – with the use of a toga-like drape and fruit in her hair. The gray make-up completes the effect. Here the background plays an important role in the shot.

▷ **I knew that well-known socialite** Lady Diana Cooper had a great selection of hats, and wanted to photograph her wearing one of them. The elegant cakes on this ostentatious piece of millinery seemed to suit her character well. I wanted to find a backdrop that also suggested grandeur and opulence, and thought that this mural suited the purpose well.

Exploring exposure

The aim of every photographer is get the correct exposure for every shot. But what does correct exposure mean? It simply means getting a well-balanced image which shows detail in the highlights and detail in the shadows. If these are present the picture should look fine.

The main exposure problems arise when the contrast between shadows and highlights is too wide for the film to cope with. A negative film will allow a difference in brightness between the highlights and the shadows of seven stops, while a transparency film can tolerate a range of about five stops. However, on a sunny day with deep shadows the brightness range may stretch over ten stops or more. In such conditions some detail has to be lost – either shadows are turned jet black or highlights are "burned out", becoming white. Weighing up the pros and cons of underexposure and overexposure is a primary skill of the experienced photographer.

A key factor in understanding exposure is knowing when your meter is likely to have problems. For instance, I find that I need to underexpose shots of flowers by half a stop to get the right intensity of color. A further important skill is recognizing when the contrast range in a scene will be too great for the film you are using. This problem is common with backlit subjects, or in regions with intense sunlight.

△ **With portraits it is essential** to have full tonal range in the skin tones. In this shot, nearly the whole frame was dark, and therefore I needed to expose for the shadow areas to get the correct result.

△ **Since much of the courtyard was in shadow** and the far wall was lit by direct sunlight, the scene's contrast ratio exceeded the capabilities of the slide film I was using. I decided to expose for the highlights, letting the foreground go darker, so that the white walls would not bleach out.

◁ **By exposing for the highlights** I turned the columns in the foreground into silhouettes. However, this treatment gives enough information about shape.

▷ **Frontal lighting** with the sun behind the photographer usually poses no problems of excessive contrast. Here a straightforward average exposure reading was adequate.

△ **Reflections in water** must usually be approached with care as one bright highlight on a ripple can mislead the meter, making the picture darker than you would want. On this occasion the contrast was not excessive, and an average meter reading gave the right result.

▷ **The light-colored bark of the trees** and the bright sky, contrasted against the dark shadows of the forest, forced me to make a choice about which I wanted to show in detail. I chose to expose for the shadows, letting the sky burn out slightly and making the tree trunks brighter than they appeared in real life.

▽ **With moody landscapes** it is more important not to lose details in the highlights than it is to keep detail in the shadows. For this reason, I underexposed the picture slightly, by taking a meter reading from the area of sky. A picture that looks slightly dark helps to add to the atmosphere of the shot.

Underexposure

As you have seen in Exploring Exposure (pages 60–1), there are times when you need to underexpose a picture because the contrast ratio is too great. By exposing for the highlights in this way, you sacrifice detail in the shadow areas. However, there are times when you may want to vary the exposure even though the difference in brightness between highlights and shadows is within the capabilities of the film.

There are two principal reasons why you may want deliberately to let less light reach the film than the meter reading suggests. The first is to increase color saturation. When you reduce exposure, colors become more intense and often look more attractive to the viewer. The blacks in the shot will also be deeper. However, underexposure should be used with caution, as if you overdo it the shot will look "wrong". Generally one half to one stop underexposure will be sufficient.

A more extreme form of underexposure is used in what is known as low-key lighting. This effect is generally used when the lighting levels are low, and the aim is, by deliberately underexposing in these conditions, to retain some of the original under-lit atmosphere. Large areas turn to shadow, and only the highlights retain any detail, so that the picture has a sombre, moody look.

△ **To maximize the intensity of the color** of these roses, I underexposed the shot by half a stop. The result is fully saturated color, which looks more appealing. Furthermore, to get the best color when photographing flowers I find it is best to use subdued daylight – that is, when the sun is obscured by clouds. These conditions prevent their being too much unwanted reflection from the petals and reduce the contrast between shadows and highlights.

△ **An ethereal atmosphere** has been created in this shot of a ruin by the predominance of highlights. The smoke and the horse have been rendered pure white by the use of slight overexposure. This effect is known as high-key – a technique in which a picture is made to include few shadows and is mainly made up of bright areas. It can be used to give a ghostly or dreamlike appearance to a scene – as in this shot. Alternatively, it can be used to give a vivid indication to the viewer of the intensity of the midday sun in a hot climate.

△ **The shot above was taken within an hour** of the one on the left from the same viewpoint and with the same lens. However, here the photograph has been deliberately underexposed by several stops, producing a dark, sombre image. The only highlight – the fire that has been lit in the ruin – appears correctly exposed, and its color draws the viewer into the picture. The white smoke and white horse have become a dark gray due to the much shorter exposure. As the shot was taken on tungsten film in daylight, the image has a blue cast.

◁ **In this informal portrait** of Patrick Heron, I have used an exposure that gives a full range of tones in the artist's face. However, the intense colors of his clothes appear more washed out.

▷ **When I deliberately underexposed** slightly, the whole picture became darker, but the color of the clothes became richer and more appealing. The subject's face is darker, too, and is now partly obscured by shadow, but this has the benefit of adding a touch of mystery to the portrait.

△ **To shoot silhouettes** from a backlit scene it is necessary to underexpose the picture. It is possible to get a similar picture using an average reading, but all that happens is that the silhouettes become a muddy gray and the intensity of the sky behind is lost. In this case I took a meter reading for the highlight area – the blue sky – and then used an exposure that gave a stop more light to the picture. This prevented the shadow areas becoming too dark, and meant that there was not too much detail in the highlights.

△ **For dramatic skies** it is often best to wait for the sun to disappear behind a cloud. This not only decreases overall contrast, making it easier to record the scene faithfully, but also adds the beauty of the stray rays that escape through the cloud cover. The secret of such shots is to be patient, and to wait for the right moment before you press the shutter. In order to retain the dark, moody atmosphere of the seascape, I deliberately underexposed by half a stop below the metered reading to give a low-key effect to the picture. The detailed patterns of the sky are clearly visible, but the pier in the foreground is almost lost in the sombre shadows.

▷ **The extreme contrast between** the highlights and the shadows in this portrait meant that any exposure used would fail to reflect reality to the viewer – because the human eye can tolerate a far greater contrast ratio than any film. For this shot, I decided to concentrate on revealing detail in the highlights, and took a meter reading direct from the areas of the woman's skin that were bathed in light. This meant that the picture as a whole looks underexposed, but as a result the viewer is spurred into taking a closer look at it, trying to see into the subject's eyes, which are partly lost in an area of shadow.

Overexposure

The effect of underexposure is generally to produce a picture that is accepted by the eye as a naturalistic rendering of a dark scene, whereas a picture that is overexposed overall is likely to look unnatural. This does not mean, however that overexposure is not, on occasion, highly effective.

High-key photography, where the whole scene is deliberately overexposed, gives a soft, bleached-out result. Just as underexposure enriches color, overexposure makes it less saturated, turning everything into pastel hues.

There are also occasions when overexposure must be used for technical reasons. A backlit subject, for instance, is likely to appear as a silhouette if you expose for the bright background. However, if you expose for the shadows – and there is enough indirect, reflected light to provide some detail – then you get a soft, shadowless light that can be particularly effective for portraits. The only drawback is that the background becomes a burned-out mass. Similarly, large expanses of sand and snow can cause problems for a meter, which automatically corrects for such areas by trying to turn them an average gray. The solution is to increase exposure so that these bright areas stay bright in your pictures.

△ **Snow-covered scenes** are always difficult to expose correctly, as the large areas of white reflect any existing light. If an average exposure is used, the snow appears a muddy gray and the rest of the picture is underexposed. The answer is either to increase exposure by one or two stops or to take a meter reading from the shadow areas. The snow will then burn out and be recorded as pure white.

▷ **Sand and water, like snow,** can act as efficient reflectors of light, causing a camera's built-in meter to believe the scene is brighter than it actually is. So for this portrait taken on a beach, I took a meter reading from the woman's face. This is easily done, even if you don't have a hand-held meter, by moving closer in with the camera so that the frame is filled with the subject's skin. Note the metered reading, then move back into the shooting position and set this aperture and shutter speed combination with the camera in the manual exposure mode.

▷ **I could not shoot the full glory** of this spectacular cathedral roof without including the windows at the top of the dome. As a result, the contrast between the brightest parts of the picture and the darkest parts was far too great for the film that I was using. As the shadowy area of the main roof occupied a much larger area of the picture, I decided to expose for this part of the scene. Getting closer to the roof to take a reading from this area was impossible; in similar circumstances you can obtain a reading with a spot meter or a longer lens.

△ **The curious hats** worn by these young women have thrown their faces into shadow. As a general rule, portraits should be exposed to give a full range of flesh tones in the face. By taking a close-up meter reading off the faces I was able to ensure that this vital part of the picture was correctly exposed. The consequence of this exposure decision is that the sky is grossly overexposed, and appears washed out.

▷ **If you overexpose a shot** when the contrast range is within the capabilities of your film, the colors will appear muted. For this shot of a floral arrangement I deliberately chose a high-key effect. This made the cut flowers look more delicate and rendered the kaleidoscope of colors in pastel hues.

Changing light

If you read this book under the midday sun, or by the light of a desk-lamp or candle, the paper would appear white to your eye. But in fact the color of different light sources varies – two examples are the blue light of a high, bright sun and the orange hue of candle light – and this should make a white surface appear the same color as the light source it is lit by. The fact that the eye does not see these changes is due to a clever compensation process in the visual cortex. Color film does not have this mechanism. With print film, these color shifts can be corrected during printing, but slide film can not be rescued in this way (the only corrective measure is to choose between daylight- and tungsten-balanced film – see page 12).

The color of sunlight itself varies considerably. At one extreme, there is the deep orange light from a sunset, and at the other there is the blue light reflected by the sky on a sunny day. In between, there is the average sunlight at noon, which is white, colorless light. These color shifts are measured on the Kelvin scale (see page 199). On most occasions these changes are perfectly acceptable in pictures, but you should be aware of the color shifts that occur during the day, and in direct and indirect light.

▽ **In this shot of early morning in Paris** the sun is low in the sky and so the light has further to travel through the earth's atmosphere. As a result, more blue light from the spectrum is absorbed and thus not seen. A golden light prevails, with a color temperature of around 3,500 Kelvin. Its colors complement perfectly the misty autumnal conditions hanging over the River Seine.

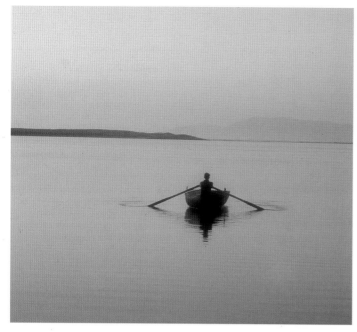

△ **Midday sun** produces pictures that are more neutral in color than at other times of day. Color transparency film is balanced for average noon daylight, which has a color temperature of about 5,500 Kelvin.

▽ **Shot in the early afternoon,** this picture was taken in the Caribbean. Despite the direct sunlight, a lot of skylight is reflected off the water's surface, giving a characteristic blue tinge to the picture. The only effective way to reduce the blue cast in a sea, beach or snow scene is to take the photograph with an amber-colored correction filter on the lens.

△ **Shot at mid-morning,** this scene has much more natural-looking coloration than the scene taken just after dawn on the opposite page. However, there is still a yellowy tinge to the light, which has a color temperature of about 4,500 Kelvin and imparts a warm feel to this shot taken on daylight-balanced transparency film.

▽ **Sunsets not only look orange** but also give everything else a healthy, warm glow. For this reason, many subjects often look at their best at this time of day, and this is worth remembering if you want to give a soft, romantic look to a landscape or a building. In this shot, much of the frame is in shadow, but the color of the setting sun is highlighted in the reflections in the water. With the rowing boat as a focal point, the resulting image is a classic portrayal of a lazy summer evening. Typically, sunsets have a color temperature of 2,000–3,000 Kelvin.

Time of day

As well as the changes in color temperature and shadow length that occur throughout the day, daylight also changes from one minute to the next. Clouds act as giant diffusers and masks — sometimes softening the light and at other times blocking it out completely. On occasion the sun is a giant floodlight, creating deep shadows. But when clouds obscure the sun, everything is lit by soft, indirect light, with fewer noticeable shadows. Between these two stages the sun becomes a spotlight as it makes its first appearance from behind a cloud.

Pictures shot with daylight, therefore, rarely look the same twice. Although a landscape will generally look better shot early in the morning rather than at midday, as the light is then less harsh and warmer in tone, on a particular day the light for a particular scene may look at its best around noon. There is no sure way to predict when the light will be right – other than to wait and see.

As an experiment to show how daylight changes throughout the day, I set up my camera early in the morning in a spot overlooking the French port of Collioure, just south of Perpignan, near the Spanish border. Each hour, on the hour, I took the same picture. The only variation I allowed was a slight tilt to include more of the sea or more of the sky, depending on which looked best at the time. It is an exercise that you can quite easily do yourself to show how color temperature, shadow length and the quality of light change through the hours of daylight. To make the project easier, set your camera up at a window in your home, and then you can leave the tripod in place for the day.

▷ **7 am** – early in the morning, and the first shot of the day. The soft, frontal light accentuates the entrance to the port. The sun is still not high enough to light up the whole town.

▽ **8 am** – one of the best shots of the day. The sun is now brighter, and is directly over my shoulder. Much more of the town is lit, and the frontal lighting brings out the best in the colors of the buildings.

▷ **9 am** – there is slightly less contrast in this shot than the one taken an hour before, and so the result is softer, less punchy. However, the shapes created by the clouds are becoming more interesting.

◁ **3 pm** – the sidelighting is now more noticeable, and is showing up nicely the rounded form of the tower at the far side of the entrance of the harbor.

▷ **10 am** – a very similar picture to the last one, except there is less cloud in shot.

◁ **4 pm** – the majority of the town in now in shadow – only the area on the right-hand side of the picture is lit by the raking sunlight.

▷ **11 am** – with the sun obscured by cloud, the town becomes a gray mass with no details highlighted. However, the sky itself looks mean and moody and now becomes the main subject of the photograph.

◁ **5 pm** – as the day starts to draw to a close, the bay and port are both reduced to shadow. The focal point becomes the brightest part of the image, the sky itself.

▷ **12 noon** – this is meant to be the time that gives the most accurate colors with slide film, but today it has produced a dark, featureless picture – even the sky looks more boring.

◁ **6 pm** – with the sun now in the frame, my patience has been rewarded with an attractive-looking sunset.

▷ **1 pm** – at last, the cloud cover is beginning to break. The shaft of sunlight has not yet illuminated the town, but has highlighted the peaks of the waves, which are being stirred up by a fresh spring breeze.

◁ **7 pm** – as the sun disappears over the horizon, night starts to set in. A few lights have come on, and the remaining glow of the sun can be seen reflected on the sea.

▷ **2 pm** – the port is again being lit up by direct sunlight. But now the light is from the side, which helps accentuate the form of the houses.

◁ **9 pm** – the town appears to be coming alive again, with a myriad lights, of different color temperatures, helping to create foreground interest. But notice that, although it is dark in Collioure, there is still plenty of color left in the sky.

Dramatic light

Everyone loves sunset pictures, but there are other outdoor lighting situations that are just as theatrical. Many of these can be difficult to predict, and it is often a matter of finding a suitable subject once you have chanced upon the lighting. However, there are examples you can plan for. Dramatic storm clouds form an ideal backdrop for any landscape, although they need a good foreground to work well. Summer storms are often short-lived, and followed by bright light. When the clouds break, you can exploit the few first shafts of sunlight to illuminate your subject. With the sun behind you, you can make sure that the clouds appear as dark as possible.

Sunsets are more predictable, but, contrary to popular wisdom, do not always occur in the west. In fact, they can appear anywhere in a 90° arc from south-west to north-west, depending on the time of year and latitude. Bear in mind that the closer you are to the equator, the less time you have before sunsets disappear.

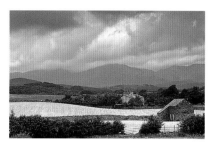

△ **Overcast skies** allow you to take a shadowless landscape shot without the problems of contrast that you get on brighter days. Here, the color and pattern of the sky have become as important a part of the picture as the arrangement of fields and distant hills.

▷ **By shooting this field of corn** with frontal lighting, I strengthened the tones of the moody sky in the distance. Shooting after a storm not only gives you dramatic cloud formations as a backdrop, but another advantage is that the air is haze-free, as all the dust particles have been washed out of the sky by the rain. This makes it an ideal time to take panoramas, as you can literally see for miles.

▽ **A mass of brightly colored flowers** becomes a light source in its own right, reflecting yellow light all around and almost silhouetting the isolated figures. The overcast weather could have led to a dreary picture but, by deliberately underexposing the shot, I exaggerated the intensity of the color.

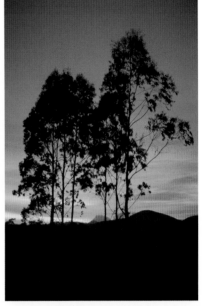

▽ **It is very tempting** to shoot sunsets on their own, with nothing else of interest in the picture. However, providing a strong focal point will give the shot more impact. You cannot rely on finding a famous landmark to help you out, but you can always find an object on which to concentrate the interest. For this picture, taken in Australia, a group of trees provided the right accompaniment. The shot was exposed for the sky, so that the trees were turned into a dark silhouette that stands out against the deep hues of the sunset.

△ **Despite the surreal colors,** this beautiful sunset over Sydney Harbour was shot without the help of any filter. When shooting sunsets, the secret of good color density is to wait until the sun has dropped below the horizon. It was a full 20 minutes after it disappeared that I took the shot, with the blurred ripples in the water helping to accentuate the pinks and oranges remaining in the sky.

Using portable flash

The flash unit is undoubtedly the most used accessory – they are now built into most SLRs. But although flash – whether integral or in the form of a portable flashgun – is good for raising the light level in dim conditions, it has limitations. The power of all portable flashguns is very small compared to daylight – they have an effect over only about ten feet (three meters). Built-in flashes have a typical guide number of 12 (m/ISO 100), and even the biggest hammerhead guns have a guide number of only 60.

Despite the limited range, flash is not just for use in low light – it gives you control when lighting close subjects. By increasing illumination in the foreground, you can increase or decrease contrast, depending on the ambient lighting. Flash is particularly effective in conjunction with daylight, as distant subjects are not as underexposed as when shot with flash at night (see page 27). It is important not to forget about quality of light when using flash. A standard flashgun produces flat, frontal, harsh light when used on camera. To vary the lighting some flashguns can be bounced, diffused, and used at a distance from the camera to give angled light.

△ **A small burst of flash** has been used in this shot to add highlights to this sidelit portrait. To reduce the output of a flashgun, a number of accessories are made that fit over the flash window. These can be pieces of translucent plastic to diffuse the output, or gadgets that allow you to soften the light by bouncing it off a small reflector. In an emergency a white handkerchief over the tube will do.

▷ **As flash has a very short duration** it can be used to freeze fast-moving subjects. This speed skater was about 15ft (5m) away from me, and I used a large hammerhead flashgun. As the flash burst lasted less than 1/1000sec it froze the movement. The shutter speed, however, was 1/60sec, so there is a faint ghost image, which was registered by the ambient light in the rink; this appears in front of the main image as most flashguns fire at the beginning of the exposure.

△ **Bounced flash** – to reduce the shadows in this scene of a French café, I angled the head of my flashgun towards the ceiling. This decreased the contrast without overpowering the effect of the natural sidelighting from the window on the left. But bear in mind that bouncing flash severely cuts the output of a flashgun, as the flash-to-subject distance is increased and the scattering of light as it bounces off the ceiling or wall can effectively halve the guide number.

▷ **A ringflash** is a special flashgun designed for use with macro lenses. As the flash tube circles the front of the lens, it produces a shadowless light ideal for small subjects where detail is more important than modelling.

△ **A silhouette at sunset** – the contrast between the figure and the sun is too high for the human eye to cope with, let alone any film.

◁ **Fill-in flash** – the same scene as above, except this time the flashgun has lit the foreground, reducing the contrast in the picture and revealing the identity of the silhouette. In such conditions the aperture, shutter speed, and the output of the flashgun must be carefully manipulated so that both the foreground and the background are correctly exposed.

Avoiding camera shake

However good the composition, and however accurate the focussing and exposure, if you use a shutter speed that is too slow you will end up with a useless, blurred picture. The cause is camera shake – movement produced by the camera itself as the shutter operates, and by the fact that is impossible for anyone to hold a camera completely still. This can be eliminated by using a tripod, but most photographers prefer to hand-hold the camera whenever possible.

The first step to avoiding camera shake is to improve your stance, the way you hold the camera, and to hold your breath as you gently squeeze the shutter release (see page 14).

Never use a shutter speed below 1/30sec with a hand-held camera fitted with a normal or wide-angle lens. If you have poor lighting conditions, switch to a faster film. For longer lenses, use a speed that is the reciprocal of the focal length used, or, if possible, use a faster shutter speed. This simple rule works for stationary subjects, but if there is movement in the picture and you want to freeze it you will have to take into account the speed at which the subject is moving across the viewfinder. This calculation should be based not only on its real speed, but also on the image magnification and the direction of movement.

△ **In low light at this school of dance** I was forced to use a shutter speed of 1/30sec. This is the slowest speed that I would recommend when hand-holding any camera. With longer lenses, faster shutter speeds are always required, or, alternatively, more light or a faster film.

▷ **A candid picture** like this can easily be shot with a standard lens hand held at 1/30sec, although 1/60sec or 1/125sec is preferable if there is enough light.

▽ **Judging the right shutter speed** to freeze movement is mainly a matter of practice. The speed, distance, and direction of the moving subject have to be taken into account, as well as the focal length. To guarantee a sharp picture of all the soccer players in the frame would require a shutter speed of 1/1000sec at the slowest, as they are moving in all directions. However, in this shot the moving player occupies only a very small part of the frame, so that a shutter speed of 1/125sec is sufficient to give the impression of fast action.

◁ **This skier is probably traveling** at roughly the same speed as the soccer player shown opposite. However, in this case the figure fills more of the frame and is traveling directly across it, and therefore I used a slightly faster shutter speed of 1/250sec.

△ **Moroccan horsemen display** their equestrian skills – with the figures filling 50 percent of the frame, and movement parallel to the film frame, I used a shutter speed of 1/500sec.

▽ **Although moving almost toward the camera,** this closely cropped shot of greyhounds racing required a shutter speed of 1/2000sec with open aperture – the top speed available on my 35mm SLR.

△ **As this log boat** headed toward the camera, rapidly decelerating as it hit the deep water at the end of the chute, the fastest-moving part of this scene was the water itself. The splash was moving across the picture, and to capture it so that it appeared at all sharp I had to use a shutter speed of 1/1000sec.

Using a monopod

The trouble with a hand-held camera is that the range of shutter speeds you can use is limited. Consequently, aperture selection is also restricted, unless you use a faster film, in which case the results will be grainier.

However, various camera supports are available, to help give the photographer a wider choice of aperture and shutter speed. One of the most useful is the monopod. This is an extendible stick that screws into the tripod "bush", on the underside of the camera – or, in the case of longer lenses, on the lens itself. It does not give a completely free choice of shutter speed, but it will allow you to use one that is three stops slower than that suggested by the "one over focal length" rule. For example, with a 200mm lens, a shutter speed of 1/250sec is needed with a hand-held camera, whereas with a monopod the slowest speed possible becomes 1/30sec. This is not only useful in low light, but can allow greater depth of field.

For me, one of the best advantages of the monopod is that is less intrusive than a tripod. Enter a building with a tripod and you are likely to be asked to seek official permission to take photographs. With a monopod, I look less like a professional and can get the job done without the bureaucracy.

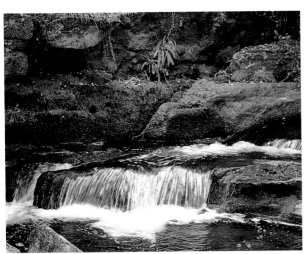

◁ **With a standard lens,** I used a shutter speed of 1/60sec for this hand-held shot of a stream. However, the picture would have looked more appealing if it had been shot with a slower shutter speed, which would have blurred the moving water, creating a sense of movement.

△ **Depth of field** is very limited with short focussing distances, often making a small aperture essential. Using a monopod, I could set an aperture of f/11 to keep all the flower in focus with a 100mm macro.

▽ **A shutter speed of 1/15sec** is not recommended when hand-holding, but is possible with a monopod, provided the lens's focal length is less than 200mm.

▷ **With the aid of a monopod,** I was able to take a picture that was identical to the one above, except that I was now able to use a much slower shutter speed. At a speed of 1/8sec, the miniature waterfall has been transformed into a soft mass of foam.

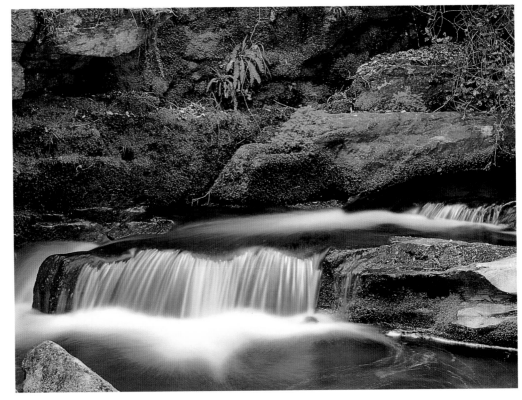

△ **With a wide-angle lens** on a hand-held camera, I would usually select a shutter speed of 1/30sec or faster. For this low-light shot I used a monopod, and was able to use a speed of 1/15sec.

▷ **Using a tripod is often not allowed** inside museums, churches and other buildings on the tourist trail. Even where tripods are permitted, special permission must often be sought in advance – which takes time and effort. A monopod is less frowned upon, and in this picture of Shakespeare's schoolroom at Stratford-upon-Avon allowed me to get enough depth of field to keep all of the room in focus without having to resort to a faster, grainier film.

∇ **For action shots and sports events** you need to be able to move around the subject quickly – something that can not be done with a tripod, especially if there are crowds of spectators, or other photographers, to contend with. A monopod, however, can be manoeuvred as easily as the camera on its own, and proved ideal for a sequence of pictures taken at a sumo training camp in Japan.

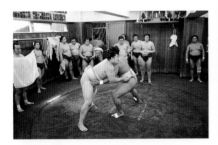

◁ **Often, using a flashgun** is the only option when the required shutter speed is too slow to make hand-holding the camera viable. This increases illumination, and means a shutter speed fast enough to avoid camera shake can be used. However, in many situations, such as the one here, the added light kills the atmosphere. But by using a monopod, I could get away with a shutter speed of 1/15sec, so that the delicate reflections produced by the ambient light were not destroyed.

Using a tripod

A tripod gives the photographer complete control over the aperture and shutter speed. Rather than having to make compromises with depth of field to avoid camera shake, the aperture that best suits the subject can always be selected. Exposures that are seconds, even minutes, in duration can be used without any worry.

There are other advantages, too. Many professionals prefer to use slow shutter speeds, rather than use a flashgun, because flash lighting is hard to use to light an interior, for instance, without making the scene look unnatural. In fact a tripod is a great asset for shooting still lifes and models in settings as well as interiors. Once the camera is set up the photographer is free to concentrate on the arrangement or the pose in the certainty that the camera is always in the same position.

Slow shutter speeds can be used creatively with a tripod as moving subjects turn into a blur, which can in some cases look particularly attractive (see page 82–3). If the shutter speed is long enough, moving subjects can disappear completely from a picture.

It is a mistake, however, to think that all tripods are rock-solid. Some are not completely stable and are likely to move during very long exposures. Unfortunately, heavier, more cumbersome, tripods are best. Whichever you use, a cable release is essential, since it ensures that the camera does not move as the shutter is fired.

◁ **The combination of a tripod and a slow shutter speed** can produce a sense of movement in what is a still photograph. Here I used a shutter speed of 1/4sec, so that the "passer-by" in the background appears blurred. A similar effect could have been achieved by using a wide aperture, to throw the other figure out of focus – but this would have lost detail in the background.

△ **Taking this portrait with flash** would have been possible, but if the quality of the ambient light is suitable it is unnecessary to use artificial light. By using a tripod, I was able to use a shutter speed of 1/8sec. With such a slow shutter speed it is vital that the subject remains completely still throughout the exposure, so make sure he or she is comfortable. Also, take several shots in case the sitter moves.

◁ **To capture the detail** of this vaulted ceiling it was necessary to expose for the shadow. This necessitated an exposure of three seconds and therefore a tripod.

▷ **Illuminating interiors** with artificial lighting takes a great deal of hard work to make sure that the scene appears natural and not too much detail is lost through unwanted shadows. Whenever possible, therefore, I use natural light for such shots. Here, to get the correct amount of depth of field, I had to keep the shutter open for five seconds.

△ **To ensure that everything was sharp** from the towel rail in the foreground to the door in the distance, I had to use the smallest aperture available on my wide-angle lens for this shot of a bathroom. As there was a reasonable amount of ambient light, I was able to achieve this with a shutter speed of 1/2sec.

△ **As part of a whole sequence** of pictures I took depicting life in a monastery, I wanted to include a shot of the nuns and lay workers eating together at the end of the day. The intimate atmosphere of the occasion, lit by candle light, was captured on fast film, using a tripod and an exposure of one second at f/5.6.

◁ **As the light** was so low for this shot of a moody landscape, a tripod would have been essential whatever exposure settings I used. I therefore used an aperture of f/22 to keep everything from a few feet away to the distant hills in sharp focus.

Improvising camera supports

In an ideal world, photographers would carry around every single accessory that they possessed every time they ventured out. However, unless you want to look like a pack horse, or you have a car to put everything into, there will be times when you need to travel light. It is more important that you have your camera and film than it is to have every gadget and gizmo at your disposal. The smaller your essential camera kit is, the more likely you are to want to carry it around with you wherever you go.

△ **A 300mm lens** should not usually be used with a shutter speed of 1/125sec, but by resting my arms and the weight of the camera on top of a car I was able to get away with this exposure setting.

The first accessory that you are likely to leave at home when traveling is the tripod. It is big, heavy, and does not fit into your suitcase, let alone your gadget bag. The lack of a tripod, however, should not put you off using slow shutter speeds for your shots, because you can always find some way to support your camera better to minimize camera shake.

Placing your camera on a flat surface, such as a table, can make it steady enough to use shutter speeds lasting several seconds. The shutter can be triggered using the camera's self-timer to minimize vibrations – if you do not have a cable release handy. Even if you still have to hand-hold the camera, you can gain extra support by resting your arms on top of a fence or parked car, for instance, or by bracing the camera hard against a wall.

▷ **With a 150mm telephoto lens,** the shutter speeds that my meter was suggesting for this low-light shot were far too slow to be used with a hand-held camera. Near to where I was standing was a low wall, and on this I placed my soft camera bag, with the camera and lens cradled on top. This gave enough extra support to let me use an exposure of 1/60sec at f/5.6.

△ **I used a 200mm lens** on a 35mm SLR for this shot. The maximum aperture with this telephoto lens was f/2.8, which gave a suggested shutter speed of 1/125sec – not fast enough to avoid the possibility of camera shake. To my rescue came a fence. By resting the camera's centre of gravity on top of one of the posts, I was able to take the shot.

▷ **My choice of a 24mm wide-angle lens** required a shutter speed of two whole seconds to allow me enough depth of field for this shot of a corridor. I moved a small table from a neighboring room, and placed it on the spot where I wanted to take the picture. I then propped the camera in position with some heavy books. The camera's self-timer was used to fire the shutter, to avoid any camera movement during the exposure.

◁ **I borrowed a stepladder** from the artist to use as a camera support for this picture. I was able to put the camera on one of the rungs, and held it tight so that it did not slip as I gently pressed the shutter. With this set-up I was able to use a shutter speed of 1/15sec, and make do with available light.

▷ **Unfortunately there was nothing suitable** to rest my camera on for this shot of Egyptian engravings. However, so that I could use a shutter speed of 1/8sec, I held the camera against a wall with my guide book in between, and pushed firmly so that the back of the SLR was kept in contact with the book. Again I used the self-timer (a feature most often used for self-portraits), so that the camera was held as rigidly as possible when the shutter was fired.

Moving lights

When night falls, slow shutter speeds become the norm for the outdoor photographer. Even the fastest films are unlikely to give you a fast enough shutter speed to hand-hold a camera. The lights of a city after dark produce a landscape that is very different from what the lens sees during daylight. However, it is moving lights that present one of the most interesting possibilities for the photographer.

Whether it is the headlights and tail-lights of cars on a busy road, or the multi-colored lamps of a fairground ride, these small bulbs turn into streaks of color as they move. The longer the exposure, the longer the streaks.

With these long exposures, it is best to use a film with an ISO rating of 100 or lower, as this will give you the richest colors and the least amount of grain. The ideal time to take the pictures is an hour or so after sunset, while there is still a little color in the sky, which can look more attractive than a pitch-black backdrop.

The longest automatic shutter speed on some cameras may not be more than a second. For longer exposures, use the B, or bulb, setting, which will keep the shutter open for as long as the trigger, or cable release, is pressed. You should count the seconds to yourself, so that you can compare the effect of different timings.

△ **To compare the effect of using** long shutter speeds of varying length, I set my camera on a tripod to photograph a rotating fairground ride. For my first shot in the sequence, above, I used an exposure of one second at an aperture of f/8. An ISO 100 daylight-balanced slide film was used throughout.

▽ **With a two-second exposure** the lights on the ride are becoming noticeably blurred. However, the effect is still subtle, giving an abstract appearance, rather than one that really suggests movement. Notice that if you shoot early on in the night there is still some color in the sky, which would have looked black later on. Precise exposure is less important with night shots than during daylight as any slight overexposure will simply make the lights brighter, while any underexposure will make them seem dimmer. It is therefore worth bracketing your exposures to get a full range of shots to compare.

◁ **A four-second exposure, using an aperture of f/16.** There is noticeably more movement in this picture than the one below. Many modern SLR cameras will control the exposure automatically up to shutter speeds of 30 seconds. But if your camera does not do this, or if you want an even longer exposure, then you will need to use the B setting, and time how long the shutter blinds remain open yourself.

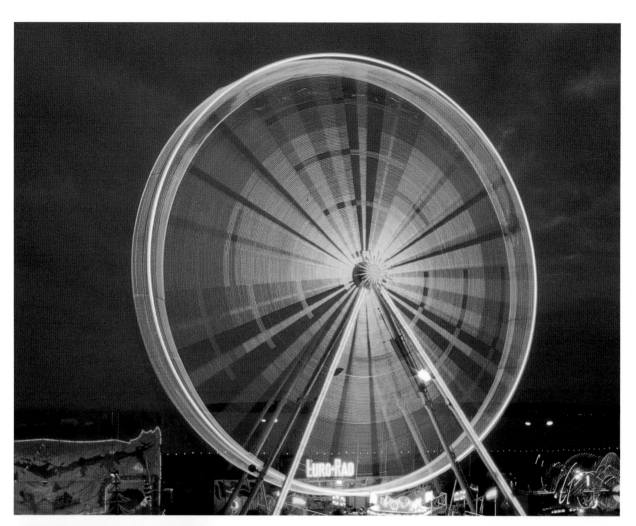

◁ **With a shutter speed of eight seconds** the moving lights on the Ferris wheel are beginning to appear as a series of concentric circles. But while there is much less information as to what the ride actually looks like, the picture is a far better representation of the movement – and of the ambience of a funfair.

△ **An exposure of a full 16 seconds at f/32** was used for this final shot. The streaks of light are not longer than in the eight-second exposure, but they are brighter and thicker, as the same areas of the film are now being painted with light again and again. With long shutter speeds, however, the film displays a peculiar characteristic called reciprocity failure, where, if the shutter speed is lengthened by one stop, the film is less exposed than if the aperture had been opened by one stop. There is also a slight change in color balance. Films are often supplied with a data sheet that tells you how to compensate for this effect.

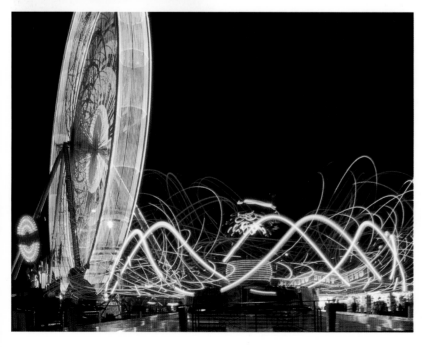

◁ **A different view of the fairground** allows us to see the movement of several different rides at once. The Ferris wheel now appears as a thick disk of light, while the carousel in the foreground has created a pattern of wavy lines. Again the exposure used was 16 seconds at f/32. Generally speaking, with shots of moving lights, the longer the exposure is, the better the final effect will appear.

Landscapes

At first sight, landscape photography seems like a leisurely pursuit. As the subject does not move, you might think that you would be able to take your time over your shots. Nothing could be further from the truth. Although the subject is stationary, the light that falls upon it is not constant, and therefore it continually changes the way that a landscape looks. While there are times and places where the light does not change significantly from one hour to the next, the most exciting time to photograph landscapes is when the light is changing. That is why landscape photographers tend to concentrate their efforts on the early morning or late afternoon. It is at these times that you get the most climatic changes, involving dust, mist, long shadows, variation in color temperature, and a changing sky.

Sunrays bursting through a cloud may last for a only matter of seconds, highlighting the area you want to dominate the picture. You must therefore work quickly, as you might wait for hours for the conditions to repeat themselves, and still be unsuccessful. A good photographer also learns to anticipate these lighting changes – as well as knowing when it would be better to return to the scene at a different time of day or even during a different season.

△ **The overcast conditions** were perfect for capturing the muted colors of this field of hyacinths in Holland, and helped to accentuate the pattern and geometry of the scene.

▽ **A shaft of light** penetrating the moody sky reflects off the sides of the buildings. As is usual with sidelighting, it adds the missing third dimension to a two-dimensional image, giving the buildings form and depth.

◁ **Strong but diffuse light** in the evening picks out the patterns in this Tuscan landscape.

▽ **A brief break in the clouds** highlights some areas of this typically British landscape, while others are left in shadow. This chiaroscuro effect creates an ever-changing pattern over the fields below.

△ **In this mountain view** of an Indian tea plantation, the bright, even lighting emphasizes the monochromatic character of the landscape, while at the same time underlining the subtle differences in the shades of green.

▷ **Two separate areas** of this shot are illuminated by shafts of light – the immediate foreground and the mountain peak in the far distance. These areas of brightness are linked by the snaking shape of the river, which leads the eye through the composition.

▽ **In hilly and mountainous regions** low clouds are often trapped, but as they move the landscape is illuminated by shafts of light like a giant torch. The effect constantly changes – one moment the scene looks exciting, and the next it looks dull.

People in landscapes

Landscape photographs without people soon begin to look repetitive and boring. A human figure not only helps to give an idea of scale to a scene – it also creates a natural focus for the photograph. Furthermore, man has played an integral role in shaping the landscape – from creating the pattern of the fields and the color of the crops, to cutting through forests and hillsides to build roads and houses.

Unfortunately, thanks to mechanization, it is becoming harder to find people working in the fields – particularly in the western hemisphere. You rarely even see people walking through their crops, since they sit behind the steering wheels of their combine harvesters, tractors and cars. To find people to help give shape, color, scale and focus to your landscape pictures you must be ready, when traveling, to make the most of every opportunity. You will find many such subjects in areas of small farms where traditional agricultural methods are still in use. When you do discover the old labor-intensive practices, you will see the concerted activity and excitement that accompany the sowing and harvesting seasons.

Remember that the figures that you include in your landscape shots should add to the composition – the picture should still work together as a whole. This means you will need to wait for the people and the light to be right before shooting.

△ **The inclusion of a single figure** in this shot helps to emphasize the amount of work that is necessary to keep this smallholding running. By including the house, the crops and one of the family at work you get a complete picture of this way of life.

▷ **The boat in this shot** is more than just a focal point for the picture. It has become the main subject, thanks to its prominent position in the foreground, its distinct shape, and its diagonal placement to the frame. This photograph was taken at Lake Dha in the Himalayan north of India.

△ **In many of the most beautiful** landscapes of the world the people that you are most likely to come across are other tourists. But they too can be used to add something to your pictures. Here, in the Canadian lakes, the woods are full of shacks used as second homes. Someone relaxing in a kayak, therefore, is an appropriate accompaniment to this tranquil scene.

△ **The Japanese farmer** is essential in this picture to give the viewer a sense of scale. As you would guess that he is five and a half feet (165cm) tall, you have an idea of the height and length of the racks that are used to dry the rice in his paddy-field. Despite the manual methods used and the setting, you can see from the buildings in the background that this was taken not far from busy civilisation.

▽ **You do not have to travel far** to see traditional farming methods still in use, but in the West such scenes take some finding. This picture shows a Portuguese family working together to bring in the crop. Harvesting and sowing are the busiest periods of the year on the land, and are therefore the best times search for landscape shots that include human interest.

Landscapes: manmade marks

From prehistoric cave paintings to a pyramid of beer bottles I once found in the middle of an Australian desert, man has always left his mark on the landscape. The things that we do to the world around us provide photographers with an endless supply of picture opportunities, each illustrating the quirky side of human nature. Whether bizarre, ridiculous or downright funny, these sights may have been set up to capture the attention of passers-by, but they are also well worth capturing on film.

When photographing these strange structures, isolate the elements that first caught your eye. This means finding the ideal viewpoint and choosing a suitable lens so that only the essential information is included in the frame. You may need to include some of the surroundings to give context, but make sure that the composition is not too complicated.

△ **Caravans were designed** for holidays in the open, but in this case the traveling home was penned in by a mesh fence.

△ **A gateway to nowhere?** There must have been some reason why this door was put up, but over time it seems that it has come to serve no practical purpose whatsoever.

◁ **A giant straw man** greeted me at a crossroads. Its purpose was to make passers-by stop and read the attached signs publicizing a local barn dance.

▷ **The art of the muralist** is to transform the ordinary into the extraordinary. Here a city car park wall has been painted to look like the countryside.

◁ **The hideous design** of these seafront buildings juxtaposed with an elegant Victorian watch-tower first attracted me to this shot. The red banner seems to be shouting a protest.

▽ **I loved the incongruity** of this simple scene. Although there was already a giant hedge to stop all trespassers, someone had decided that a little fence might add some extra protection. The fact that the fence had been freshly painted proved that it remains well cared for.

Seascapes

Seascapes, like landscapes, can be busy, cosmopolitan areas. Boats, surfers, and donkey rides – all can combine to make a seaside scene as busy as any that you will find in a city. However, for the most part, the seashore is a solitary place. Take a walk along a boardwalk or pier on any quiet, cloudy afternoon and you will find more people on their own than in almost any other place you could visit. The huge expanses of sky and water create a feeling of remoteness.

It is the sheer scale of the sea that I have emphasized in the pictures here. Because looking out to sea can give you an uninterrupted view that stretches to infinity you begin to appreciate the size of the planet as a whole. On a calm day the water can look as smooth as a skating ring, but the huge walls built to protect harbors always remind us of the power that the sea can hold.

Although all water is harmful to cameras, if it reaches the mechanical and electronic parts inside, salt water is particularly corrosive. You should therefore always take precautions against sea spray, by keeping your camera tucked away when not in use, and covered with a transparent plastic bag when taking pictures. Even if there is no spray, the wind can blow sand into a camera, which can cause as much damage – and this will not be covered even by a manufacturer's usual warranty.

▽ **An immense feeling of space** is conveyed by the photograph below. I selected a camera height that made the quayside coincide perfectly with the horizon. This deliberate arrangement creates the strength in the picture, while the contoured side of the wall echoes the pattern of waves and helps to simplify the composition.

△ **A solitary wave on an ocean of water**. I saw this unusual phenomenon from a cliff above a Moroccan beach, but it was gone before I could fit the right lens on my camera. After getting myself into a better position, I had to wait for over an hour for it to happen again within the range of the lens.

△ △ **The solitary figure at the end of the jetty** conveys not only a feeling of isolation, but also the coldness of the exposed position. The red hat and belt lead the eye directly to the woman, while the converging lines of the sea-defence point us out to sea and to the distant horizon.

Water

A stretch of water can add considerable interest to a photograph – particularly if it is still. Its surface becomes a mirror, and therefore can change color depending on the color of the sky – turning from the deepest blue to the brightest orange, depending on the lighting conditions. If your subject is in or beside the water, you get a near-perfect reflection of the subject, helping you to fill the foreground.

It is therefore very rewarding to look for pictures wherever you find a stretch of water – whether it be a great lake or a rain-filled puddle. Reflections of brightly colored objects, such as neon signs, look particularly good when framed on a pavement after a heavy downpour. But water is not only picturesque – it can be moody and dangerous, too. Moving water appears pure white in pictures, as the droplets reflect the sunlight to create highlights. The droplets appear sharp and well defined if a fast shutter speed is used, but softer and frothier with a slower speed.

On occasion, reflections can spoil a photograph, making the composition too cluttered, or stopping you from seeing how clear the water is. A polarizing filter can be used to reduce the amount of reflected light reaching the camera, the amount cut depending on how much you rotate the filter, and your angle to the reflection.

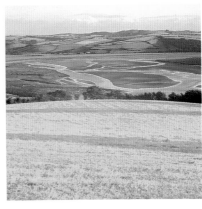

△ **The meandering river** in this shot changes color depending on the depth of water. This pattern is contrasted against the patterns of the corn in the foreground and that of the fields on the horizon.

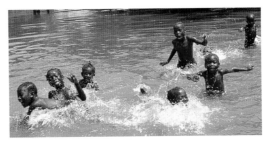

▽ **Under an overcast sky** the water in this lake appears a dark gray, reflecting the sombre color of the clouds. The mood set by this weather matches well that conveyed by the main subject – the sunken boat. But even though the sorry vessel's red paintwork may have faded, it is still bright enough to grab your attention at once.

◁ **Children playing in the Nile,** in Cairo. Despite the muddy appearance of the water, the splashes appear a brilliant white as they catch the sunlight. They were frozen with a moderately fast shutter speed.

▷ **The sky and the water** seem to merge in this shot taken in the early evening. Only the boat breaks up the yellow and blue backdrop, providing a strong shape. The central positioning of the subject against the barren islands adds to the feeling of tranquillity.

Rain

Just as there are fair-weather golfers who will only venture out onto the fairway on a sunny day, there are many photographers who will not go out with their cameras in the wind and the rain. But without being too masochistic, it is possible to take exciting pictures in wet conditions.

Heavy rain is difficult to cope with, because not only are light levels and contrast levels low, but it can be hard to stop water getting on the lens and blurring the picture. However, in lighter rain, or from a sheltered vantage point, it is possible to keep the front element of the lens dry enough to shoot pictures. Often, in light rain, subjects can be lit in a way different from usual, as so much light is reflected back from the wet surfaces. Alternatively, you can take an easier option and start shooting only when the downpour has ceased. As discussed in the previous project, puddles can add interesting reflections to your pictures – but the water also washes away the dust from buildings and from the air itself, making objects look cleaner and fresher than they did before, as well as giving you better visibility for panoramic landscapes.

The ultimate solution if you do not like getting wet is to fake the rain yourself using a hosepipe. This technique is both controllable and particularly effective on a sunny day, producing an effect that looks like a summer storm.

△ **Taken with a macro lens,** this close-up of water droplets on a twig is framed against the out-of-focus globe of the sun itself. Each drip has become a bauble of light, hanging like a decoration on a Christmas tree.

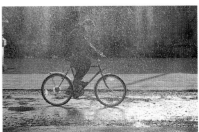

△ **Using a pressure hose** adjusted to give a coarse spray I faked this shot of a summer shower, positioning the camera so that the sun backlit the drops of water but gave some sidelight to the cyclist.

▽ **In this alternative to the shot above** I set the hose to produce a fine spray, and this time the cyclist was positioned so that he was lit directly from behind, to appear as a silhouette.

△ **This rain-swept seascape** would have looked dull on its own. The model is needed to add an interesting foreground to the picture. I used fill-in flash to increase the contrast in the picture overall, and to light up the girl's face. People do not look their best when they are soaked to the skin, but this fact helps in this particular picture.

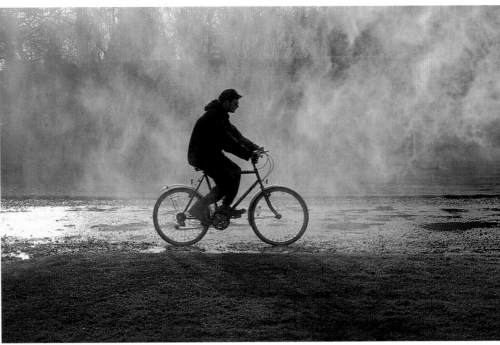

▷ **Fine rain can help** produce moody landscape pictures. Cloud-covered skies reduce the contrast and color in this shot, and the water produces an appearance of mist. The viewer is forced to look closely to make out the farmer herding his cows towards the milking parlour.

◁ **After the rain has stopped,** pools of water on the roads and pavements form mirrors, creating symmetrical reflections of everything beyond them. If the conditions are still dull, the best reflections will be of light sources themselves – such as neon signs or floodlit buildings.

▽ **As a project of your own** you might try to shoot a series of candid portraits of people battling through the rain. You will find that their facial expressions tell you as much about the weather conditions as the rain itself. Use wide shots that include enough background to show the rain. I took the picture below on a New York street during a heavy downpour. The faces of the two shoppers show the discomfort that they are feeling, but their posture tells us that they are resigned to getting wetter still.

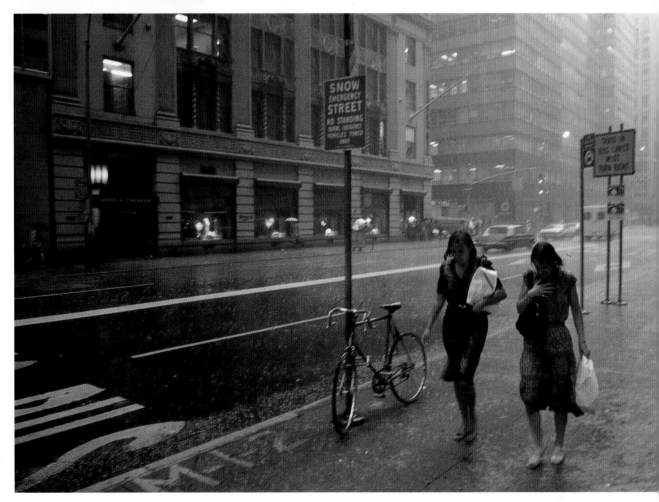

Ice

Ice, as with snow, can cause many problems with exposure for the photographer. As it is predominantly white, it reflects so much light that the meter is likely to underexpose the scene, as it tries to reduce it to an average gray. In practice, I find that it is essential to give at least half a stop more exposure than the meter suggests, and then to bracket. If you catch a highlight, the meter reading can be particularly high, and therefore inaccurate, so you can never trust the meter alone.

However, not all ice is white; not only can it be tainted by dirt, but if it is compacted enough it is clear, or at least translucent. If compacted, it takes on the appearance of glass, and causes fewer exposure problems because it produces a far greater range of tones – from white to black. The patterns that ice forms – for instance, on the surface of a pond – offer great close-up studies. As always when shooting in the cold, keep the camera, and especially the batteries, warm by keeping it close to your body when not in use, either under your coat or in a pocket.

△ **To make sure that the whites** in this iceberg appeared white in my shot, I overexposed by a full stop from the metered reading, and then bracketed the exposure from that point.

◁ **Ice can form interesting patterns** with the appearance of sculptured glass, as shown in this close-up of a frozen puddle, shot with a macro lens.

▷ **Icelandic men try to keep** the channel clear by using a boat to move drifting icebergs out of the way. Notice how some of the ice is translucent.

▽ **The layer of hoar frost** accentuates the patterns formed by the branches of a tortured willow in this shot taken with a 100mm macro lens at 1/250sec at f/5.6.

Steam

Although a comparatively rare phenomenon, geysers can be found all over the world in areas of volcanic activity. The Yellowstone National Park, in the USA, has 200 geysers, but there are also spectacular examples in Iceland, New Zealand, Mexico, South America, and Japan. As well as geysers, which shoot up water and steam, there are also fumaroles, which vent only gas and steam.

Unless you use backlighting to record the steam, the effect tends to get lost in the clouds. To help avoid losing the subject against the background, you should also underexpose the shot by between a half and a whole stop from the metered reading. Avoid cropping the scene too closely as you prepare for the geyser to erupt – some shoot up to 200 feet (61 meters) or more, and you could lose the overall shape if you zoom in too tightly. You can also get great shots from man-made steam – such as that produced by chemical plants, breweries and power stations.

△ **The discharged coolant water** of this chemical plant is bathed in by visitors in the belief that it is a panacea for skin diseases. The clear, shallow water is still warm, and reflects the color of the sky.

△ **Some Icelandic geysers** can shoot up pillars of water and steam 200 feet (61m) high. I avoided zooming in too closely, to record one in its entirety.

△ **A minute or so later** the geyser had reached its full height, and my conservative cropping (top) proved to be spot-on to record the characteristic shape of the geyser.

▷ **I was absorbed** by the sulphurous puddles and the colors and textures of the scalded ground around these hot springs. By underexposing this shot by half a stop I have tried to keep the column of steam from disappearing against the cloud-covered sky.

△ **An alternative view** of the Blue Lagoon, in Iceland. Again you can see the bathers, but this time the overcast lighting has created a moodier picture in which the clouds of steam from the factory take over the frame.

▽ **In this shot the steam** fills much less of the photograph, and there was the danger that it would camouflage itself against the cloudy sky. By waiting for the sun to break and for the foreground to be lit, I made the steam a highlight in the scene, and it can be seen clearly against the storm clouds in the distance. I exaggerated this effect by using a polarizing filter.

Animals

The standards set by today's crews of professional wildlife photographers, who will often spend months waiting to get the right shot, are extraordinarily high. Competing on equal terms with these dedicated cameramen is therefore impossible. Even to get a reasonable shot of an animal or bird in the wild is a hit-and-miss affair in which patience is your most valuable asset. It is far better to improve your technique in easier surroundings.

Safari parks and open zoos are the best places to start photographing exotic animals, as they are set up to make taking pictures easy. For a start, the wildlife is presented in environments similar to those found in the wild, so that there are naturalistic backgrounds to shoot against. Furthermore, bars are used less widely nowadays, allowing you to shoot more freely through car windows, perspex screens or wire meshing. However, it is still necessary to avoid too much background or foreground detail, and therefore you should use a reasonably long lens (for 35mm cameras, a focal length of 150–300mm is ideal). This should be used at maximum aperture, to help throw unwanted detail out of focus. When shooting through mesh or perspex, you should get the front of lens very close to the barrier (touching it if you can) as this will ensure that it is as out of focus as possible in the picture.

△ **As with any portrait,** when photographing animals the most important part of the subject to get in focus is the eyes. For this shot of a chimpanzee I used a 200mm lens on a 35mm SLR.

△ **The shape of this snowy owl** has been accentuated by the dark background. Getting the right pose was a matter of standing patiently until the bird moved its head to look straight at the lens.

▷ **The peculiar plumage** of this exotic bird in an aviary immediately caught my attention. Using sidelighting I was able to highlight its form and show off the dark cloak of feathers on its back, as well as its spiky hair-style.

△ **The widest aperture** available was used for this shot, not only to blur the background, but also to throw the wire mesh of the cage completely out of focus. I leant forward to press the lens through a hole in the wiring to ensure that this unwanted foreground was not visible in the final picture.

▷ **Look for poses** that show the natural behavior of the animal. Here this backlit shot of a monkey not only shows off its athletic shape, but also tells the viewer about the way it moves around.

▽ **Yawns and growls** make for more exciting pictures, as the shots look more animated. Take the straight shot first, to make sure that you have a good picture, then wait patiently for a more interesting facial expression, as in this study of a big cat.

△ **Pictures of young** animals elicit strong emotions from most viewers. Here the mother looks suspiciously at the camera as she cradles her newborn. A 200mm lens was used at full aperture, ensuring the monkeys stood out sufficiently against the background.

▽ **Practise your wildlife** technique with your pets. They may be more cooperative than wild or caged animals, but it still takes patience to get good poses and suitable facial expressions. Sidelighting from a nearby window was used for this photograph.

Close-ups at any distance

I am frequently asked by students which lens they should use for close-ups. The correct answer, I tell them, is that any focal length can be used – it all depends on how big the subject is, and how far away from it you want to be when shooting.

The virtue of close-up pictures is that they provide immediate impact. By using a longer lens or by moving the camera close to the subject, you will see detail more clearly. Close-ups can be over-used, however, and you must remember that they miss out information about surroundings, size and scale that are obvious from a wider composition.

If you can get as close to the subject as you like, the ideal focal length will be one that avoids excessive distortion. Use a wide-angle lens too close to a person's face, and the nose can look longer, or one ear can look much bigger than the other. Similar tricks of perspective can come into play with long lenses, making objects that are some distance apart concertina together so that they appear on top of each other. Sometimes these distortions will be acceptable, at other times not.

△ **A 35mm wide-angle lens** is not often used for close-up portraits, as it tends to distort the features. In this shot, however, it has been used to include a wider view of the background. Having the subject sit in the middle of the frame, facing the camera, has kept distortion to a minimum.

△ **I used a 50mm** standard lens on my 35mm SLR for this close-up. Because this is effectively a half-length portrait, there is no distortion, although I would normally use a slightly longer lens for this type of shot.

▷ **The 90mm lens** is my usual choice for taking close-ups of people, as it allows for a sensible working distance without exaggerating or flattening the facial features. In this case the short telephoto lens has brought the background closer to the subject than it appeared in real life, making it an integral part of the photograph.

◁ **Although an ultra-wide lens** is not normally used for close-ups, its effect on a picture is to exaggerate the foreground of the frame, which often is only inches away from the front of the lens. In this example, shot with a 15mm lens on a 35mm SLR, the statue on the right and the ornate detail on the far left are effectively seen in close-up.

▽ **A long lens is often needed** to pick out detail in a subject when it is not practical, or safe, to get the camera any closer. In this shot I needed to fit a 200mm telephoto to my 35mm SLR to get a close-up of these ornate pillars from ground level. To ensure an exposure that gave enough depth of field, the camera was supported on a sturdy tripod.

Macro lenses

For users of the 35mm and APS formats, zooms offer the photographer the chance to select from a variety of focal lengths in a single lens. Prime lenses, with a fixed focal length, are becoming much less common. However, there is one prime lens that every SLR photographer should find room for in the gadget bag – the macro lens.

This lens is specifically designed for use at short shooting distances, and can normally be used so close to the subject that the image on film is exactly the same size as the subject (1:1 magnification). Although these lenses perform best in macro work, they can also be used at normal shooting distances.

Two focal lengths of macro lenses can commonly be found: the 50mm and the 100mm. Of these, I find that the 100mm is by far the most useful, as you do not need to be so close to the subject to obtain life-size magnification. This choice of lens also avoids the problem of the photographer being near enough to cast a shadow over the subject.

Macro lenses also offer a very small minimum aperture (usually f/32 or f/45), which is necessary when you need extensive depth of field.

△ **A macro lens is essential** for wildlife photographers, as it allows you to fill the frame with the smallest of subjects. For this shot of a tree frog, I used a 100mm macro. This type of close-up can be taken with the use of other gadgets such as bellows and extension tubes, but the advantages of the macro lens are that it is easier to use and can also be employed for ordinary subjects.

◁ **Grass growing in a rotting tree trunk** – to get close enough to the subject so that it filled the frame, I used a macro lens. The macro lens opens up a whole new area of photography – minute subjects that are hard to see with the naked eye. You must use a tripod, and take care with the composition.

▷ **Depth of field** is very shallow at close shooting distances, and particularly when image magnification approaches life size. For this reason, macro lenses have minimum apertures that are one or two stops smaller than those found on other lenses. This shot was taken with a 100mm macro at f/32.

△ **Macro lenses can also be used** for ordinary subjects, at more usual shooting distances. I took this portrait shot with a 50mm macro lens.

▷ **Butterflies and insects** can not be photographed adequately with a normal lens, as these lenses do not allow you to focus closely enough. My 100mm macro, however, allowed me to fill the frame with this moth.

Urban life

Whether it is your home town or a famous city you are visiting for a first time, it is very tempting to produce pictures that are little more than imitations of postcards. The classical architecture and photogenic panoramas can mesmerize you, and you end up with a collection of romantic images that would not look out of place as a jigsaw puzzle or on the lid of a chocolate box.

There is nothing wrong with idealized pictures for which you wait so that passers-by do not clutter up the frame, but it is just as rewarding to try to capture the real essence of urban life. Roads are jammed up with cars, walls are covered by advertising slogans and graffiti, and people do visit the shops and buildings you are shooting. The secret is to look at the streets with fresh eyes, and once you have worked out what you see, find a suitable way of recording the scene on film.

One of the most important things you should remember when undertaking this type of photography is to include people in your pictures. Most do not object, but if they show any reluctance, apologize and move on. The inhabitants are as an important part of a city as its buildings and parks and should not be ignored by your camera. And look out, too, for the unusual and the incongruous – city life provides examples all the time.

△ **Central Park, New York,** is well known for its greenery and surrounding skyscrapers, but it is also a hive of activity, with joggers, roller-skaters, and walkers. This candid action shot conveys the fun and relaxation that the locals get out of this famous park.

△ **Atlanta, Georgia** – my main memory of this city was just how hot it was during my stay. This picture seems to sum up my own view of the city – that it should be seen from the air-conditioned comfort of a building. By including the window blinds in the shot, I have added a pattern to the picture that helps to unify what is essentially a mundane urban sprawl.

◁ **Bucharest, Rumania** – street entertainers are a common sight in any city where tourists congregate. However, I was particularly attracted to these young performers because of their costumes. The boy, in particular, gave an outstanding performance, to the pleasure of the onlookers.

▷ **Skyscrapers** are often idealized in photographs because it is easy to show off their sheer size and their clean lines. However, the reality is often an urban sprawl of mismatched shapes. This aerial shot provides a more realistic view of the architecture of a modern city.

▽ **The Arsenale in Venice, Italy** – an unusual viewpoint on a famous building. Here the sculpture of the lion becomes the main subject of the picture, thanks to the low camera angle and the use of a wideangle lens.

◁ **When you think about it,** a balding man is just the sort of person who would look in a wig-seller's window. Even so, most viewers are likely to find this candid New York scene rather comical.

▽ **In postcard photography,** advertising hoardings and graffiti are cropped out of the views of a town. In the shot below, however, graffiti carries a social message for our times. Also, it serves as a suitable foreground to the nondescript terraced housing behind.

◁ **Street photography** is a great way to help shatter social stereotypes. In front of your camera you find all kinds of people doing the most mundane things. Here a New York road worker is sandwiched amid the traffic, combing his hair in front of a mirror.

◁ **Piazza San Marco, Venice, Italy** – in a city famous for having canals rather than roads, it comes as bit of a shock to see the figure of a long-distance runner putting in some training in the shadow of the Campanile bell-tower. The incongruity of the scene makes a great photograph.

Architecture: exteriors

Architecture is a demonstration of man's endeavors and achievements. Buildings have progressed from simple huts to structures that go far beyond the practical needs of providing shelter. Architecture is not simply an art form in its own right – a building also serves to capture the essence of the age in which it was created – in its size, opulence and style. The same goes for the decoration used.

When photographing the outside of a building, resist trying to get the whole structure into the frame with every single shot. Often it is better to concentrate on one element. Sometimes this can be achieved by getting in closer, or using a longer lens, but it can also be done by using something in the foreground to mask off the unwanted parts of the structure.

Tall buildings present their own problem. If you get close, you are forced to tilt your camera so much that vertical lines converge, making skyscrapers look like giant spires. Sometimes this effect works well, suggesting their magnitude or their oppressive nature. However, it is often better to shoot from a distance, perhaps even a mile or more away, so that the sides of the building appear parallel to each other.

△ **Cathedral buildings, Vienna** – the strong, converging lines of the buildings in the foreground lead the viewer's eye straight to the cathedral itself. To help liven up the composition even more, I tilted my camera slightly so that the church appears at a slant.

▷ **Apartment blocks decorated by Hundertwasser,** Vienna, Austria – this extraordinary building was a must for any photographer, but rather than show the whole thing, I concentrated on the irregular patterns formed by the famous painter's design. Instead of shooting the building straight on, I took a more angular stance; this created diagonal lines across the frame, which produce a more dynamic composition.

△ **Saint Stephen's Cathedral, Vienna** – in this shot I have chosen to frame a detail from the roof that highlights the symmetry found in the building. Furthermore, the composition shows how the patterned roof mimics the triangular shape of the windows below.

◁ **Pointing the camera** upward to include a whole skyscraper in a frame causes vertical lines to appear as if they are converging. This effect of linear perspective seems normal when shooting, say, the tracks of a railway line, but looks strange with buildings. But as the bottom of the building is much closer to the camera than the top, the effect is inescapable – unless you move much further away to shoot the picture. Alternatively, find a raised shooting position that is approximately level with the middle of the building you are photographing. Here, in this shot of the Peach Tree Hotel in Atlanta, Georgia, convergence helps to convey the vast height of the skyscraper and almost creates a study in pattern.

▽ **The ultra-modern** Wotruba Kirche in Vienna must be seen in its entirety if you are to get a real feel for the radical design. I moved around the church to a position where I could use sidelighting, which helped to emphasize the form of the building.

◁ **I discovered this unusual,** geometric house on a barren hilltop in Peru. Isolated against the rock, it looks like something out of a science-fiction movie.

Architecture in its setting

Just as style and decoration are important in architecture, so is setting. Occasionally buildings are intended to stand out in their surroundings, to act as a landmark for the area or even to shock. Usually, however, they are designed to blend in with their surroundings. New buildings are often designed, therefore, to work sympathetically with those around them, by incorporating similar styles and materials.

The architectural photographer tries to emphasize the synergy between a building and its immediate surroundings, as this produces a picture with more information about the purpose and suitability of the structure. To do this, it is a matter of selecting a viewpoint to include foregrounds and backgrounds that harmonize with the building. In the case of a stately home surrounded by its own well-tended garden, this is easy. However, in built-up areas the search is more difficult. By adjusting the camera angle and, more importantly, its height, it is possible to mask unwanted details, for example unsightly car parks or ugly edifices, with an overhanging branch, a bed of flowers, or even another building.

△ **This aerial view** of an English country house shows symmetry and detail that would be impossible to capture at ground level. I took this shot with a 50mm standard lens on a 35mm SLR, and used a shutter speed of 1/500sec to compensate for the movement of the small plane I was in.

△ **Seeming to grow** out of the swampy landscape, this early Rumanian church was a magnificent sight. Close up it turned out to be in poor condition, but even so it was a gem of a subject. The boy and the reeds added to the atmosphere.

◁ **The spreading tree in the foreground** of this shot lends a sense of mystery, as the viewer has to peer through the branches to see the building on top of the hill. The technique presents a different view of Edinburgh Castle, Scotland, than that normally seen in picture postcards. However, the approach can also have a more important role in masking unwanted detail from view.

▽ **Warwick Castle, England** – it would have been possible to use a longer lens to shoot this majestic building, or to use the horizontal format, so that the castle filled more of the picture area. However, by framing the shot more loosely I was able to include more of the river and surrounding parkland, emphasizing the romantic setting. For this picture I used a 35mm wide-angle lens and a tripod, setting an aperture of f/22 so that the whole frame was sharp.

△ **By framing this shot** of a mosque in India within the archway, I masked the empty space around the building that would have burned out the picture with its intense light flooding straight into the lens. The arch itself reinforces the shape of the arches of the mosque itself, while the figures add a sense of scale and life to the architecture.

▽ **Salzburg, Austria** – the domes of the churches and bell-towers seem so tightly packed in this photograph that they look as if they are on top of each other, filling the bottom half of the picture. I achieved this effect simply by using a telephoto lens, which made the buildings seem much closer to each other than they actually are. The inclusion of the romantic city's mountain backdrop completes this idyllic image.

Architecture: interiors

While the exteriors of most buildings remain the same from one decade to the next, interiors are constantly changing, with decorations and details being altered to suit current fashions or practical needs. Guide books, I find, are of limited use for predicting what I will discover when I visit a building for the first time.

The main difference between shooting the inside of buildings and their exteriors is that inside the lighting conditions are frequently more difficult. Either there is insufficient light for a high-quality image, or the contrast between the windows and the unlit shadows is too great for the film to cope with. Artificial lighting is very difficult to arrange quickly if it is to look natural, so often it is better to wait for the light outside to fade, so that the contrast problem becomes less severe. Alternatively, you can try to crop the picture to avoid areas of high contrast, so that the areas included are of similar brightness to one another.

△ **Strong sidelight** on this pulpit's façade reveals the beauty of its carving, but in a different light I might have passed it by.

△ **I let the windows** of the church burn out to get detail in the shadow areas of this shot, and tilted the camera to pack more of the subject into the frame.

△ **I waited for the light** to become more diffuse outside, so that the contrast in this church interior decreased, making it easier to get a detailed photograph.

◁ **I took this picture from a balcony** half-way up the nave, as this gave a good perspective and avoided the problem of converging verticals.

△ **The shot above of a Viennese** restaurant was taken by using available light alone. The light was low and maximum depth of field was needed, so a tripod was essential to allow the required long shutter speed. The symmetrical view above right emphasizes the orderliness of the restaurant and conveys a sense of space, whereas it is in fact a tiny room.

△ **I chose my viewpoint** carefully for this picture of the audience chamber in the royal palace in Madrid, Spain, so that the image highlighted the balanced design of the room. Even the furniture has been arranged to make one side of the chamber a mirror image of the other, so it would be foolish to try to be more adventurous with the composition.

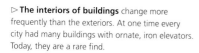

▷ **The interiors of buildings** change more frequently than the exteriors. At one time every city had many buildings with ornate, iron elevators. Today, they are a rare find.

Unusual viewpoints

To get architectural photographs that look different you must experiment. One of the techniques I use a lot involves lying flat on my back; few people think of shooting ceilings, but these can often yield spectacular pictures. I do not actually shoot from the prone position, as the shutter speeds are too slow to allow me to hand-hold the camera. Instead I frame up the picture and focus while on my back, then place the camera on its back on the floor and use a cable release to fire the shutter.

Interiors rarely give you enough room to use a full range of focal lengths. Even trustworthy wide-angle lenses can not fit everything into the frame, so sometimes a super-wide-angle or fisheye lens is needed. The other type of lens that is of particular use for architecture is the shift lens (see pages 170–1).

An alternative to buying a wider lens is to use a technique that movie-makers call a dutch tilt. It simply involves rotating the camera slightly, so that the horizon becomes a diagonal line across the frame. By doing this, you will often find that you can squeeze more of a building into the frame. A 45° tilt looks best – anything less can seem like a mistake, rather than a deliberate framing decision.

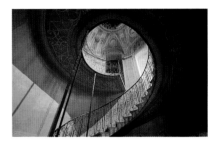

△ **Melk Monastery, Austria** – shooting this spiral staircase from below creates an interesting shell-like pattern well worth craning your neck for.

▷ **Another staircase in Melk Monastery** – this time I used a super-wide 15mm lens on my 35mm SLR, and laid the back of the camera on the ground to get a perfectly straight viewpoint.

△ **I had to lie flat on the ground** to frame up the composition and focus this shot. It shows the spectacular ceiling in the opera house in Barcelona, in northern Spain.

◁ **The dutch tilt technique** not only allowed me to fit more of this colossal building into the frame, but the angular composition has also helped disguise the barrel distortion at the sides of the picture, caused by the use of a super-wide-angle lens.

▷ **The highly reflective** glass used on many modern buildings is ideal for presenting an alternative view of a neighbouring piece of architecture. Here an older building, seen as a reflection, is juxtaposed against the complicated pattern of windows of the principal subject.

Daylight or flash?

Experienced portrait photographers, like many other specialist photographers, need the right equipment for all circumstances. Find out as much as possible about the sitter before a session. You could suggest what they wear and explain the type of shot you want, but be prepared to be flexible. You probably will know little about the location until you arrive, and should be prepared to take pictures indoors, as well as out, as it is here you might find a backdrop that mirrors their lifestyle perfectly.

I always turn up for a portrait session with at least two studio flash heads. These mains-powered units are much more powerful than portable flashguns. I look around first, decide where I would like to take the picture then ask for 15 minutes to set up the shot. Only after this do I call the sitter, as I am then free to devote my whole attention to him or her without having to concern myself with any technical matters.

▽ **I had arranged to take a portrait** at the home of the sitter, Mrs Kay Lockwood. I already knew a lot about the fun-loving lifestyle of this sister-in-law of Margaret Lockwood, the Hollywood screen legend. I had not been to her house before, and was not sure what I would find. With me, I took a set of three studio flash heads, just in case they were needed. My first shot, however, I took outside, while the light was still reasonable (always assume the light will get worse when on assignment, especially if you have only a little time). Knowing the sitter's fondness for the company of young people, and her love of fast cars, I composed the shot to include her resting against her own sports car, and accompanied by a friend.

◁ **Always shoot simple shots** as well as more complex arrangements. This full-length portrait was shot outside with diffuse sunlight. Despite the lack of props and background, even the elaborate cocktail dress tells us a great deal about the person in the picture.

▷ **The subject's fascination and love** of animals was immediately apparent from the hundreds of ornaments that adorned her home. In this particular shot, however, I used a single flash head to light the subject, allowing the background of the sitting room to appear much darker. As well as giving a feeling of greater depth to the room, this also makes it obvious that the woman herself is the principal focus of attention.

▽ **As an alternative to the shot on the right,** I used all three of my studio lights to illuminate most of the room. Now the menagerie of porcelain animals is as prominent as its owner. Although I did not move any of these ornaments into position for the shot, I needed to remove some of them from the room – to simplify the composition slightly and to give myself enough room in which to work!

Tungsten lighting

Although studio flash heads are the most adaptable way to light a portrait, they are beyond the budget of some photographers. It is tempting to try to make do with small, portable flashguns instead, but many of these do not have enough output to light the scene evenly, or to allow you adequate depth of field.

A good compromise in these situations is to use tungsten studio lights. These photofloods function in the same way as any household bulb, using a tungsten filament, except that they burn much brighter. Photofloods usually have a life span of only a few hours, and tend to deteriorate with time. Tungsten-halogen lamps, on the other hand, last longer and give a more consistent output. One advantage over flash lighting that tungsten lamps offer is that you can see the exact effect that you will get on film, which enables you to adjust the relative positions of several lights easily. A drawback, however, is that these lamps get very hot, and this can make the working conditions uncomfortable for the model and yourself.

Tungsten light is redder than daylight or flash, and produces orangey pictures with normal color film. Special tungsten-balanced slide film is made for use in these conditions. However, this means that tungsten lighting cannot usually be mixed with daylight or flash without one of the light sources being filtered.

▷ **The effect of using tungsten-bulb** lighting with daylight-balanced film is illustrated in this shot. A desk-lamp illuminates the woman's face as she works indoors, while the camera is outside. The interior takes on a warm glow because of the mismatch in color temperatures between the lamp and the normal slide film.

▽ **Two tungsten lamps** were used for this portrait. The main light was positioned at the side of the camera, while a second, smaller lamp was placed in the alcove at the rear of the room to help fill in some of the shadow areas. Tungsten-balanced slide film was used.

▽ **Tungsten lighting** is best suited to short portrait sessions, otherwise the heat can become unbearable. In this shot, photofloods bounced off a side wall gave me the advantage that I could see exactly where the shadows were going to fall in the picture – something that is harder to anticipate precisely with flash lighting.

Selecting the setting

Although a picture of a person's face tells the viewer a great deal about that person it still leaves out much information. From the lines on the face and hands you might hazard a guess as to the sitter's age and occupation. From the color of their skin you may be able to tell their ethnic origin or whether they lead an outdoor life. But from these features alone it is impossible to guess whether the sitter is a brain surgeon or a ballet dancer. It is the other things that you include in a portrait shot that tell the viewer more about the subject's profession and lifestyle.

The best portraits are often those that tell you a good deal about the person, and this is done by careful choice of clothing, props and backgrounds. A farmer, for instance, becomes instantly more identifiable when surrounded by cattle than when framed against a blue sky.

It is tempting, however, for photographers to impose stereotypes on their models, on the basis of what they have heard, read or briefly observed about them. I find it better to ask my sitters to choose their own props, clothes and backgrounds, as this allows them to express their own personality. Remember, however, as with all pictures, the simpler the composition the more effective the end result is likely to be.

△ **Although this portrait** of a trapeze artist was set up in the studio, I allowed the tightrope walker to decide exactly what he wanted to have in the shot before he arrived. The suggestion that the picture makes – that he relaxes at home having a cup of tea while lying on a rope – has produced an amusing study, but one that still tells the viewer how this performer earns his living.

△ **When you arrange to shoot a portrait** of someone at their home, you could be in for a surprise. A bed of nails was the main prop in this performer's act, and he was clearly in the middle of a rehearsal when I arrived.

▽ **I discovered this street performer** entertaining crowds on a busy street and asked if he would pose for me. When he agreed I suggested that we move somewhere where the background would be less cluttered. On the nearby beach he proceeded to do parts of his act. The rocks helped to emphasize the skill needed to balance on a unicycle, while the clear blue sky formed a plain backdrop that showed off his colorful costume to best effect.

△ **Once you have persuaded** someone to pose for you and found a suitable backdrop, it is worth trying to get several different shots. Once the street artist had performed on his unicycle, he wanted me to shoot his juggling skills in the same setting. Luckily, he volunteered to change his clothes, producing an even more striking costume for the camera.

△ Some portraits tease the viewer: what is this man doing dressed as a Viking with his sword in such an incongruous setting? In fact he is the curator of a Viking museum on the Isle of Man. I arranged to meet him while he was on his lunch break at home and when I arrived he was watching the television. Fortunately, I had a camera round my neck, so I was able to get this candid shot. I prefer it to all the more formal pictures I took.

◁ The setting is just as important when photographing a friend or acquaintance. I took this portrait of an Austrian boy using available daylight from a nearby window. The large chair and confident pose give an almost regal air to the shot.

▽ I took this portrait of the delightfully-named Stella of Jurby in the studio where she sold works of art. It provided the perfect setting for her as she posed amid her paintings and bric-à-brac.

Children

Although children can be great fun to photograph, they can also be very difficult to work with. While you can persuade and cajole an adult to provide you with a variety of poses over an hour or so, it is not easy to keep the attention of youngsters for more than a few seconds at a time. The younger your sitter, the shorter his or her attention span will be.

If you have a preferred setting, make sure everything is ready before beginning the session, otherwise your sitter will quickly become bored and restless. Use fast film and a shutter speed no slower than 1/125sec. Talk to the child all the time – most children like to be the centre of attention. And stay alert, because the best pictures are usually spontaneous shots.

With some children you may find that letting them play with your camera will help to relax them and make them feel involved in the session. Older children, who have had years of baiting by family photographers, are frequently camera-shy. Instead of asking them to adopt formal poses, be casual about the session. Let the children adopt their own stance and "play up" to the camera by pulling faces at the lens, while you wait patiently for them to adopt the right pose – not all your pictures will look enchanting, but some will.

△ **Natural lighting is best** for child portraits, as it allows you to be ready for when the eyes are looking in your direction and the expression is just right. There is rarely time to wait for flashguns to recharge.

▽ **Do not let young sitters** adopt artificial poses – just wait patiently for the right pose to appear spontaneously. Always keep your camera ready to fire, as children will never hold the same pose for long.

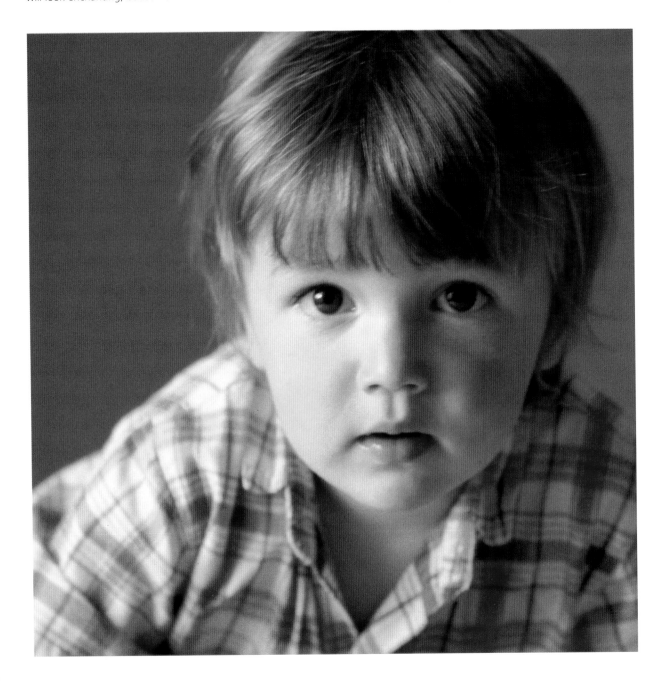

△ **Like adult sitters,** older children will be more cooperative if you let them choose the pose and setting for their photograph.

◁ **One of the easiest ways** to shoot children is to capture their expressions when they are totally absorbed in something that they really enjoy.

△ ▷ **Children hate having** to hold staid, formal poses for minutes on end. Furthermore, many will have been put off having their picture taken long ago by dogmatic or teasing photographers. Try to make the portrait session fun – let them perform in front of the camera and pull silly faces, if they wish. They will enjoy being given licence to "muck up" the pictures, and in the process you will capture some typically childish expressions.

Close-up portraits

There is a conventional way to frame a portrait. In essence, you should avoid shots where the edge of the picture cuts through the joints of the sitter. If the frame truncates the body at the knees, waist or elbows the shot looks unnatural – so you should aim to crop slightly above or below these points. Also, you should place the subject in the frame so that there is some space above the head – if this rests on the top of the frame the picture again looks strange. A close-up portrait is essentially a head shot but, to avoid the frame cutting through the neck of your subject, it should also include some of the shoulders. Bear in mind, however, that all these rules can be broken with success. It is best to use them as guidelines to begin with and then, once they have been mastered, to try to improve on them.

Lens choice is also particularly important with close-up shots of people. If you use a focal length that is too long you will be too far away from your subject to communicate effectively, but if the lens is too wide you will be in danger of producing distortion.

A short telephoto lens is ideal for portraits, which means a focal length of between 85mm and 135mm if you are using the 35mm format (for other formats, see the table on page 198).

△ **It is the facial expression** that dominates this portrait. The shot may well have looked better in an upright format, but expressions are momentary and you need to have the camera ready for when they happen spontaneously.

▽ **The soft, warm evening light** used for this portrait enriches the autumnal color of the girl's hair. Although the shot is cropped quite close, I have still left space above her head, and included the top of her shoulders.

◁ **The shape formed by the mother and child** makes this picture, and it is emphasized by the light-colored, out-of-focus background. With the boy's head lower in the frame than his mother's, a strong diagonal line is created in the picture, encouraging the viewer's gaze to wander from one set of eyes to the other.

▷ **The format and framing** for this formal portrait was dictated by the girl's hair-style – the long tress could not be cropped. I chose a backdrop that would harmonize with her coloring, and lit her with diffused flash.

△ **Although he was in his late 90s** when I took this portrait, the French designer Erté was still a fashionable dresser. His fastidiousness is summed up by his monocle, which is accentuated by the light reflecting off the glass. For this shot I used a 135mm lens on a roll-film SLR.

◁ **When using natural light** you have to exploit what is available. Top lighting is normally the worst light for portraits, creating shadows under the eyes and the nose. But in this case it has accentuated the lines on this old man's face, as well as emphasizing the shape of his head and his powerful gaze.

Posing a portrait

In addition to composing portraits sympathetically, there is a further skill in posing a subject so that he or she looks relaxed and natural. Professional models do this instinctively and can adopt stances and expressions that work on film without any prompting. With most portraits, however, you will work with people who lack this skill, and it will be up to you to cajole them into the right pose.

One of the simplest ways to get a subject to look natural is get them to pose in familiar surroundings, doing something that they usually do. This has the added benefit of telling the viewer more about their lifestyle.

If you are aiming at a formal portrait, you should encourage your models to sit up, or stand up, straight, as a slouched pose looks worse on film than it does in reality. Furthermore, set up your camera, lights and background before you put the subjects in position. The longer a particular pose is held the more artificial it will appear. Engage your subjects in conversation as you make the final adjustments to the framing and focussing, so that they keep their minds off what they are doing and look more relaxed. Finally, shoot as many pictures as possible – there will always be some in which you have not noticed that they have closed their eyes or adopted an awkward expression.

△ **Although this is a posed portrait,** the Peruvian girl was, at the same time, anxious to show me her spinning skills.

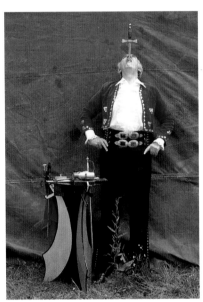

△ **This portrait of a sword-swallower** was best posed with the man standing – not just because that is the way the act is performed, but also because a more dramatic effect is produced when the eye travels up the entire body to the disappearing sword.

▽ ▷ **For this Moroccan craftsman,** his hands are his tools. It was appropriate, therefore, to concentrate my photograph on these. With his arms outstretched, his hands became larger in the frame, and it was possible to throw his face slightly out of focus – concentrating the viewer's attention. The accompanying picture below, shows his medium – the Zillig mosaic tiles – before they are placed in their elaborate patterns.

△ **A leather worker in the Gambia, West Africa** – when you ask a person to adopt a particular pose for a picture, let the subject relax his or her facial muscles between shots, otherwise the smile, or grimace, will appear increasingly artificial the longer it is held.

▷ **This curator of a Moroccan museum** has been literally surrounded by the exhibits for this picture – the costume, mosaic and chairs are all in her charge. The composition has therefore been kept simple and symmetrical to let the many patterns in the photograph speak for themselves.

Unusual approaches

Just as rules are created to help the photographer learn the fundamentals of good photography, so they can be broken. By flaunting the conventional approach to an area of photography, you can devise new and exciting ways to photograph your subject. Portraiture is perhaps one of the best areas in which to experiment with unusual approaches, as there is never any shortage of people on whom you can try out your ideas.

Earlier, in the project on taking close-up portraits, I showed that there are good reasons why a medium-length telephoto lens is best suited to portrait photography (see page124). But there is no reason why you should not occasionally use a wide-angle lens, filling the frame with the distorted features of your subject.

Similarly, soft lighting and balanced sidelighting are often used to take pictures of people, but backlighting can also be used effectively, describing the subject by shape alone, as in the silhouette cut-out portraits of the past. Composing the picture so that part of a person's face is hidden or obscured can also help to tease the viewer. Such rule-flaunting should be used sparingly, in case it loses its effect and begins to look merely idiosyncratic.

△ **Unusual framing** and a light positioned beneath the model have combined to produce an eerie effect in this photograph.

◁ **Careful composition** has hidden the head of the subject behind the lampshade, but the identity of the person is then revealed in the mirror's reflection

▽ **Using an ultra-wide-angle** lens with a focal length of 21mm and 35mm film, I shot this fun portrait from just a couple of inches from the noses of the two subjects. The distortion in their features caused by the unusual perspective is acceptable, however.

◁ **Only part of the face** of this girl is seen directly by the camera – the rest is seen as a reflection in the polished stainless-steel coffee-making machine.

▷ **Henry Moore, the sculptor,** is seen here in silhouette resting on a beach. For this shot I took advantage of the strong Mediterranean sun, using backlighting to show the shape of the man's head through the translucent material of the deck chair. I exposed for the shadow areas, so that the silhouette was not too overpowering.

Hands

After the face, hands tell you more about a person than any other part of the body. Whether it is the smooth, chubby hands of a baby, or the worn, lined hands of an 80-year-old, the fingers and palms tell you not only the age of a person, but also how much manual labor the person has done. While the ageing and weathering of the face can be disguised, it is impossible to hide the tell-tale signs on the hands with make-up or even cosmetic surgery.

It is an exciting and demanding exercise for the student of photography to try to take pictures of hands. To be able to express a person's character, you need to light the hands in a way that highlights the texture, or lack of it. This invariably means placing the light source at an angle to the lens's axis. So that your models, especially if they are children, keep their hands still during these close-ups, get them to rest their elbows on the back of a chair to limit movement.

△ **The way that people play** with their hands is an interesting project in itself. Here the doorman of a luxury hotel shows his technique for keeping his hands still as he stands ready at his post.

△ **In this series** of pictures of a child's hands, the color of the skin stands out well against the dark background, creating a strong composition.

▷ **A more subtle effect** is achieved by using the skin of the person's body as the background. Because of the similarity in color and tone, there is less contrast in the picture, and it is harder to make out the form and shape of the hands.

◁ **In this black and white print** I have juxtaposed the wrinkled hands of the subject with the smooth skin of her back. The sidelighting has helped to exaggerate this contrast.

△ **This is a more experimental shot,** in which I have included the whole arms and used colored lights to create a more abstract picture.

▽ **The sculptor Henry Moore –** this great artist told me that the joints of his fingers had become enlarged from decades of wielding chisels and hammers. The pose underlines the manual effort involved in his labor-intensive art form.

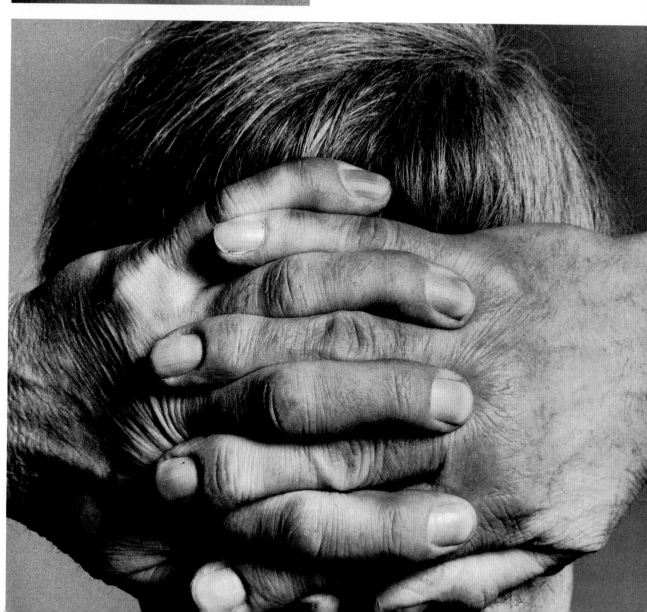

The nude

The human body is one of the most evocative of subjects, as well as one of the most difficult to photograph. It is a subject that painters and sculptors have struggled with over the centuries – as has every generation of photographers.

There are two extremely important aspects to shooting nudes – the choice of model and the lighting. The pose and composition are also important, but if the figure and the illumination are not right then the picture will not work.

At its most challenging, nude photography can become a means of expressing mood and emotion. However, I recommend that you start by learning to observe and capture the changing forms of a woman's or man's body from a more abstract viewpoint. Think of the exercise as photographing a piece of sculpture, as this will make the lighting, as well as the choice of model, easier.

To produce a three-dimensional effect, showing form, on two-dimensional film, the lighting need not be elaborate. Soft sidelighting from a window or from a diffused studio flash head works best. To soften a flash unit or tungsten bulb, you could bounce the light off a white wall. To prevent there being too much contrast, you will also need to place a reflector on the other side of the model – a piece of white card, or a sheet, is ideal. It should be larger than the area you are shooting.

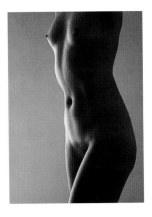

△ **Just a single light** to the side of the female model was used for this shot. With no fill-in light, the sidelighting throws half the torso into deep shadow, creating a dramatic, moody photograph.

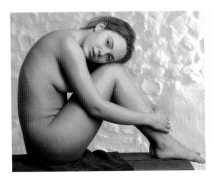

△ **Soft lighting is the key** to successful nude photography. For this shot I used a large diffuser, called a soft box, over the main studio light. To fill in the shadow areas, a piece of white card was used as a reflector on the other side of the model.

▽ **Avoid using complex props or backgrounds** when you begin to shoot the human form. These will only complicate the lighting and decrease your chance of success. This simple door frame has not cluttered the composition, but adds color and pattern to the photograph.

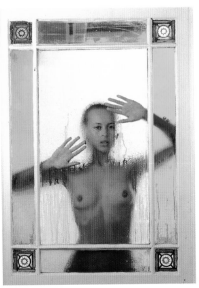

△ **Using the same simple lighting set-up** as in the shot at the top of the page, this is again a contrast picture. However, it remains exciting because one half of the woman's body appears as an outline, where you see shape alone, while the other side appears more three-dimensional, showing the form of her back, thanks to the range of skin tones.

▷ **Body builders are experienced posers** as they have to exhibit their muscles in competitions. I was amazed at how long it took this potential Mr Universe to pump himself into the form you see in this shot. A light oil is spread over the body by these body builders, to accentuate its shape and increase the size of the highlights in the shot.

◁ **As a general rule,** when photographing male models I expose the pictures to show darker skin tones than with female models.

△ **With men** it is possible to use stronger, less diffused, sidelighting, with less fill-in, than when shooting the female form, since this lighting accentuates the muscles attractively.

The nude model

A vital point to remember when photographing nudes is to keep the model comfortable. There is still a tremendous taboo about taking your clothes off in front of someone else – even if you are close friends, or even the same sex. Both you and the model are likely to be ill at ease to begin with, just because nakedness goes so much against social convention. Even if you are photographing a partner, he or she may still feel uncomfortable about appearing naked in front of the camera. The photographer needs to put the model at ease both physically and mentally.

To begin with, you should ensure that the room or location is secluded, so that you are not disturbed, and that it is warm. Background music may also help the working atmosphere. You must reassure the model constantly, but most importantly do not rush. It is often better to start with portrait shots, or fashion pictures, so that he or she gets used to working with you and the camera, before you proceed with nude photography. It may be a gradual process to get the model feeling comfortable enough to take his or her clothes off – and it is a process that it is wise not to hurry. Some models are natural nude models, and need only a little confidence to get going – others will never feel comfortable naked in front of the lens, so it is best to photograph them wearing clothes.

△ **Get the model** accustomed to the surroundings by first shooting portraits. This will also give him or her a chance to feel more relaxed about the photographic session.

▽ **Before moving on to fully nude pictures,** further acclimatize the model by taking semi-naked pictures. Remember not to move on any further if he or she feels uncomfortable. Most people are naturally shy about taking their clothes off, so it is necessary to provide somewhere private for your models to undress, even if they are going to appear nude in your photographs.

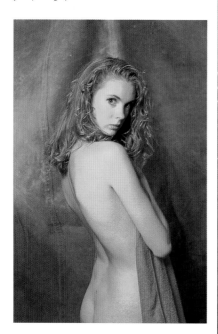

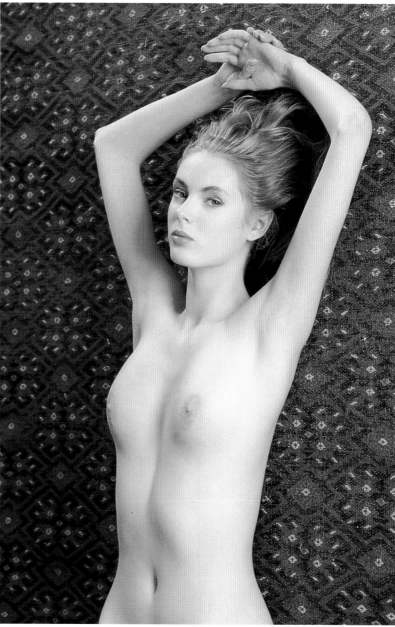

▷ **When the model feels completely comfortable** with you and the surroundings, you can start to do full-figure work. Remember, however, that models will quickly tire of holding a particular pose, so give them regular breaks and refreshments.

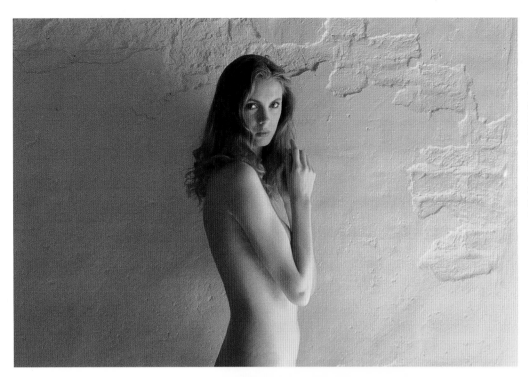

◁ **When lighting** the human figure it is important that the effect looks like sunlight, even if you are using flash. For this shot I used a single flash head, bouncing its light off a gold-colored umbrella to give the impression of sunlight streaming through a window.

▽ **This is essentially a fill-in flash shot.** With the model standing in front of the window, her back should really appear in shadow. But if you add a strong flash unit at the side of the camera, the skin will retain a full range of tones without the window behind burning out too much.

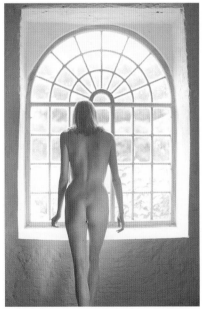

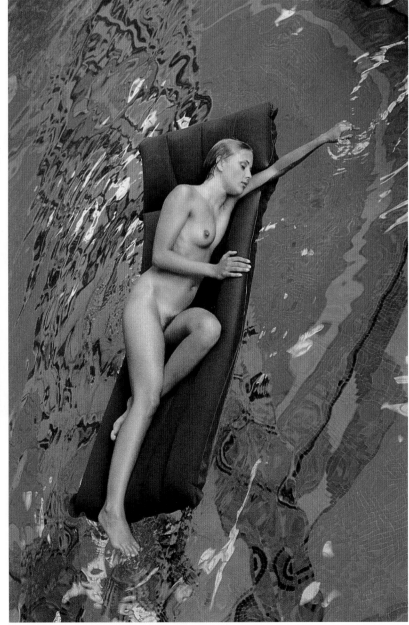

▷ **Photographing nudes on location** brings with it many problems. You need to find a secluded spot, so that you do not have too many onlookers to contend with – and you have to be careful of the various laws concerning decency and creating a public nuisance, which vary according to the sex of the model, and the country you are in. Also, you will have more difficulty lighting the subject than you would in the controlled environment of the studio. And finally, the model is likely to feel less at ease. It is no wonder that professional glamour photographers have assistants and stylists to help them take shots such as these.

Simple shapes

Although all photographs are, to some degree, an abstraction of reality, black and white pictures are more abstract than color ones. In the absence of color, black and white photographs rely on tonal range alone to differentiate between different subjects and lighting.

Monochrome photography allows you to concentrate on the spirit of your subject and the image you want to communicate – it is a much less factual representation of reality than color photography.

What black and white film does is to make the photographer concentrate on the elements of form, texture, shape and pattern. As we do not see the world in black and white it is also a more difficult medium to work with, forcing you to think about how a scene will appear on film. It is for these reasons that many students of photography are still encouraged to learn their craft with black and white film.

▷ **With no colors to consider,** this shot allowed me to concentrate on the texture, form and pattern of this thorny leaf. Notice how many shades of grey are possible between the extremes of black and white.

▽ **This burned-out barn in the snow** was essentially a black and white shot to begin with. Shooting it in color would have meant only that the viewer would have been distracted by the hues of the foliage, rust, wood, and the model's clothes. The choice of black and white film, therefore, has both simplified the scene and made it stronger.

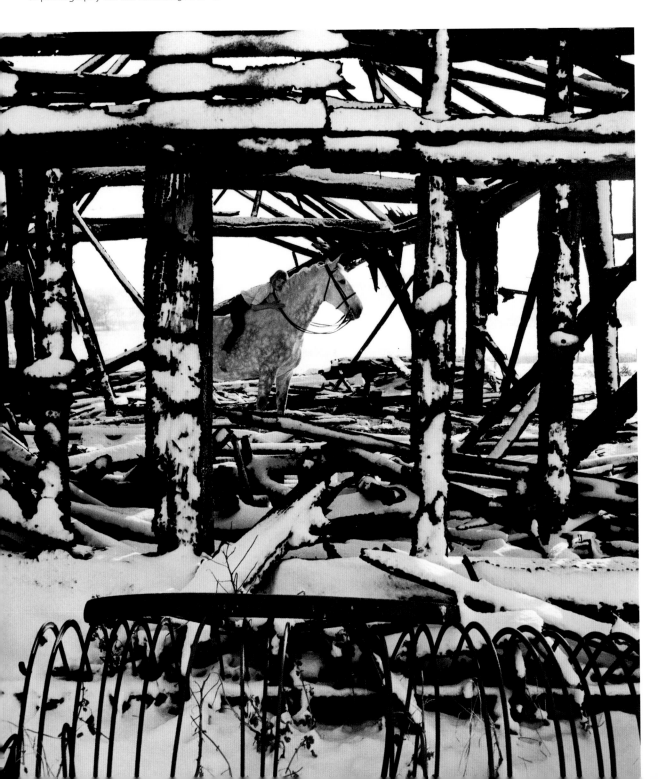

◁ **A silhouetted** portrait of a young boy appears like a cut-out piece of black paper when shot on black and white film. Despite the picture's lack of tonal range, the outline of the features makes for a very expressive result.

▷ **Black and white** pictures can have a tremendous emotional power – hence their continued used in advertising. Here a country lane snakes through the picture, gently leading the viewer's eye from the foreground to the horizon. The solitary figure of the old man forms a poignant central subject in this simple scene. The low-key printing, causing dark tones to dominate, has helped to make the shot look more sombre.

Monochrome for mood

Although black and white transparency film can be found, print film is the most widely used by professionals and hobbyists alike. The reason for this, and one of the key attractions of the medium, is that black and white print film is relatively easy to develop and print yourself (see pages 179–192). Enlarging and printing your own pictures gives you tremendous control over the result, allowing you to manipulate the crop, grain, contrast and exposure of the picture to a degree that is simply not possible with color film once the shutter is fired. It is even possible to expose the photographic paper so that different parts of the scene receive more or less light – in this way detail in the shot can be hidden or brought out of the shadows (this technique is known as dodging and burning – see pages 188–9).

What these techniques allow you to do is to control the mood of a picture more effectively than you can with color film. A high-key picture, for instance, where light tones dominate because the paper has only been briefly exposed under the enlarger, can create a soft, even romantic, atmosphere. Using exactly the same negative, but using a high-contrast paper to produce a dark print, can produce a more moody picture. For the black and white photographer, shooting the film is just the beginning – the really creative part of the process does not begin until he or she is safely behind the light-proof door of the darkroom.

△ **It is hard to shoot** a negative where the subject fills the frame, so that the viewfinder does not show the entire picture area, or where the film format is not suitable. But home printing allows you to enlarge the negative and cut the paper to the best size.

◁ **Dodging and burning** this beach scene during printing has made the sky darker, so that it looks more menacing, and the pier has been held back, to retain some detail. The result is a more moody shot than straight printing would have produced.

△ **This high-key shot** of a Sheffield street lightens the background and forces the workman and the street lamp to become the focus of attention. By changing the paper, and the printing exposure, you can easily produce this type of effect in the darkroom.

▽ **In this straight print** the mood is conveyed by composition alone. The isolated farmhouse on Canvey Island, Essex, and the field of corn in front of it look threatened by the industrial sprawl, with its menacing chimneys and pylons, that has sprung up behind.

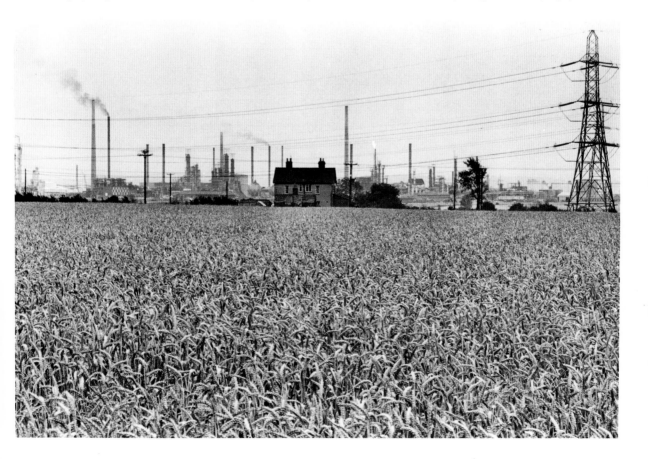

Black and white portraits

If there is one subject area where you could successfully argue that black and white pictures are usually stronger than color ones it is portraiture. Not only is color largely unimportant for identifying a person, but it can often be distracting. Also, the color of clothing can easily work against the effect that the photographer is achieving. Furthermore, black and white film eliminates all problems of color temperature and mixed lighting. You can use tungsten-bulb lighting, and mix it with daylight, with no need for any correction filter.

However, color must still be taken note of, as the visual weight of specific colors does not appear the same on black and white film as it appears to the eye. Reds and blues appear lighter, while greens and cyans appear darker. Grass, foliage and skies, therefore, can prove a problem and may occasionally need to be lightened or darkened by using a heavily colored filter over the lens (see the table on page 199).

△ **Henry Moore is seen here** relaxing at home, with all his treasures around him, in one of the last portraits of the sculptor. With black and film there are no problems with mixed lighting, so usually the camera can be hand-held.

◁ **The color of people's clothes,** wallpaper, curtains, and other items incidental to a portrait can prove a distraction when you use color film. With black and white film the problems are lessened, although some tones can appear lighter or darker than expected. In this portrait of Stanley Spencer I used a 5 x 4in (12.7 x 10.2cm) camera, which allowed me to capture every nuance of the artist's face in the available window light.

▷ **This amazing character** ate 20 mackerel each and every day – a gargantuan feat that I just had to record on film. This portrait would have undoubtedly worked almost as well in color – although the fact that it was done in black and white with existing light gave me extra flexibility in controlling the tonal range in the darkroom.

Nudes in black and white

When photographing the human form with black and white film, whether for portraits or nudes, it is essential to record a full range of tones. To do this you need to expose the film precisely (and then develop it correctly). Although black and white film has a wider exposure latitude than color transparency film, if a shot is overexposed you get a "dense" negative which, although it has sufficient detail in the shadows, lacks contrast in the highlights. The overall problem with the exposure can be corrected by giving the print more time under the enlarger, but it is impossible to add detail to the shadows if there is none there to begin with.

Underexposed shots, on the other hand, produce "thin" negatives, which lack detail in the shadow areas. To produce a rich print with a complete tonal range correct exposure is essential – something that will not be a problem to someone used to the rigors of transparency film. A further advantage of shooting the human figure in monochrome is that the quality of a model's skin and make-up become less vital. Blemishes can be disguised photographically, or by using darkroom trickery, rather than your having to rely on carefully color-matched, and expertly applied, cosmetics.

△ **Black and white film** can help to provide an amusing period feel to your photographs, and was essential for the Victorian setting used for this shot.

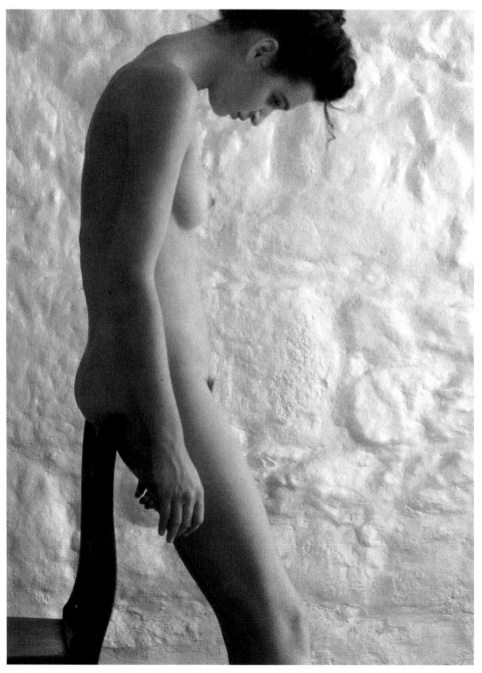

◁ **As discussed earlier** (see pages 132–3), the most effective nude photograph, and the easiest to shoot, is one that concentrates on the shape, form and texture of the model's naked body. Using black and white film makes this easier, as the viewer's eye is not distracted by the coloring of the model's hair and skin – or of the props. This picture was simply shot in light from a window, with a reflector helping to reduce the overall contrast of the sidelighting.

▷ **The color of the background** should be chosen, and then lit, carefully so that they do not appear to have the same tonal value as midtones of the body. For this photograph, I used a dark background, creating a sombre study reminiscent of an Old Master.

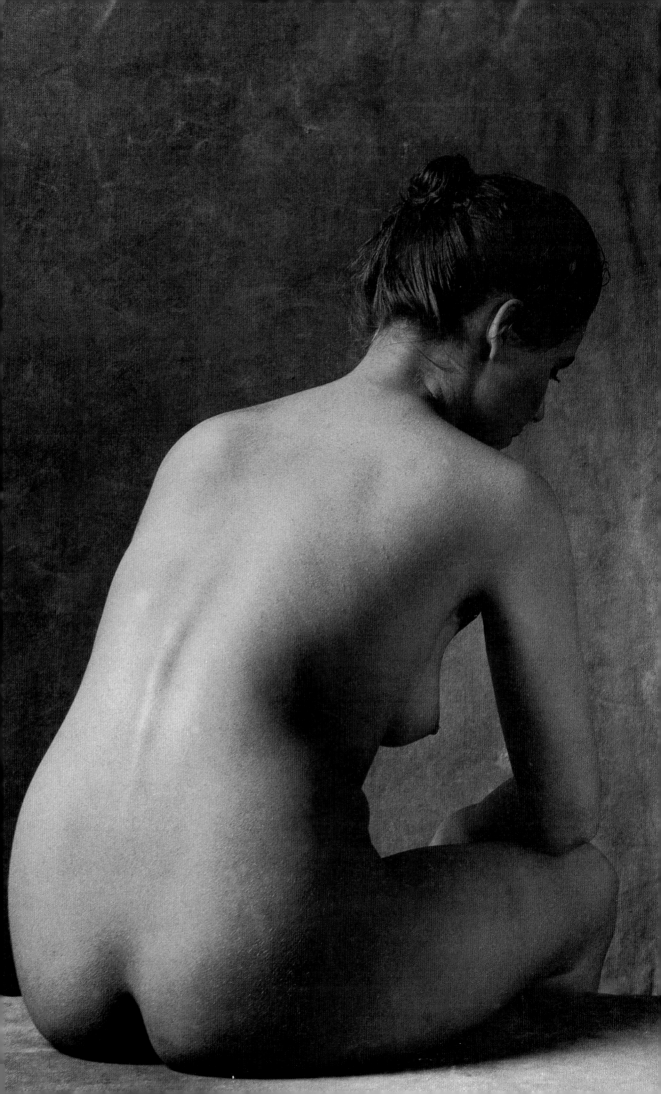

Lighting

A still life photograph is a picture in which inanimate objects are arranged and photographed for their own sake. You can approach still life photography either as a formal exercise in composition and lighting, or as an opportunity for self-expression in which objects are selected and arranged to create a mood or express an idea. The best still life photographs are both technically skillful and imaginative.

When lighting a still life, or any other subject, it is important for all the individual objects in the shot to appear to receive their main illumination from a single direction. In other words, the shadows should not give contradictory information about the relative position of the main light source. This does not mean you have to use just a single light, but additional lights must be for fill-in purposes only.

The first decision to make when setting up your lights is whether the subject requires hard or soft lighting. Hard lighting produces a greater contrast between highlights and shadows, giving sharper outlines and coarser textures. Soft light is more suitable when you want a gentler effect, producing delicate modelling and smooth textures. Studio lights and flashguns are made softer by either bouncing the light off a surface or partly obscuring the light with a diffusing material. To minimize shadows, reflectors are often used on the opposite side of the subject from the main light, helping to throw light into what would otherwise be denser areas of shadow.

△ **Hard sidelighting** produces a high-contrast photograph with deep areas of distinct shadow and bright highlights, where the light reflects off the shiny surface of the glaze.

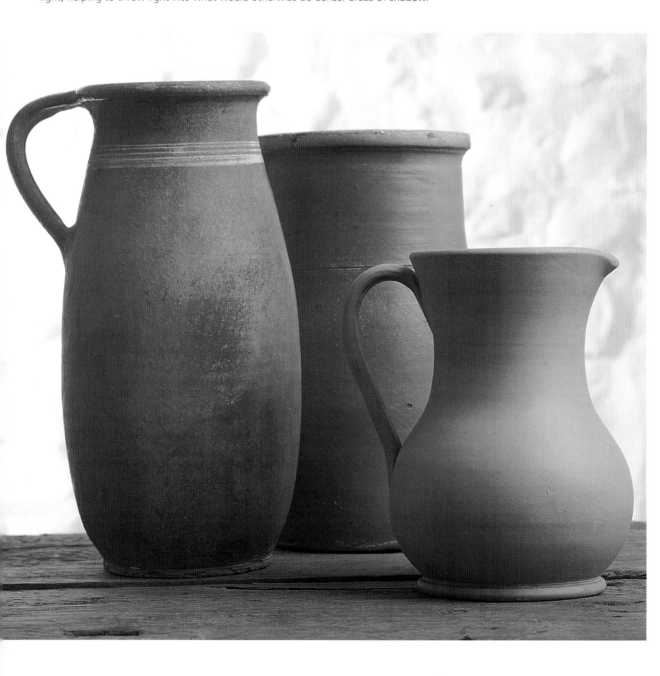

◁ **Sidelighting with no fill-in light.** A distinct line is formed between the parts of the jug that are in direct light and those that are in relative darkness.

▽ **Sidelighting with heavy fill-in light.** In the shot below, the lighting is the same as in the shot on the left, except here a large white reflector has been placed just out of shot on the left of the camera. This has helped light to bounce back into the areas of the jug which are not lit directly. As a result, the shadows have become very subtle.

◁ **The same still life** as in the shot above except that here soft, diffuse lighting has been used. Again the lighting is coming from the side, but this time there are no distinct shadows. Here the tones change more gradually from light to dark, subtly suggesting the curved form of this collection of jugs.

▽ **Sidelighting with soft fill-in light.** The lighting is the same as in the shot above and the shot on the right, except here the reflector has been placed farther away from the jug on the left-hand side of the picture. This gives a shot that is mid-way between the other two. There is a distinct difference between the shadow and highlight areas, but there is noticeably less contrast than in the shot without the reflector.

Color

Still life photography gives you complete control over the subject – not only can you change camera angle, lighting and lenses, but you can endlessly move the subject round as well. As most still life set-ups are shot at short subject distances, moving just one of the objects an inch or so can have a dramatic impact on the way a picture looks. You will invariably spend a lot of time fiddling with the arrangement so that the objects look their best. Professional food photographers often employ stylists whose sole job is to arrange the items in the most artistic fashion. Always remember to check your arrangement through the viewfinder, as looking at it from a slightly different angle and height will make it appear quite different.

One of the simplest ways to choose items for a still life is to select things whose colors match – or at least harmonize. If you use too many colors the arrangement is likely to look a mess. Having restricted the colors in the props and background, you can then use color to attract the viewer's eye. For example, if you arrange a pile of green apples, by adding a single red apple you make this the focus of attention. If you keep to the one-color scheme, it will be the highlights that the eye will first be led to. Moving the lights will allow you to move this bright area to an area that best suits your composition (and if necessary it can be toned down by using a diffuser).

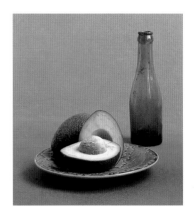

△ **It is not just the color** that matches in this arrangement – the plate and bottle also echo the shape of the avocado pear. With such shots it is important to work fast, before the cut fruit becomes dried out or changes color.

▷ **The white bulbs of the spring onions** immediately catch your eye in this predominantly green arrangement, the brighter area acting as a natural focus of attention. Notice how one of the onions has been loosened from the main bunch, which helps to create interest by breaking up the pattern and creating a diagonal line across the picture.

△ **To complement the color** of these pairs of boots, I chose a backdrop that used a third shade of brown. The difference in the tones is so great that the darker boots look almost black.

▷ **The restricted range of colors** used in this composition immediately draws the eye to the red blotches on the apple. The plate and background were chosen to match the green tones of the other areas of the fruit.

▷ **A ramble through the countryside** in autumn yielded all manner of nuts, fungi and leaves with a seemingly similar coloration. In fact, when seen in close-up, under the bright, even illumination of the studio lights, this nature trail has revealed a multitude of hues. However, natural colors have a way of blending together in a way that man-made ones would not – and in this case the result is a diverse arrangement that is united through its autumnal palette.

▷ **Arranging flowers** is very similar to arranging still lifes, as color coordination is one of the key skills in both. So a good floral bouquet makes an ideal subject for the studio photographer.

Abstract arrangements

When you are photographing still life, the subject matter is strongest if the picture conveys a theme or idea. You can also give a familiar subject new meaning by removing it from its usual context or associations and concentrating on new ways of presenting it. Almost anything around the house can make an appealing picture; what might seem like old junk or domestic waste can prove to be an aesthetically pleasing shape to the photographer. Having found the subject, you should then try to shoot it so as to accentuate the element that first caught your eye. The lighting and composition you use can help, of course, as can suitable props and background. If chosen carefully, these can complement or emphasize a particular aspect of the subject.

With this approach in mind, the studio photographer becomes a collector of plates, patterned materials, receptacles, and countless other bits and pieces that might some day be used in a picture. Look around junk stalls for low-priced items that could prove useful as props. Builders' merchants provide a treasure chest of materials that can be used as backdrops or bases for your displays – mirrors, wallpaper, weathered stone, and pipes can all be pressed into service in the studio.

◁ **These poor dried-up amphibians** were found on the floor of one of my studios. However, their demise was not completely in vain, as their shape formed the centerpiece of an abstract still-life shot in the same studio. The green plate was chosen to symbolize a lily pad – the frogs' usual habitat – but it is also, of course, a direct reminder of their culinary uses. For this shot, overhead shadowless lighting was used.

◁ **A fishbone** might not seem like a particularly appealing subject for a photograph. But the shape of the bones and the deep, blood red of the head are strong elements that have been accentuated by the use of props. The red has been strengthened by the addition of the glass of wine and chequered napkin in two corners of the frame. The weathered pewter plate forms a neutral backdrop, while the antique carving fork mimics the shape of the mackerel's tail.

▷ **Fruit and vegetables** are often far more interesting to the still life photographer raw than when they are cooked. The geometric form of this partly cut melon, which gives no clue to its scale, looks like a piece of modern sculpture. Accessories would simply detract from the strength of the image. However, a large piece of mirrored glass, placed under the melon accentuates the form, reflecting the shape in the foreground of the picture. A textured backdrop gives the appearance of a cottage wall behind but does not distract the eye or lessen the impact of the shot.

Variations on a theme

There is a well-proven principle of photographic composition – do not clutter up the frame if a simpler arrangement will suffice. This is particularly important when you are setting up a still life; it is easy to add more and more objects to the arrangement, even though the picture would look better with just one of these items. As you saw in the last project, on abstract arrangements for still life, you should rationalize the number of colors used – and the same applies to the number of patterns and shapes in the frame.

Once you have decided what is going to be the main subject of your still life, you should then photograph it in as many arrangements and styles as you can think of and have at your disposal. This is not only good practice – it also makes you allow enough time to explore the possibilities with the constant aim of taking a picture that is better than the last.

The more complex the coloring and shape of your subject, the more you should keep the composition simple. If the subject, however, is simple, you can afford to add more items, patterns, colors and shapes to the picture. Still life is a matter of compositional harmony and you will only find this balance by trying as many different variations as possible.

△ **All the pictures on these two pages** are of parsnips whose roots had split into a complex network. I was intrigued by the complexity of this apparently simple vegetable. The shot above was one of the first that I took, using a simple composition and doing my best to match the color to that of the background and the bowl.

◁ **A more complex arrangement** in which I added a range of other produce from the garden. The wooden bench creates the feeling of an old-fashioned kitchen, but there is perhaps too much detail in this shot for it to be completely effective.

▷ **My favorite shot** – again the composition is simple, but here the same parsnip as in the shot above becomes the immediate focus of attention, being the lightest area in the frame. The picture has been made more elaborate by the reflection of the arched window in the shiny background.

▽ **A slightly less complex version** of the shot on the left, where the parsnips are accompanied by the strangely colored ornamental cabbages. This time I have shot the arrangement from above, using the tiled floor as a rustic backdrop. However, the details and texture of the parsnips are lost unless the shot is printed large.

Capturing action and movement

Sport is not the only type of action photography. Nearly every subject that you shoot has some movement in it – whether it be clouds, trees, or portraits. Therefore if you use a slow enough shutter speed your "still" photograph gives an impression of movement by making that part of the picture appear blurred. Choosing the right shutter speed for this depends not only on the speed, image magnification and direction of the moving subject (see pages 16–17), but also on how much blur you want. If the blur is subtle it can appear to be a mistake, but make it too extreme and the subject becomes unrecognizable. Using a shutter speed that is eight times longer than the one you would use to get a perfectly sharp picture is a good starting point for experimentation.

 With subjects moving across the frame there is a further possibility. By moving the camera at the same speed as the image, and using a slower than usual shutter speed, you can make the background appear blurred, while the subject stays relatively sharp. This technique is known as panning, and although it takes a bit of practice to track your target accurately, it is a very rewarding approach, as it has the benefit of diffusing the background at whatever aperture you use.

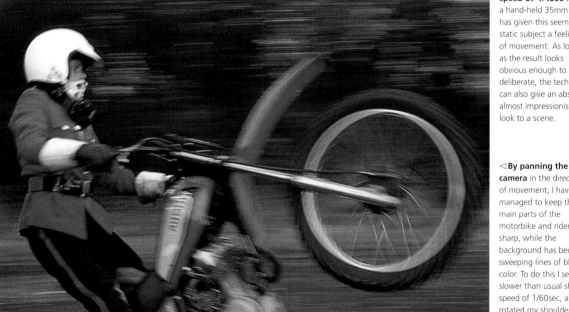

△ **Using a shutter speed of 1/4sec** with a hand-held 35mm SLR, has given this seemingly static subject a feeling of movement. As long as the result looks obvious enough to be deliberate, the technique can also give an abstract, almost impressionistic, look to a scene.

◁ **By panning the camera** in the direction of movement, I have managed to keep the main parts of the motorbike and rider sharp, while the background has become sweeping lines of blurred color. To do this I set a slower than usual shutter speed of 1/60sec, and rotated my shoulders and camera in the direction of movement. Note that the wheels, moving the fastest, convey movement well.

△ **To add some movement to this interior shot** I used a shutter speed of 1/8sec – just slow enough for the sweeping movement made by the cleaner to appear slightly blurred. To make certain that everything else in the shot remained perfectly sharp, I was obliged to use a tripod.

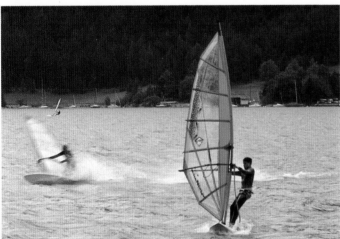

◁ **This shot graphically illustrates** the fact that the shutter speed needed to freeze a moving subject depends not only on the subject's speed, but also on its direction of movement. Shot at 1/30sec, the sailboarder heading toward us in the foreground appears sharp, but the one crossing the frame in the middle-ground is blurred.

▽ **By using a shutter speed of 1/2000sec** I was able to freeze the log-boat so that you can clearly see the facial expression of its excited occupant. However, the speed of the fairground ride is shown by the splashes of water, which, traveling at a much faster speed, appear blurred in the photograph.

Sporting action

Camera positioning is crucial in sports photography. For every sport there are camera angles that will yield better shots than others – for example, the side of the goal in football, or looking onto a bend at a racetrack. Unfortunately, these positions are often inaccessible to the amateur. Accredited professionals will be allowed the best vantage points while others will have to stay in their allocated seats.

However, to learn the skills of sports photography it is not essential to have the best players and athletes as subjects. Making do with fixtures that are attended by only a handful of people will give you much more flexibility – whether it be an amateur match or a minority sport. To take successful pictures you do, however, need some knowledge of the sport, as only this will give you the ability to predict when something interesting is about to happen. Your only restriction on positioning will be to keep yourself and your camera safe from danger.

There are a few sports that can be tackled effectively with wide-angle or standard lenses, such as cycle road races or skateboarding, but for most you need a good telephoto lens. For the 35mm format, a lens of 300mm focal length is a good all-round choice, and it should have the widest maximum aperture you can afford, to throw spectators and advertising hoardings out of focus.

△ **To get good close-ups of hang-gliders** you need to get to the site where they are taking off or landing. I took this shot with a 200mm lens on a 35mm SLR camera.

▷ **Backlit shots of windsurfers** work well as the sails are translucent, and so seem to glow with warmth. In this shot the backlighting has also created a bright pattern of highlights across the waves that works well as a backdrop to the silhouetted figure battling against the wind and surf.

▽ **Minority sports** such as land yachting rarely attract large numbers of spectators, allowing you almost a free choice as to where to stand to get the best pictures. However, to keep at a relatively safe distance, I used a 300mm shot for this shot. Using a shutter speed of 1/125sec I panned the camera during exposure to help blur the background and give an impression of speed.

◁ **A close-up shot of this rock climber** would have shown nothing of the hazards and attractions of this sport. Instead I used a shorter lens to show the whole rock face. The climber is reduced to a small spot on the frame, but this lends scale to the whole picture, showing just how far he could fall if it were not for his rope.

△ **Acrobatic skateboarders** will perform jumps at almost the same place on a specially constructed bowl. You can therefore use a wide-angle lens to capture them in mid-air. To help freeze the subject, and to increase contrast, in this shot I used a flashgun to provide fill-in lighting.

▽ **I took this shot of a water skier** from the speedboat itself. This allowed me to get a tightly cropped shot with a short telephoto lens. After watching him for some minutes, I realized that the best shots would be those when he traveled across the back of the boat, throwing spray into the air as he turned against the light.

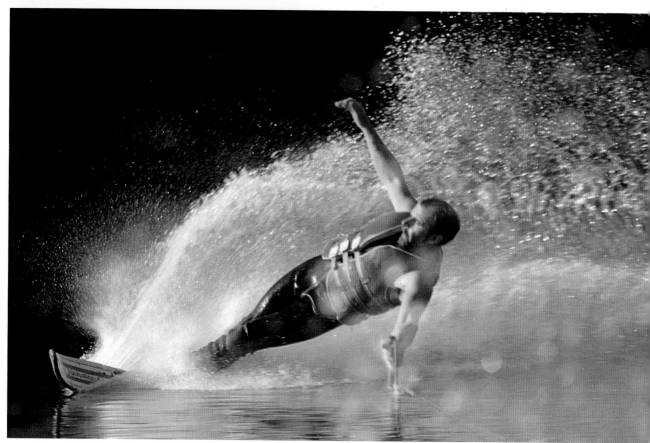

Snow sports

Skiing and other winter sports bring their own particular problems to the photographer. If you are not a competent skier, an accessible and safe place to stand on the mountain is a primary consideration. The cold weather, too, can be difficult. In constant sub-zero temperatures, the camera must be kept as warm as possible between shots to avoid the batteries packing up. To do this, keep it under your jacket and near your body. Exposure, as with any predominantly white scene, must be approached with caution because your pictures will tend to be underexposed unless you compensate for the highly reflective background (see pages 62 and 92).

One technique that is useful, as in many sports, is that of prefocussing. As the skiers follow a predetermined course it is possible to set up the composition and focussing of a shot before the subject even arrives. By focussing on a mound that the brave skier will jump, or on slalom gates that he or she will brush against, you can do much of the hard work in advance. You can then concentrate on waiting for the subject to fill the frame and on pressing the shutter at exactly the right moment.

△ **Large expanses of snow** tend to be rendered a muddy gray if you trust the camera's built-in exposure meter. To make sure that they appear white in your picture you need to compensate for this by overexposing your shots by one or two stops.

△ **If you are not a competent skier** then you have to make do with safe, flat shooting positions within easy walking distance of a ski lift. However, such positions do not have to lead to dull pictures. Here a beginners' class makes an interesting pattern against the snow as it struggles down the mountain.

▷ **When framing a moving subject** it is important to leave more space in front of the subject than behind it. This convention, which is known as "moving space" in film-making, makes the composition comfortable for the human eye to look at. Leave too little space in front of the subject, and the picture looks cramped and you lose some of the feeling of movement.

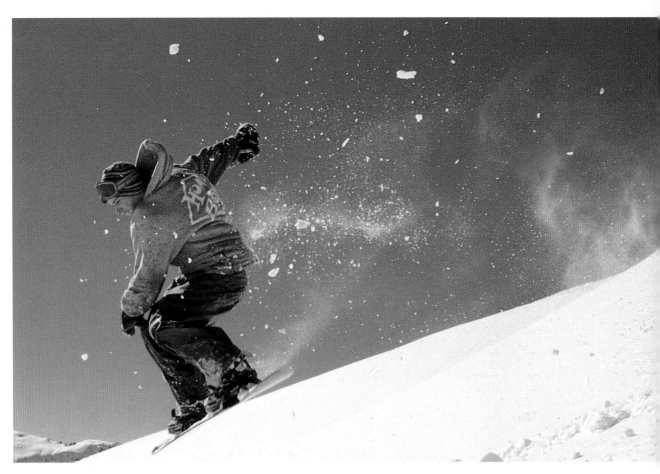

▽ △ **These two shots of snowboarders** were taken from the same position just below a man-made mound that skiers and surfers alike used to jump off. By prefocussing on a spot at a point in mid-air, I was able to concentrate on releasing the shutter at just the right moment to capture my subjects flying through the air.

I found that I needed to leave the composition fairly loose, as some of the surfers jumped higher and farther than the others. By using a low-angle viewpoint, I caught them against a deep-blue sky, and this allowed me to use a small aperture to make sure that everything was sharp with a shutter speed of 1/2000sec.

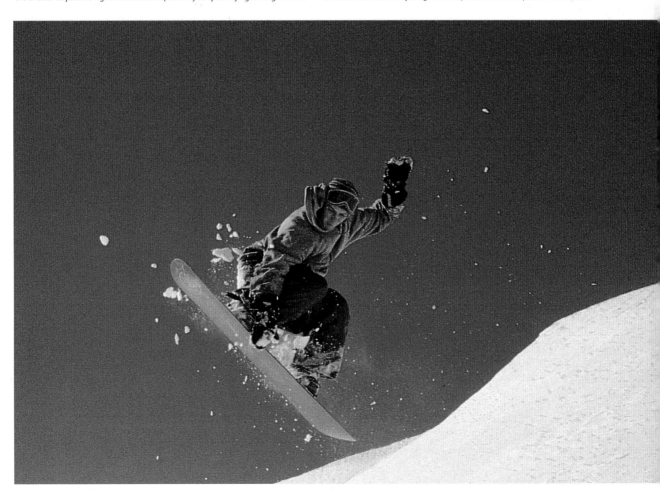

The photo essay 1

A photo essay is a collection of pictures that tells a story. It is an approach frequently used by magazines to give insight into an area, a person or a way of life. Although a photo essay is often accompanied by words, the pictures should not only stand on their own, but they must also go further than showing what is described by the text. To tackle a photo essay well you must explore all the possible shots to show the story.

Wide-angle panoramas must be mixed with detailed close-ups. Different pictures must evoke different moods, and the viewer must be given the chance to understand the characters and to see the landscape that they live in. A good photo essay may take months to shoot, as you find new pictures every time you return to the subject.

This photo essay was shot to show how reeds are still grown in the Norfolk Broads for use as a roofing material. The age-old craft of cutting the reeds has changed little over the centuries, and I wanted to provide an insight into this. In all I visited the reed beds three times, and ended up with several hundred pictures, which I then whittled down to a couple of dozen that would serve as my essay.

The main character in my photo essay is Eric Edwards, who cuts reeds for use by thatchers. It is important that with any such assignment you include as much human interest as you can. People like to see pictures of people, and to see the sort of life that they lead. The two shots on this page show the solitary nature of Eric's work, as well as the traditional practices that he uses.

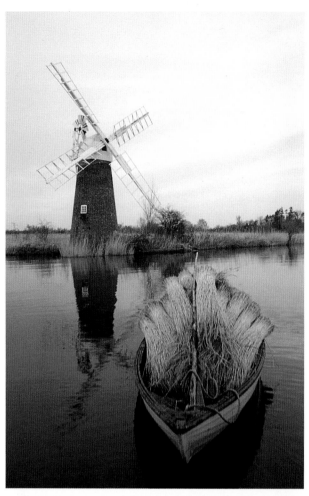

It is important to show pictures in context. In this case I wanted to use the landscape of the Broads as a backdrop as much as possible, showing the street-like layout of these man-made canals and the windmills. But also it was important to show the scale of things – the reeds are almost as tall as the reed-cutter himself. It is a lonely, laborious job, but perfect for someone who loves nature and solitude.

The photo essay 2

The reeds are not wild, but farmed in much the same way as any cereal crop. By showing the vast and uniform flood pastures where this harvest grew, I could show the similarity between cultivating reeds and growing wheat. However, the differences between the production methods are made obvious by the solitary figure reaping the crop.

To show the physical nature of the reed-cutter's work, I used a variety of different shot sizes. In some pictures, Eric Edwards appears as a small figure dwarfed by the reeds or the East Anglian landscape, in others you see his weathered face in close-up, sweating in the heat of his labors.

The photo essay 3

Although reeds are used for the outermost covering of thatched roofs, a second water-loving plant is also used as part of the process. Sedge is used as a lining material underneath the reeds – a crop that is also commercially grown on the Norfolk Broads. Eric Edwards also cuts this broader-leaved, shorter plant. The method of collection is much the same as for the reeds, with a wide-hulled punt being used to manoeuvre around the shallow waterways.

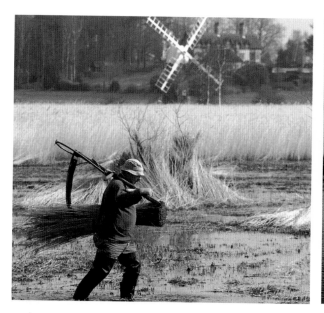

Just like any story, a photo essay should have a beginning, a middle and an end. I shot a variety of pictures to draw my essay on reed cutting to a close, and they are shown on this page. Shots showing the end of the working day were one possible ending, with the workman carting his heavy cutting tool home, and the bundles of reeds waiting for collection as the sun disappears over the horizon. An alternative was to demonstrate the cyclical nature of the crop – showing the reed beds being prepared in anticipation of the following year's harvest. However, perhaps the best final shot for this sequence was the one showing an old cottage being re-thatched. To re-roof such a building completely can require the use of several thousand bundles of reed.

Interpreting a theme

When you enter a photography competition or are given an assignment as part of a course, you are often provided with a specific subject or theme, but also with a great deal of latitude as to how you interpret it. Whether the topic, there will be an infinite number of ways to approach it. Start out by "brainstorming" – writing down as many words and situations as you can think of that represent the subject. You can then look at each idea in turn, and decide on the techniques you could use to illustrate it photographically. With all the options on paper, you can decide on which to shoot.

△ **The first of four ways to interpret the theme of music** – to shoot this accordion player, I chose a technique that would accentuate his shape. Finding a light-colored background, and exposing for the highlights, the outline of the bellows stands out well.

△ **For this shot of a French horn player** I chose again to emphasize the shape of the instrument. However, this time I did so through the background, echoing the pattern and outline of the horn by placing the player near a circular window.

▽ **I chose the simple technique of framing** to photograph this concert pianist. By using the grand piano to form the border of the shot, the viewer's eye is naturally drawn to the musician's face by the lines of the piano and the bright background.

△ **A wide-angle lens** and the careful choice of background has provided yet another means of interpretation. The classical architecture of the building mimics the style of music, while the ornate shape of the instrument is reflected in the wrought-iron balustrade behind the player.

Special situations

Special effects

Most photographers aim to portray a lifelike view of reality, but photography has the ability to give a more artistic interpretation of the world. In the 160-year history of the medium, a vast range of ingenious techniques and special effects has been discovered by people wishing to take their pictures beyond the purely representational.

There are many established practices and guidelines in photography that we follow with the aim of achieving the best possible results. However, there are no penalties for breaking these "rules" – and by flying in the face of convention photographers are continually discovering fascinating techniques for creating unusual images.

You can even buy cameras with special effect facilities built in. For example, cameras are usually designed to make it impossible for you accidentally to shoot more than one picture on a section of film. However, some models allow you to make double or multiple exposures, in which two or more different images are superimposed or juxtaposed. A different type of multiple exposure can be made by firing a flash several times at a static subject. Called "painting with light", this does not create an unusal image, but increases the effective power of a flashgun, or helps to cover a larger area with flash.

Keeping the camera still during exposure may be a fundamental rule of photography, but moving the camera as you shoot can also give interesting results – of which panning is just one example (see page 152). With a zoom lens you can change image magnification during a shot, producing blurred radial lines that emanate from the middle of the subject. These images are known as zoom bursts.

You can also alter your pictures when you process them (see page 192). For instance, fashion photographers often shoot onto color print film but develop it as though it were slide film, producing high-contrast pictures with strange-looking colors and skin tones.

Practice and experimentation are the keys to special effects photography – you should not expect a technique to work the first time you try it.

△ **Multiple exposure** – some cameras allow you to re-cock the shutter without advancing the film, allowing you to position several different shots on the same frame. A black background for each exposure helps to make the final image more convincing.

▷ **Zoom burst** – this abstract shot was taken by changing the focal length of a zoom lens during the exposure. I used a shutter speed of 1/4sec.

▽ **Double exposure** – two different shots have been exposed on the same frame: a close-up portrait and a close-up of a wall. For this effect, it is best to use a simple pattern for the background.

△ **Zoom burst** – this technique can give an explosive quality to an action picture. Here I used a 35–80mm lens on a 35mm SLR, and "zoomed out" during an exposure of 1/8sec.

▽ **Manipulated Polaroid** – Polaroid instant film starts to develop as soon as you fire the shutter. However, if you firmly draw on the back of the print with a blunt instrument before it has finished developing you can add interesting patterns – but you need to work quickly.

▷ **Distortion with mirrors** – curved mirrors produce distorted reflections. You can buy special mirrored plastic sheets that you can bend and twist to give a number of different effects to photograph.

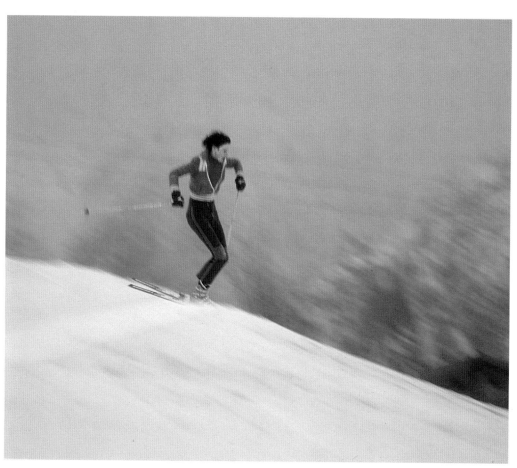

◁ **Panning** – in order to capture subjects that are crossing the frame quickly it is often useful to move the camera in the direction of movement as you fire the shutter. This allows you to use a slower than usual shutter speed, and has the added benefit of blurring the background and so giving an impression of speed in your picture.

▽ **Painting with light** – these arches in the Great Mosque in Cordoba, Spain, were lit insufficiently for a standard, long exposure. A single flash would have lit up only the foreground, so I used the camera's B setting for an exposure of one minute at f/22, during which time I fired the flash manually six times, pointing at different parts of the architecture.

Specialist lenses

The most common lenses used by photographers range from the wide-angle to the telephoto – and for the popular 35mm format SLR this usually means that focal length can vary from 24mm to 300mm. However, for some camera mounts a number of specialist lenses is also available, to increase the scope of your photography.

TYPES OF SPECIALIST LENS

Ultra-wide-angle lenses These have an angle of view of 90° or greater and are useful not only for wide panoramic images and shooting in confined spaces, but also for exaggerating perspective because they can keep everything from a few inches away to the horizon in focus at the same time. The shortest focal lengths available are known as fisheyes, because they form the image into a circle and give an angle of view of about 180°.

Super-telephoto lenses With an angle of view of less than 7°, these lenses are used for surveillance, astronomy, wildlife and sports photography. The maximum focal length available for the 35mm format is usually 1000mm. Some use a mirror, or catadiotropic, construction in which the length of the lens is kept short by bouncing the light off a series of mirrors in the lens. Such lenses are more

fragile than those of a traditional construction because the mirrors can become misaligned and produce ring-shaped out-of-focus highlights.

Macro lenses These are used to shoot objects at a much closer focussing distance than standard lenses, by extending the barrel between the main lens elements and the film. As a result, they can produce life-size images (see pages104–5).

Shift lenses These allow users of 35mm and medium-format cameras to perform limited camera movements, similar to those that are possible with large-format cameras. They usually consist of a wide-angle lens on a mount that can be racked to the left or right of center. You can rotate the mount through 90° to convert this to an upward or downward shift. The main use of these lenses is for correcting converging verticals when

shooting tall buildings from ground level. Sideways shift allows you to take a shot from the side so that it appears to have been taken head-on, and can be used to avoid a reflection of the camera appearing in a photograph showing a mirror. These lenses are also known as perspective control, or PC, lenses.

Fast lenses Such lenses, with extra-wide maximum apertures, are designed either for use in low light, or for applications in which depth of field must be severely restricted. The usual maximum aperture for a 400mm telephoto lens on a 35mm SLR is f/5.6, but the "fast" version could have a maximum aperture of f/2.8. These are used mostly by sports photographers to isolate a player against a backdrop of spectators. They are found in many focal lengths, and are much bigger, heavier and more expensive than standard prime (fixed focal length, or non-zoom) lenses.

△ **Shooting with a 50mm lens** on a 35mm SLR, the relative sizes of the trumpet and the boy look normal to the human eye.

▷ **With a 17mm ultra-wide-angle lens,** the trumpet's size is exaggerated, making it look much larger than it is in real life. This trick of perspective is possible because the lens allows you to focus on subjects that are just inches away while retaining tremendous depth of field.

△ **Shooting with a standard 28mm lens** and positioning the camera straight in front of the building results in the main door being obscured by the statue.

▷ **With a 28mm shift lens** the camera can be placed slightly to one side, and the image can be re-centered using the sideways shift control so that both the door and the statue are in full view.

△ **Shooting with a 28mm wide-angle lens,** on a 35mm SLR tilted at an angle to the building, has produced an image in which the sides of the structure converge.

◁ **With a 28mm shift lens,** a shot taken from the same position as the one above does not cause the vertical lines of the architecture to converge. The shift control allowed me to raise the front of the lens to include the top of the building without having to tilt the camera, and therefore the film plane remained parallel to the front of the building.

Using filters

Filters serve a multitude of purposes – from creating impressive special effects to subtly correcting colors to allow for color temperature. These pieces of glass or plastic, which fit over the front of the lens, can be used with all types of film, although some are specifically designed for either black and white or color photography.

There are two designs of filter, for attaching in two different ways. The "round" type screws into the front of the lens, while the "square" type slides into a special adaptor. The square design is ideal if you have a number of lenses with different sizes of filter thread.

Some filters are best used with color slide film, rather than color print film because the color effects they produce may be cancelled out by the filtration used at the printing stage. The following are some of the most common filters:

Color correction filters These are mainly for use with slide film, allowing you to correct for the color temperature of the light source when using either tungsten-balanced or daylight-balanced film. Some of these are warm-up filters, which make the image redder and are amber in color, while others are shades of blue (see the table on page 199).

Graduated filters One of the most useful type of filter for use in landscape photography, the graduated filter has a tint that fades to transparent half-way

across. These not only allow you to color the sky alone in a shot, but also to reduce the contrast between sky and foreground. Gray graduated filters are used to increase the saturation of the colors in your picture. Popular colors for graduated filters include blue, tobacco and yellow.

Starburst filters These turn highlights into pointed stars, with tails that can stretch across the whole frame, and are particularly useful when shooting cityscapes at night.

△ **A UV filter** can be useful in helping to reduce atmospheric haze when shooting panoramic landscapes. A skylight filter can also be used, but gives a warmer-looking result.

▷ **Polarizing filters** are commonly used for increasing color saturation. Not only do they strengthen the color of objects by reducing the number of reflections visible in the picture, but they also deepen the tones of the sky.

△ **A polarizing filter** is useful for reducing unwanted reflections in glass or water. The exact effect depends on the angle between the reflective surface and the camera, and also on the orientation of the filter.

Soft-focus filters These filters soften the definition of the entire picture, giving it a romantic or dreamlike appearance.

Color burst filters Used to diffract light, these filters produce a rainbow-colored pattern around any visible point of light in the scene.

Prism filters Available in many different designs, these filters multiply the subject either three, four, five or six times.

Neutral density or ND filters These filters cut down the overall amount of light reaching the lens, without affecting the color. They can be used when you require limited depth of field or slow shutter speeds but are unable to use the settings you want.

Polarizers One of the most versatile of filters, the polarizer cuts down reflections from water and glass, and can increase the saturation of the sky by reducing the amount of indirect light reaching the film. You can also use them as ND filters.

They must be rotated to the position that will give you the correct effect.

UV filters These cut down the amount of ultraviolet light reaching the lens, and are primarily designed for use at high altitudes and by the sea to reduce the blue light that can spoil pictures taken in these locations. UV filters can help to penetrate haze, too. Very similar is the "skylight" filter, which is amber-colored and corrects the blueness of haze.

Filters for black and white film These are made of a solid color, and are designed to increase contrast or to change tonal balance. A filter of a particular color will lighten tones of that color in your shot, but also strengthen hues of its complementary colors (see the table on page 198). For instance, a yellow filter lightens areas of yellow, orange and red, but particularly darkens blue areas. The most common colors of filter used are blue, green, yellow, orange and red.

△ **A center spot filter** is clear in the middle but has a colored surrounding halo. The subtlety of the effect you achieve depends on the focal length of the lens and the aperture setting.

△ **A binocular mask** gives an image that suggests you are spying on the subject at a distance. These masks, which are also known as "mattes" or "vignettes", are available in a number of shapes such as hearts, keyholes and ovals.

◁ **A graduated gray filter** darkens the top or bottom part of a picture without affecting its color, reducing the contrast between the sky and the foreground. Colored graduated filters can be used for increasing the dramatic quality of a sky – for instance, by making it more blue or more orange.

△ **Filters with a solid, uniform color** are primarily used for black and white shots, but can be employed with color film, such as here, where a yellow filter has given the impression of late afternoon.

△ **An orange filter** has given the appearance of a sunset here. The small amount of dark, featureless foreground, is largely unaffected by the color of the filter, which shows more in the light areas of the sky.

△ **A light blue filter** gives a more subtle effect to the black and white sky of the original scene. However, the use of filters has helped to emphasize the moody cloud formation in each of these three shots.

Digital image manipulation

More and more photographers are turning to computers to help them to achieve a perfect-looking picture. Special darkroom techniques, and retouching, have always required great skill and patience. With a reasonably powerful computer you can make alterations to your image in a moment – and keep changing it until you like the result.

Manipulating pictures with a computer is still a specialized skill. You can learn how to make changes quite easily, but it takes practice to achieve convincing results. Furthermore, you need a fairly powerful computer because a great deal of memory is required to heave large images around while they are being processed. The software is less prohibitive in price, however, and there is an ever-increasing choice for different computer platforms.

Computers have to a large extent replaced the airbrushes, scalpels and retouching inks in the worlds of design and publishing. Images are now digitized, modified, stored and transmitted every day, when once this was the preserve of specialists.

However, these developments signify more than simply the future of image retouching, with many amateur and professional photographers exploring the opportunities that computers offer as a tool for image creation.

More and more "professional" software uses terminology associated with photography: you can dodge and burn, sharpen and blur, add color filters, retouch (despeckle and reduce "noise" – unwanted grain) and change contrast. Creating the effect of multiple exposures, enhanced grain and solarization (the Sabattier effect) are all possible.

The advertising industry has been the driving force behind much of the demand for perfection in imagery, as models with perfect complexions and teeth, pure whites to their eyes and facial symmetry are in short supply.

As recently as the 1980s, the only economical way to alter or correct an image on film or paper was to do so systematically by hand. Today, image manipulation by computer is commonplace, and when carried out properly can be impossible to detect.

The equipment may be different, but it is still the art of photography that is being practised – an artistic eye and plenty of patience remain essential.

△ **This straight scan** is quite over-saturated and makes the scene look humid and smoggy, with poor foreground definition. It is not a good rendering of the original image, and has more inaccuracies than you would tolerate on a print or slide.

△ **Desaturating the colors** freshens up the image, and gives the impression of a shot taken in early morning. Improving contrast brings up some foreground detail. The dark areas have been emphasized, adding ominously to the raincloud.

△ **Pulling the color** towards the cooler end of the spectrum seems to change not only the time of day that this picture was taken but also the season, and to move the location from the Far East to a cooler climate.

△ **But why stop there?** Shifting the color balance still further can produce a fantasy image to convey mood rather than information. Here the sunset colors have been transformed to a cyan blue. New colors can be previewed in seconds.

△ **The original scan** shows the black and white print achieved with traditional darkroom methods.

△ **Lightening and increasing contrast** give the impression of a print made on a harder paper grade.

△ **The sharp focus** has been confined to the features, increasing the intensity of the subject's gaze.

△ **Reducing the number** of shades of grey, effectively produces a posterized image.

△ **Adding a grainy mask** to the picture lends character, but decreases eye contact.

△ **Coloring the image** helps to create mood or a sense of period. Toning in any color is possible.

△ **Simulating a printed duotone** is easy, with fairly true blacks and the midtones in shades of colour.

△ **Selectively coloring** produces very similar results to using traditional hand-coloring techniques.

△ **Selectively coloring** makes a picture within a picture, irresistably drawing the eye into the portrait.

WORKING WITH IMAGES

All the images on pages 174–7 were produced (very quickly) on a Power Macintosh 8100/100 with a color monitor capable of displaying millions of colours, and with 40MB of RAM, using Adobe Photoshop. The landscape was a 35mm transparency, while the portrait was a good black and white print. They were scanned in on a mid-range desktop scanner, but could have been digitized into PhotoCD format by a film processor. Although this is professional-level equipment, you cannot expect it to produce the image quality that you see every day in books and magazines. Such images are scanned (usually by a reprographic house or printer) at much higher resolutions, and color-corrected for the print process being used.

Advanced image manipulation

It used to be said that the camera never lies, but times have changed. With a computer and specialized image-retouching or image-painting software, a whole new world of possibilities opens up. You can correct faults, and enhance and combine images to create pictures limited only by the power of your imagination.

Computers are not only firmly established in the office and home but also in the photographer's studio. You will still be using film in your camera for many years to come, but these new tools, and the possibilities they offer, cannot be ignored. And once you begin to experiment with image-manipulation software, you will find it very hard to limit yourself merely to improving or correcting pictures.

Most retouching software started out with the basic necessary tools for adjusting brightness and contrast, color balance, spotting out dust and scratches and similar manipulations. However, software developers soon realized that

users were pushing their images to new limits, deliberately degrading them or creating fantasy-inspired pictures.

Add-on facilities for the software – known as filters – became common. Some perform a simple task such as intensifying color. Others add pattern and texture, or explore the boundaries between color areas.

Digital cameras (film-less cameras that capture an image in a computer-ready form) are also widely available. As with all emerging technologies, they are expensive – especially if you want to have good image resolution and the range of features that you would expect to find on a traditional SLR camera.

However, it is not necessary to obtain a digital camera in order to manipulate your images digitally. Many film processors will scan your pictures onto diskette or CD for you. A desktop scanner – the affordable version of the high-precision rotary scanners used by the reprographic and printing industries – allows you to capture images from transparency or paper. All the images shown here have been "scanned in" and manipulated on mid-range equipment.

Depending on the kind of work you want to do, it is possible to output your images back onto transparency, to print them from inkjet and laser printers, or to store them digitally for display on screen.

△ ▷ **The foreground was removed** from the shot above to create the picture on the right. The sky was copied and distorted to replace the water, and a wave filter was used to give an impression of broken reflections. Finally, a sun with lens flare was added.

△ ▷ **The sky was removed** from the shot above, together with the flapping coat tails and some of the rocks. A new sky was added, with two "cloned" clubs to make the juggler seem even more skilled. The mossy colors on the rocks, which detract slightly from the reds in the costume, were recolored. The dark shadow of the figure had cloned rocky texture combined with it to make it appear lighter.

▷ **The initial scan** (top left) provided the starting point in an exercise to show exactly what can be done with one picture and a computer. The petals were "repaired" by selecting and cloning small undamaged portions to rebuild the surface color. Blemishes were spotted out and subtle streaks painted in sample colors. Next, the petals, stamens and background were split onto three different layers, providing three separate elements that could be manipulated individually. The petals were first lightened and then converted to negative, to produce the strange-looking blue color. Each element was then modified using proprietary filters. Some allow degrees of change, while others offer a single option. Shadows beneath the petals were created by copying the petal shape to a new (fourth) layer above the background, filling the shape with transparent dark gray, and blurring or distorting it. The perspective tiling (third picture, bottom row) and the vortex (fourth picture, bottom row) were the instant creations of two common filters. The sphere was created with a mid-range 3D program, using the image to the left as a surface map and adding simple lighting effects.

Infra-red film

Infra-red film is primarily designed for scientific uses: foresters use it to spot trees from the air that are diseased, while armies use it to distinguish camouflage from real leaves. For photographers, these special films produce pictures with fantastic colors and tones – but as we cannot see infra-red light, the way they are used involves special techniques.

Infra-red (IR) film is sensitive to part of the electromagnetic spectrum that the human eye cannot see. It is also sensitive to the visible wavelengths of light and therefore these specialist films must be used with heavily-colored filters in order to achieve the most successful results.

Black and white infra-red film is made by several manufacturers, but in a limited number of formats. It needs to be loaded into the camera in total darkness, to prevent IR light from penetrating the felt (visible) light trap on the film canister. A number of color filters can be used, but for the best and most predictable results use a deep red filter (a Wratten 25 or equivalent). This gives the effect of deep black skies and the ethereal, snowy foliage that this film is known for producing in shots taken on sunny days.

Another quirk is that infra-red light is not focussed on the same plane as visible light, and therefore the human eye can not carry out the focussing. Instead you need to use the special infra-red marker found on most lens barrels and estimate the distance. A small aperture is recommended to avoid any inaccuracies.

Color infra-red transparency film is only made by Kodak, and is only available in the 35mm format. It uses the antiquated E4 processing chemistry, for which suitable laboratories are hard to find (see page 198). Focussing can be carried out in the usual way, but a small aperture is essential. The best filter to use is a dark yellow one.

The main characteristic of this film is that it depicts the world in strange colors: blue skies become cyan, foliage turns purple, red objects appear yellow, the iris of the eye becomes an eerie black and skin looks like wax – while black and white subjects remain black and white.

△ **Black and white infra-red film** gives foliage a ghostly white appearance. This shot was taken with a dark red filter, using an aperture of f/32.

▽ **Color infra-red film** completely transforms your picture-taking palette – but leaves black and white areas untouched. This shot was taken using a yellow filter (choose a Wratten 12 or equivalent).

Processing and printing

Setting up a darkroom

CHOOSING A SPACE

A spare room fitted with purpose-built work benches and which is permanently blacked out is the ideal starting point for good darkroom procedure. Here your equipment can remain undisturbed between processing sessions. However, for many, more makeshift arrangements are necessary, by making do with temporary use of a bathroom or kitchen. Surfaces and materials have to be cleared away at the end of each session, and equipment that can be packed away easily is therefore a distinct advantage.

THE ESSENTIAL REQUIREMENTS

To be suitable as a darkroom, a room must fulfil three essential requirements:

First, it must be possible to black it out effectively. Even a small amount of light creeping through the door frame could be enough to spoil unprocessed film and paper. Secondly, mains electricity is needed to power the enlarger and the safelight.

Ventilation to clear the fumes from the chemicals is the third necessity, especially as the lightproofing can block existing air flow.

A factor that is convenient, but not essential, is running water – for washing prints and films, and for disposing of chemicals. If this is not available, a bucket of water can be used as a stop-gap measure after processing, before the prints or films are removed to somewhere where they can be washed thoroughly.

Heating is also useful, as adequate temperature control for processing can be difficult if, say, you are using a garage in winter.

WET AND DRY

Whether permanent or temporary it is important to divide your darkroom into two distinct areas of activity. A dry area should be reserved for all work that does not involve the use of water or chemicals – such as selecting negatives, or exposing paper under the enlarger. The dry bench should be firm so that the enlarger does not vibrate during exposure.

The wet area is reserved for mixing and using chemicals. Black and white processing involves three steps: developing the image, stopping the action of the developer, and fixing the image so that the paper is insensitive to further light exposure. The three dishes needed for these steps should be arranged so that the fixer dish is next to the sink (or bucket). The safelight should be positioned above the developer dish.

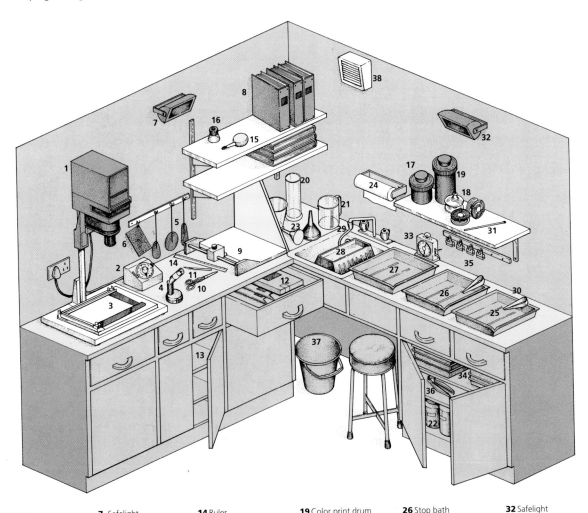

Dry area	**7** Safelight	**14** Ruler	**19** Color print drum	**26** Stop bath	**32** Safelight
1 Enlarger	**8** Negative files	**15** Blower brush	**20** Measuring cylinder	**27** Fixer dish	**33** Timer
2 Exposure timer	**9** Print trimmer	**16** Magnifier	**21** Measuring jug	**28** Print washer	**34** Large print dishes
3 Print easel	**10** Scissors		**22** Undiluted chemicals	**29** Rubber hose and	**35** Film clips
4 Focus magnifier	**11** Scalpel		**23** Funnels	water filter	**36** Squeegee
5 Dodgers	**12** Printing paper	**Wet area**	**24** Kitchen roll	**30** Print tongs	**37** Bucket
6 Burner	**13** Storage area	**17** Developing tank	**25** Developer dish	**31** Thermometer	**38** Extractor fan
		18 Film developing spirals			

Processing negatives

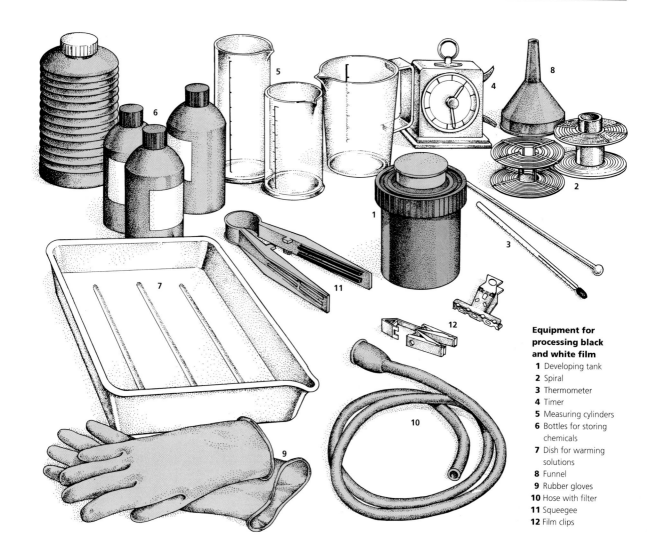

Equipment for processing black and white film
1 Developing tank
2 Spiral
3 Thermometer
4 Timer
5 Measuring cylinders
6 Bottles for storing chemicals
7 Dish for warming solutions
8 Funnel
9 Rubber gloves
10 Hose with filter
11 Squeegee
12 Film clips

BLACK AND WHITE PROCESSING

You can process your own films at home without a photographic darkroom. The only essential items of equipment (apart from the chemicals) are a thermometer and a daylight developing tank – a lightproof container with a lid specially designed so that liquids can be poured in and out of the tank without letting in any light.

Inside the tank is a spiral reel, which holds the film and allows the developer to circulate freely over its entire surface. The film must be loaded onto the spiral in total darkness, either in a room (or cupboard) that has been blacked out, or in a special light-tight changing bag. Once the tank has been closed, the processing can be carried out in ordinary light. Practise loading the spiral with waste film until you are confident of being able to carry out the whole operation smoothly in the dark. Note

that the spiral should be completely dry. Your thermometer should be accurate to 1°F (0.5°C). A few additional items are needed, although you may be able to improvise substitutes: a timer, measuring cylinders, warm water, a bottle opener, a funnel and a tray are the most important. Other accessories are shown above.

PREPARING THE EQUIPMENT

Although you can not watch the process of development as it takes place, you can control it by measuring time and temperature. Both these factors are essential for a successful outcome, and being exact with them will help you to achieve consistent results.

Black and white films are usually developed at 68°F (20°C). The development time for the film is given in the instruction sheets of the developer.

Chemicals are usually supplied in the form of a concentrated solution, or as

powdered crystals. The first step in processing, therefore, is to mix the chemicals to their working strengths as shown in the containers' instructions. Next, load the film in total darkness into the developing tank, as shown in the illustrations on pages 182–3.

I always soak the film in water at the development temperature and pour it away before adding the developer. This pre-wash assists even development, helps to remove air bubbles, and brings the film and tank up to the correct temperature. You should bring the working chemicals up to the required temperature by standing the containers in a bath of warm water. Only the temperature of the developer is critical. However, the temperature of the other two solutions – the stop bath and fixer – should be about the same temperature as the developer, as any sudden change in temperature can damage the film.

Developing the film

Pour the developer, which has previously been diluted to the correct working strength, into the tank as quickly as you can, and then start the timer.

Tap the tank gently on the table or worktop to release any air bubbles on the surface of the emulsion. If these are left on the film during development, they will form circles on the negatives

and it will be impossible to prevent them from appearing on your prints.

Pay careful attention to the manufacturer's instructions regarding agitation, a procedure that is necessary in order to bring fresh chemical regularly into contact with every area of the emulsion, and so to make sure that the development is even.

Some developing tanks are agitated by inverting the whole tank at periodic intervals (with the lid on!), while others have a rod that is twisted to rotate the spiral holding the film.

Start pouring the developer out of the tank about ten seconds before the end of the recommended development time because the film will continue to develop

1 In total darkness, open the cassette using a bottle opener and remove the film. Avoid touching the film surface with your fingers.

2 Cut off the tapered film leader with a pair of scissors, taking care to cut between the sprocket holes, since this facilitates loading onto the spiral.

3 Wind the entire length of film onto the spiral and place it in the developing tank. Close the lid of the tank. You can now turn on the light.

6 At the end of the development period, quickly pour the developer through a filter back into the bottle using a funnel.

7 Without opening the tank pour in the stop bath to halt development. After a minute or two empty the tank. The stop bath can be re-used.

8 Pour in the fixer. After the film has been in contact with the fixer for a few minutes, it will be safe to open the tank in the light.

△ **Stainless steel spirals** are loaded with film from the center, where a clip holds one end of the film.

△ **Plastic spirals** are loaded from the outside by twisting each side alternately. They must be completely dry, or the film will stick to the grooves.

until the next chemical is added. It is possible to re-use some developers, in which case it should be poured into a storage bottle – preferably a consettina-type, from which the air can be removed to stop oxidization. Take care to mark the bottle with the number of times the developer has been used, and when. No developer can be used for an unlimited number of times

Processing solutions should not be poured neat down the sink when they have been exhausted. Always read the manufacturer's instructions about diluting the chemicals before they are disposed of.

The next solution you use in processing is the stop bath. This is a weak acidic solution that neutralizes the alkaline developer and therefore halts any further development. At the same time, it serves to prevent the developer from contaminating the fixer, which is acidic. You can, if necessary, rinse the film in water instead of using a stop bath, but it is not recommended.

The final chemical stage of processing fixes the image and stabilizes the film so that it can be safely exposed to light. Once fixing is completed you can take the tank apart and have a look at your film, but do not remove it from the spiral. You must first wash the film for at least half an hour. This is an essential part of the process because it removes the unused silver compounds and any trace of chemicals. A film that has not been properly washed will deteriorate with time, leaving stains that will make the negatives almost impossible to print at a later date.

It is a good investment to buy a special hose with a built-in filter for the washing process to ensure a continuous circulation of fresh water. One end of this hose attaches to the tap and the other is inserted into the centre of the spiral as it sits at the bottom of the lidless processing tank.

When the film has been washed it must be hung up to dry. A few drops of wetting agent (a weak detergent) added to the final rinse helps the film to drain evenly, and prevents the appearance of irritating drying marks (natural salts and minerals that are deposited on the film as the water evaporates).

Wipe off the excess water with a special squeegee or with your fingers, but do this very gently because it is extremely easy to damage the emulsion at this stage.

Hang up the processed film to dry in a dust-free area (drying cabinets can be bought for this purpose). Specially-designed, weighted clips attached to the top and bottom of the film will prevent it curling as it dries (clothes pegs make a thrifty alternative).

When the film is completely dry you can begin to print your black and white photographs.

4 Bring the developer to the correct temperature, within the required limits of accuracy. Pour it through the opening in the light-tight lid and start the timer.

5 Lightly tap the tank on the bench to remove air bubbles. During development agitate the tank as recommended by the developer's manufacturer.

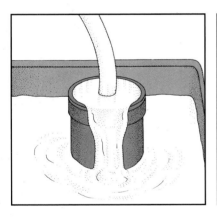

9 Complete the fixing process according to the manufacturer's instructions and then wash the film in running water for at least 30 minutes.

10 Drain off the water and unwind the film from the spiral. Remove excess water carefully with a squeegee and hang up the film to dry in a dust-free area.

△ **Roll-film**, such as 120 film, must be separated from its backing paper before it can be loaded.

SHEET FILM

Sheet film is sometimes processed in dishes in the same way as photographic paper. However, it is more convenient for each sheet to be clipped onto a hanger as illustrated and immersed in a deep tank full of solution, maintained at the correct temperature. A separate tank, or partition, is used for each solution. The whole processing sequence must be carried out in total darkness.

Making a contact print

△ **A contact printer** consists of a sheet of glass hinged to a baseboard on which you place the printing paper, and ridges that hold the negative strips in place.

THE CHEMICALS

In the wet area of the darkroom, set out three mixing beakers and three plastic trays for each of the three chemicals: the developer, the stop bath and the fixer.
1 Dilute the chemicals to the correct strengths.
2 Stand the beakers in warm water to bring them to the recommended temperature – usually 68°F (20°C).
3 Pour the solutions into their respective trays. (You can economize by using trays only slightly larger than the paper.)

It is useful to make contact prints – which are the same size as the negatives – for every roll of film that you develop. A roll of 36-exposure 35mm film, cut into six sections, can be printed onto one sheet of photographic paper measuring 10 x 8 inches (25.4 x 20.3cm). These sheets allow you to keep positive images of all your photographs filed alongside the corresponding negatives, and provide you with an easy reference for making enlargements at a later date. Seeing the images side by side also allows you to make careful comparisons between similar pictures, which would be more difficult to make if you were looking at the negatives alone. The best negatives can then be selected for enlargement.

A commercially made contact printer is little more than a sheet of glass hinged to a baseboard on which you place the printing paper. You can easily improvise your own by using a piece of clean,

unscratched glass and a firm surface such as the baseboard of an enlarger.

It is not even necessary to use the enlarger as the light source. The darkroom's ordinary lighting can be switched on for the exposure, or the negatives can be laid on a light box that is normally used for viewing slides. The correct exposure must be found with experience or by making a test strip (see page 186), but you could try ten seconds as a starting-off point.

You must make sure that the emulsion sides of the film and paper are in close contact. The emulsion side of film is matt, and is on the concave side of the film's natural curl. The emulsion side of the paper is shiny. A medium-contrast grade of paper is best, such as grade 2 or 3. Resin-coated papers are much more convenient than bromide ones because they need only about five minutes' washing, instead of at least half an hour.

1 Position the negatives under the ridges in the contact printer's lid, with the shiny side of the film touching the glass. Make sure that the frame numbers are visible for easy identification later.

2 With the safelight on, place a sheet of printing paper, with its emulsion side facing up on the baseboard. Make sure that the contact between the negatives and the paper is good, then close the lid.

3 Turn on the enlarger light, or the darkroom's ordinary light source, to expose the paper. The exposure time should be about 10–20 seconds. Turn off the light and take out the paper.

4 Tilt the developer tray and quickly slide in the print while laying the tray down, so that the developer makes contact with the whole area of the print as quickly as possible.

◁ **Part of a contact print** showing a series of medium-format pictures. A good contact print serves a number of purposes. First, it shows your pictures in positive form for the first time – allowing you to see quickly which pictures look the most promising. It should also tell you about the contrast of the negative and the exposure – which will help to save you time when printing. Finally, the contact print is a lasting quick-reference record that you can store with the appropriate sheet of negatives for future use. You can write notes about exposure times and other information on the contact sheet.

5 When the print is fully developed, lift it out of the solution with a pair of tongs, letting the excess fluid drain back, and then transfer the print as quickly as you can to the stop bath.

6 After 20 seconds use the second set of tongs to transfer the print to the fixer. Leave the print for the recommended time. Agitate the fixer for 20 seconds by gently raising and lowering the sides of the dish.

7 Wash the print thoroughly in running water and then carefully wipe off any water left on it with a squeegee. Dry the print in a warm place before assessing the results.

Making an enlargement

The key to a good print is a good negative – in other words, one that has medium contrast, a range of tones, and some detail in both the shadow areas and the highlights. The most satisfying aspect of making your own enlargements is that it gives you the chance to bring out the best features of your negatives. You can dictate both the size and the shape of the print, and exercise considerable control over its tonal quality.

A black and white enlarger is a relatively simple device that projects light from behind the negative and focusses the image onto a sheet of sensitized paper. Enlargers vary in their versatility and cost. The only essential requirements are solidity, a lens that produces a sharp image, and a column height that allows you to make prints up to the sizes you require. Try to find an enlarger that takes several negative carriers, to allow for all the negative sizes you may use, as well as

a filter tray, for use with variable contrast paper (see also page 191). An automatic exposure timer is useful, too.

As with film processing, you need to be methodical to avoid errors and to achieve predictable, repeatable results. First, assemble the following equipment: your negatives and contact prints, a notebook and pencil, a pair of scissors, a blower brush (or soft watercolor brush), and a box of printing paper. Prepare the wet area with the materials used for contact printing (see page 184).

HOW TO ENLARGE A NEGATIVE

1 Remove the negative carrier, open it and, holding the film by its edges, position a negative over the carrier window with the emulsion (matt) side facing down. If you find the frame is not centered when you close the carrier reopen it because you can damage the film by tugging it with the carrier closed.

2 Open the lens aperture fully.
3 Remove the red filter from the lens, switch on the enlarger's light and turn off the darkroom light.
4 Hold the carrier under the beam and gently remove any dust with the brush.
5 Insert the carrier into the enlarger, turn on the safelight and adjust the height of the head until the image projected is the size you want. To help you, place a piece of white paper that is the right size on the baseboard, or use a printing easel.
6 Focus the lens until you can see the grain clearly. Again, use a piece of paper or an easel to help you do this.
7 Stop down the enlarger lens by at least two stops – to about f/8. This will produce better quality results from the lens, and give you greater depth of field (in case the paper or the negative is not completely flat, or they are not parallel). The smaller aperture will also necessitate a longer printing time,

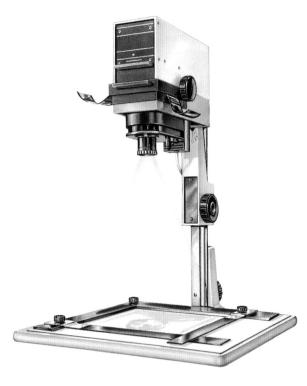

△ **The enlarger head** carries the light source – often an opal lamp with a mirror that absorbs heat and reflects light through two condenser lenses to the negative. Diffusion enlargers give softer and less contrasty light, but the condenser type is more usual, giving sharp, lively prints. Head height is adjusted by a winding knob. The negative carrier fits in the enlarger head, and is designed for only one size of negative. Open carriers are

preferable to glass ones, as there are fewer surfaces to clean. Below this is the lens, which has an aperture ring but no shutter. The aperture is stopped down in a series of click settings, each halving the brightness of the previous one. A red filter placed above or below the lens provides a safelight for viewing the image without exposing the paper. The baseboard often features an easel for keeping the paper flat, or for adding white borders to the print.

MAKING A TEST STRIP

With the red safety filter over the enlarger beam, carefully position a strip of printing paper across the projected image, making sure that the strip is covering a representative range of tones.

If the image includes people, the skin tones are the best ones to test because if the skin tones are well reproduced, the picture as a whole will look right to the viewer, even if other tonal values are not completely accurate.

Cover four-fifths of the width of the strip with a

piece of card and remove the filter to start the exposure. After 10 seconds move the card a fifth of the way across the strip. Move it again after another 10 seconds, and then after a further 10. Move it a fourth time, after 5 seconds. Finally, remove the card completely for a 5-second exposure, then turn off the enlarger (or replace the red filter). The result will be four bands on the strip representing exposure times of 40, 30, 20, 10 and 5 seconds. Develop the strip as described above.

making slight timing errors less critical.

8 Turn off the enlarger and, by safelight only, take a sheet of printing paper from the box and cut off a strip at least an inch wide. Replace the unused piece of paper in the box and close the lid.

9 Make a test strip as described opposite.

10 Use the test strip to gauge not only the exposure time but also whether you need a different grade of paper. If you choose another grade it may be necessary to expose a new test strip. At f/8 a reasonable exposure time is 10–20 seconds. If the test strip suggests a shorter printing time use a smaller aperture and re-do the test strip.

11 With the red filter in place, turn on the enlarger. Take a sheet of paper from the box and close it securely. Place the paper on the baseboard or easel, using the red image from the enlarger to make sure that the paper is exactly where you want it. Turn off the enlarger. Remove the filter and expose the paper to the projected image for the required time.

12 Process the paper in the same way as your contact prints (see pages 184–5).

△ **When printing your enlargements,** you must adopt a meticulous approach. The print will display a full range of tones only if kept in the developer for the recommended time and at the correct temperature. Errors should be corrected by changing the exposure of the print, not the development time. The sequence above shows the effect of stopping development at different stages. Only the fourth example displays the qualities of a fully developed print – the others appear too light. After development, the print is put through a stop bath and fixer, as with contact prints.

◁ **A good print** has a well-defined tonal range, with solid blacks and clear whites. There should be a continuous range of tones, sharp definition, and little apparent grain. The exact amount of exposure under the enlarger and the choice of paper (in other words, the level of contrast) can be a matter of personal taste, but the development time must always be constant.

Dodging and burning

When you are assessing a negative, choosing a suitable grade of paper and determining the right exposure by making a test strip, you will naturally work on the basis of the density and contrast range of the negative as a whole. You may find that to produce an acceptable-looking print you have to ignore areas of the negative that represent extremes of brightness or shadow. Some areas of the print will be pure white or jet black, and reveal no detail at all, even if you know that these areas showed some detail when you took the shot.

In order to bring out detail in areas of extreme light and dark, which cannot be accommodated by the contrast range of the printing paper, it is necessary to give these areas either more or less exposure than the rest.

Therefore, an enlargement may require a basic exposure of, say, 15 seconds, but need 25 seconds in the highlights, or only 8 seconds in the

shadows. You can either estimate the corrections, or make separate test prints.

The technique used to give briefer exposure to a selected area is known as "dodging" or "shading". To do this you simply mask the chosen portion of the image during the exposure time. "Burning in" works in the opposite way. Instead of holding back part of the image, you give it additional exposure by masking the rest of the picture.

When dodging or burning in, it is essential to keep the shading device moving slightly, in order to avoid a hard edge from appearing around the area you are masking. The mask should also be held about half way between the lens and the paper so that the edges of the shadow it casts are slightly blurred.

For complex areas, you will need to make a custom mask by projecting the negative onto a piece of stiff black card and then drawing around the outline of the shape you need. Cut out the shape, making it slightly smaller than the

original outline. If it is a small, attach it to a piece of wire with black tape.

As a final twist, when using variable contrast paper you can effectively change the grade of paper for selected areas of the print. If an area is too contrasty, for instance, you can hold this back during normal exposure and then burn it in later with the filtration for a softer grade of paper (see also page 191).

△ **When the areas to be** dodged or burned in are simple you can use your hands. Otherwise you should use ready-made masks such as those shown above. For complicated shapes you should make a specific mask for the job.

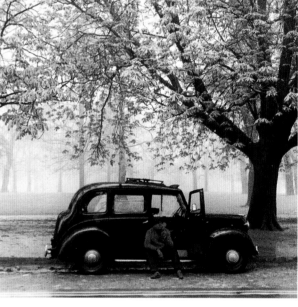

△ **The highlights in this portrait** are too light, losing detail and texture. A longer exposure would have made the shadow areas too dark. To make the print on the opposite page, I used a card with a specially shaped hole to burn in the highlights – holding the mask between the paper and the enlarger lens.

△ **The taxi driver** above is barely visible against his car, while the trees in the background are correctly printed. For the final print, shown opposite, I used a simple circular mask to shade the area of the taxi during the latter part of the exposure, in order to restore some of the missing detail.

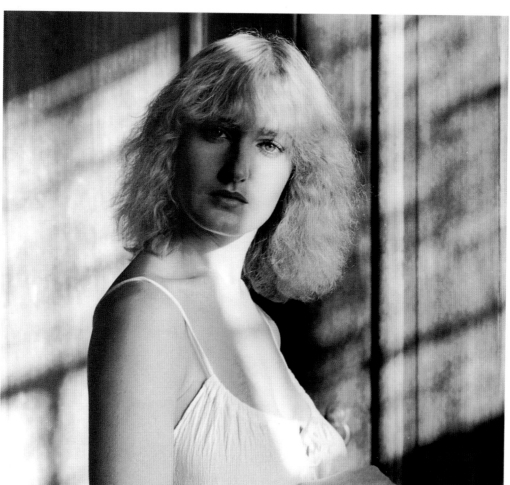

◁ **The whole print** was given an exposure of 20 seconds, and then the right-hand, highlighted, side of the girl's face was given a further 12 seconds' exposure using the mask shown in the diagram on the opposite page.

▽ **The exposure time** needed for the trees in the background was 20 seconds. However, to see the taxi driver clearly, this section of the image needed just 10 seconds. Therefore I exposed the whole image for 10 seconds, and then gave it a further 10 seconds while masking the central part of the taxi using the dodger shown in the illustration on the opposite page.

Controlling the print

Apart from the satisfaction of making your own prints, the principal attraction of home processing is the degree of control you have over the style and presentation of your pictures. Changing the grade of paper, dodging and burning are only a few of the techniques you can employ for achieving the effect you want. The following are three further techniques that you can add to your creative armoury.

CONTROLLING PERSPECTIVE

You can modify the perspective of an image at the enlarging stage by tilting the paper so that the negative is projected obliquely across the paper. This enables you partly to correct the converging verticals that occur when a camera is tilted upwards. However, you are likely to cause large areas of your picture to be out of focus. You can avoid this to a certain extent by using the smallest aperture possible on your enlarger's lens, but in practice you may find that you cannot correct the distortion as much as you would like.

The effect can also be used for other types of picture, adding distortion where there was none in the original image. You can even bend the paper under the enlarger to give pictures that look like a reflection in a fairground mirror.

VIGNETTING

A vignetted photograph is one that has been printed in such a way that the subject fades into either a black or a white surround, giving the picture an old-fashioned air. The technique is particularly well suited to portraits.

A vignette is made by using a circular or oval mask. For a white surround use a mask with a hole in the middle to hold back the edges of the image while printing. To create black edges, enlarge the negative in the usual way, then turn off the enlarger and remove the negative. Holding a piece of card mounted on wire so that the shadow falls over the central area of the print, turn on the enlarger for a further 15–20 seconds to fog the border. If you want the boundary of the image to be very diffuse, keep the mask moving during the exposure; otherwise, hold it still. For a completely sharp edge, place the mask flat on the paper during exposure.

△ **The grain** in this picture as been deliberately exaggerated by enlarging a small part of the negative onto a high-contrast piece of paper (grade 5).

◁ **To create this vignette** with a white border I exposed the paper through a cardboard mask with a circular hole. The mask was held half-way between the lens and the photographic paper so that the edges of the picture would appear indistinct – instead the image gradually becomes white at the edges.

◁ ▽ **Changing the grade of paper** that you are using is one of the simplest ways of change the contrast of your picture. For the shot below, I used grade 2 paper, but this has produced a flat, gray print in which it is hard to identify the main elements distinctly. Simply by switching to grade 4 paper for the shot on the left, the reasonable contrast range has been restored to the picture, with a full range of tones visible between the highlights and the shadows. With multi-grade (variable contrast) paper, you have no need for several boxes of paper. To change the paper grade, you simply place a different filter under the enlarger.

ACCENTUATING GRAIN

Grain is usually regarded as a picture fault because it degrades the definition and distracts the eye. However, some subjects are improved by a strong, grainy texture. The atmosphere of the shot on the right, for instance, is enhanced by the large clumps of grain that make up the image. Exaggerating the grain simply involves reversing all the established rules intended to keep grain to a minimum. In other words, use the fastest possible film and uprate it, setting the camera to a higher speed than usually advised by the manufacturer. Use a longer development time than recommended to compensate for this, and print on hard, glossy paper.

A safer method of accentuating grain is to enlarge only a small part of the negative. Some enlargers can be tilted at right angles to project huge-scale images onto the wall; on others, the enlarger head may have to be turned back-to-front on the central column to enable you to project an enormous image onto the floor.

Darkroom effects

Just as there is a variety of special effects that you can use when shooting a photograph, there is also a range that you can employ later, in the darkroom, to make your picture look remarkable.

For the simplest, you do not need a negative, or even a camera. A piece of photographic paper reacts to light in the same way as a piece of film. By placing objects on the paper and exposing them under the enlarger you can create silhouetted shapes, called photograms.

Other effects involve breaking the traditional rules of the darkroom. For example, by switching on the light part of the way through the development of a print – in other words, by purposefully fogging the film – some of the image appears to be negative.

◁ **The Sabattier effect** was used to create this solarized picture. The technique involves printing the negative onto high-contrast photographic paper in the usual way, but turning on the main darkroom light for a short time half way through development. The result is a print that is part negative, part positive. The effect is difficult to predict, and it may take a great deal of paper to discover the correct exposure times to achieve exactly the desired result.

◁ **I made this standard photogram** by placing my hand on a piece of photographic paper under the enlarger. I switched on the enlarger lamp for a few seconds and then developed and fixed the paper in the usual way. Even more intricate results are possible using translucent subjects, such as leaves.

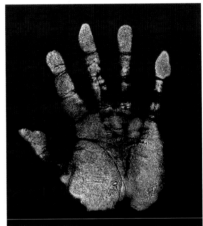

◁ **For this variation on a photogram** I wetted my palm with fixer and pressed it down onto a piece of photographic paper. When I had placed the paper in the developer dish I switched on the main darkroom light. I took the print out of the developer tray and put it in the fixer as soon as the background reached a deep black tone. The print was then fixed and washed in the usual way.

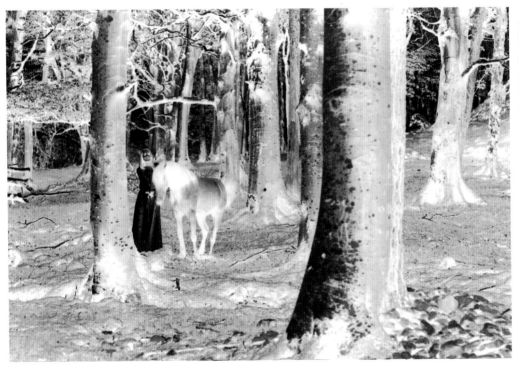

◁ **This negative effect** was achieved by printing a black and white transparency onto standard photographic paper. Color slides can also be printed in this way to achieve similarly eerie results.

Technical guide

Identifying faults

△ Fault: Subject blurred
Cause: Incorrect focussing
Remedy: Pay careful attention to focussing before shooting, by checking the focus in the viewfinder of the SLR. In low light, you may be better off using the focussing distance scale on the lens barrel if the viewfinder becomes too dim. Also, check that the subject is not closer than the lens's minimum focussing distance. A smaller aperture will make it easier to focus, as more depth of field gives a greater margin for error.

1/30sec with a 28mm lens. It may be necessary to use a faster film to enable you to use these shutter speeds. When shooting, take a firm stance, hold your breath at the moment of releasing the shutter, and squeeze the trigger gently.

Fault: Subject blurred, other parts of picture sharp
Cause: Subject movement
Remedy: Use a faster shutter speed for moving subjects. The exact shutter speed needed will depend on the direction of movement, its speed, and its size in the viewfinder (see the table on page 199 for recommendations).

Fault: Hazy, soft-focus image
Cause: Grease, dust or condensation on lens
Remedy: Clean the lens thoroughly with a special cloth or tissue. When entering a warm, moist atmosphere from a cold one, wait for the camera to warm up, and for condensation to clear.

△ Fault: Whole image blurred
Cause: Camera shake
Remedy: Use a faster shutter speed that is at least equal to the reciprocal of the focal length used. For example, use 1/250sec for a 200mm lens setting, or

△ Fault: Dark streaks on negatives, or light streaks on slides
Cause: Fogging of the film by stray light

before or after exposure, but before development. This may be caused by a non-lightproof join between the camera body and the film back, or by a light leak in the cassette. It can also result from accidentally opening the camera back.
Remedy: Have the camera serviced to ensure that it is light-tight, or make sure that you load the film in the shade. Check that the film has been rewound before opening the camera back.

△ Fault: Overlapping images
Cause: Double exposure due to faulty film advance, or the accidental re-use of a previously exposed film
Remedy: Have the camera repaired, or ensure that used films are clearly marked as such as soon as they are removed from the camera.

Fault: Negative completely clear, or transparency completely black
Cause: Film not exposed
Remedy: Check that the film is loaded correctly before closing the camera back. Check the film advance indicators to see if the film is moving correctly through the camera. Make sure that the lens cap is removed, particularly when using rangefinder and compact cameras.

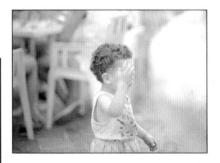

△ Fault: Negative is too dark, or slide is too light
Cause: Overexposure
Remedy: Overexposure occurs when too much light reaches the film, due to an incorrect shutter speed/aperture

combination, or to setting the wrong film speed on the camera or meter. Overexposed results from a wide variety of situations may mean that the camera (or meter) needs to be repaired. Alternatively, remember the situations where your meter fails, and compensate accordingly by reducing overall exposure.

△ **Fault:** Overall orange cast to shot
Cause: Using a daylight color film in tungsten lighting (that is, in light from an electric bulb.
Remedy: Use a special, blue-colored correction filter on the lens to correct the color balance. Alternatively, the flashgun may not have fired, possibly because it had not fully recharged when the trigger was pressed. Special tungsten-balanced slide film is available for regular shooting in these lighting conditions.

Fault: Overall blue cast to shot
Cause: Using a film balanced for tungsten lighting in daylight conditions
Remedy: Use a daylight film, or an appropriate orange-colored filter. Note that flashguns are balanced for daylight film, so can not be used with tungsten film without having a filter or gel attached to the flashgun's diffuser.

Fault: Overall green cast to shot
Cause: Using a daylight-balanced film under fluorescent striplights
Remedy: Use a special purple-tinted color correction filter over the lens.

Fault: Red eyes in shots taken with flash
Cause: Light reflecting off blood vessels in the eyes because the angle between the flash and the lens is too narrow.
Remedy: The simplest answer is to increase the angle between the flash and the lens. If the camera has a detachable flashgun, put it on a bracket to the side of the camera, or hold it at arm's length. With built-in flashguns, the solution is to move closer to the subject, using a wider-angled lens if necessary. Some cameras have a red-eye reduction system that forces the subject's pupils to contract, thereby minimizing "red-eye" effect.

△ **Fault:** Negative is too light, or slide is too dark
Cause: Underexposure
Remedy: As with overexposure, this can be caused by setting the wrong aperture/shutter speed combination, or setting the wrong film speed on the camera. If underexposed results are found in a wide variety of situations, the camera (or meter) may need to be repaired. Otherwise, remember the situations where your meter fails, and compensate accordingly by increasing overall exposure.

△ **Fault:** Only part of last picture on roll is exposed correctly
Cause: Trying to squeeze too many pictures out of the roll of film
Remedy: It is tempting to try to get 37 pictures out of a 36-exposure roll of film, but this can result in just 36½ shots. The ruined shot will often be unimportant, but one day it will be essential. Do not gamble, rewind the film as soon as the last paid-for shot has been taken.

Fault: Picture very underexposed except for a band at one side or in the centre of the frame
Cause: Use of the wrong shutter speed with an electronic flash unit
Remedy: Use the flash synchronization speed, or a slower speed, when taking photographs with flash. On some cameras, this shutter speed is marked with an "X".

△ **Fault:** Irregular blotches of color, or low contrast, on negatives or slides
Cause: Incorrect processing, caused by uneven development or fogging
Remedy: When home processing, make sure that air bubbles do not form on the film's surface during development, by agitating the tank as soon as the developer is inside, and by tapping it on the workbench. Agitate the tank at regular intervals, as instructed by the manufacturer. Check that the darkroom and tank are lightproof, and do not remove the film until it is properly fixed.

Setting up a studio

CHOOSING A SPACE

A studio vastly increases the scope of your photography by giving you an area in which you have total control over lighting and background. It is easy, and not expensive, to improvise a studio in your home – almost any reasonably spacious room is suitable, especially if it has a large window or skylight to provide a source of natural light.

THE ESSENTIAL REQUIREMENTS

The floor should preferably be made from a hard and easy-to-clean material such as hardwood or tile. It should be non-reflective and is best not covered with carpets, since they hold dust.

A hard, smooth floor is necessary to provide a firm surface for tripods and lighting stands, as well as to allow a model to stand on background paper without creating ugly crinkles.

As well as being suitable for picture sessions, the studio provides a useful working area for preparing subjects, backgrounds and props, for storing materials and equipment, and for displaying or projecting pictures.

The walls and ceiling should be painted matt, and ideally one wall should be white and another dark gray or black. The white wall can be used to reflect light into areas of shadow, and the dark wall to prevent stray light from finding its way into the shadows. Black, dark gray or white walls and ceilings are desirable because they do not give a color cast to reflected light, which is also exaggerated by color film.

Most of the space available should be kept clear for the set – the area in which you will place and photograph your subjects. It should be close to the room's source of natural light.

The set area should extend at least 10 feet (3m) in front of the background, to allow you to use a variety of lighting equipment and to give you the maximum freedom of movement to shoot subjects from different angles.

Rolls of colored paper or material are useful for providing a range of settings. They can be hung from special roller racks, or pinned to the wall itself. You can also achieve exciting effects by throwing colored light onto the plain walls with a slide projector, which can provide you with an endless variety of backgrounds.

To use a telephoto lens, which is more flattering for portrait photography, you will need a larger area of working space than when using a standard lens. To employ a 135mm lens with 35mm film for a full figure shot, the camera to subject distance needs to be over 20 feet (6m) – in other words, more than twice the distance required for a 50mm lens. An additional space of a few feet is needed behind the subject in order to avoid unwanted light spilling onto the background.

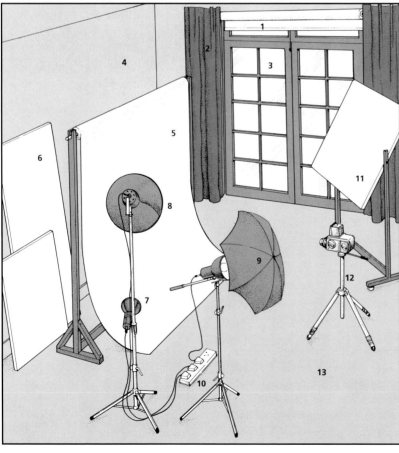

1 Diffusing blind	**5** Paper roll	**9** Umbrella reflector	**13** Non-slip floor	**17** Extension cable	**21** Camera equipment	
2 Lightproof drapes	**6** Reflectors	**10** Extension sockets	**14** Trolley	**18** Storage space	**22** Negative/slide files	
3 Large window	**7** Auxiliary spotlight	**11** Reflector	**15** Filters and lenses	**19** Work surface	**23** Reflector bowls	
4 Gray wall	**8** Photoflood	**12** Tripod	**16** Lens cleaners	**20** Storage hooks	**24** Snoot	

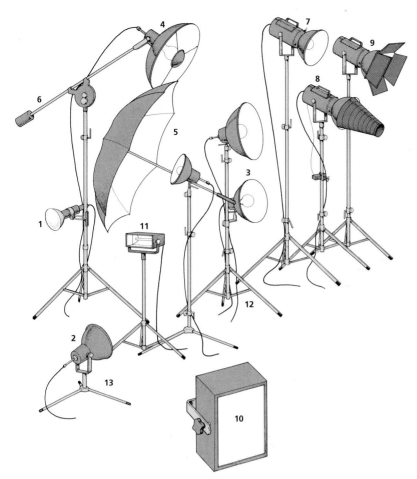

1 A simple photoflood bulb gives hard light, although some spills onto walls and acts as fill-in

2 A small, deep reflector bowl helps to direct light, which can then be aimed more accurately but still gives hard shadows

3 Large, shallow reflector bowls provide a slightly softer lighting effect

4 A large reflector is fitted with a small shield that blocks direct light from the bulb, so that the unit provides diffused illumination

5 A brolly reflector gives bounced light with a very soft quality

6 A boom arm lighting stand helps when positioning a unit by directing its light accurately

7 A studio flash unit provides more light than a tungsten bulb and can be used with daylight-balanced color film. It may incorporate a modelling light, used during the setting up of a shot.

8 A slave flash unit is fired by a light-sensitive cell triggered by the main flash. This example is fitted with a snoot, which channels the light into a narrow beam

9 Barn doors limit the beam of light at its sides

10 Fluorescent tubes in a light box can be used if they are specially balanced for daylight

11 Tungsten halogen lamps have longer lives than conventional tungsten lamps, and their color is more stable

12 A lighting stand allows you to adjust the height of a lamp quickly

13 A short lighting stand, or adapted table-top tripod, can be useful for low-angle lighting

It helps to have plenty of electrical power points in the studio, which will give you greater flexibility when arranging lighting equipment. You will also need good heating and ventilation so that you and your models can work in comfortable conditions.

STUDIO LIGHTING

When you have created the basic set-up for your studio, your next priority is to light it. Natural daylight plays a vital role in a studio lighting scheme, either as the main light, or as fill-in light for the shadow areas of a scene. It can be regulated by using an opaque blind, and can be softened by using a diffusing material such as greaseproof paper or net curtains. For some shots, it will also be necessary to black out the window completely.

Artificial lighting can be provided by tungsten filament lamps, which are essentially high-output domestic light bulbs, or by electronic flash. Tungsten photoflood lamps are cheap to buy, but the short lamp life (a matter of just a few hours) can make them more expensive in the long term. In addition, tungsten bulbs quickly heat up a studio – and your subjects. However, they are easier to use than flash lighting because they allow you to see the effect you will achieve in your shot before you take the photograph and, furthermore, they do not need to be synchronized, or even connected, to the camera.

Electronic flash units are mains operated, and at least one of them must be connected to the camera's PC socket or hotshoe via a synchronization lead. Other units are synchronized by slave units – light sensitive cells that are triggered by the main flash units – which cut down the number of trailing wires in the studio.

A wide range of accessories is available to fit over studio lights (especially flash units, which do not heat up as much as tungsten). Bowl light reflectors can help brighten the lighting effect, while barn doors and snoots can help minimize the spread of light. You can soften the light by bouncing it off umbrellas, or by using soft boxes (large diffusing head attachments).

Although flash units often offer a secondary, tungsten light source, known as a modelling light, to help you when setting up the lighting, it is helpful to have a special flash meter to work out the correct exposure when using several lamps. This may not be necessary if your camera accepts a Polaroid back and you can therefore check results as you go along, but a meter is more economical.

Avoid the temptation to buy an excessive amount of lighting equipment at first, as you can spend more time arranging the lamps than taking pictures. A great deal can be done with one or two light sources plus a reflector to provide fill-in light where necessary.

△ **The flash meter** is invaluable when more than one flash unit is used because reliable calculations of exposure are difficult in these circumstances. A reading is taken by firing the flash units once while holding the meter close the subject. It records the total amount of light falling on the subject, and indicates the required camera aperture.

Useful data

FOCAL LENGTH AND FORMAT

The focal length of a lens needed to get a particular image magnification depends on the film format. The smaller the format, the shorter the focal length needed for a particular angle of view. This table compares focal lengths and angles of view against a range of formats. Dashes indicate that lenses with this angle of view are not usually made for this format.

FILM FORMAT MEASUREMENT CONVERSIONS	
35mm	
36 x 24mm	1¼ x 1"
36 x 18mm	1¼ x ¾"
17 x 24mm	¾ x 1"
120 roll film	
6 x 4.5cm	2¼ x 1¾ "
6 x 6cm	2¼ x 2¼ "
6 x 7cm	2¼ x 2¾ "
APS	
30.2 x 16.7mm	1¼ x ¾"
120/126 cartridge film	
17 x 13mm	¾ x ½"
26 x 26mm	1 x 1"
sheet film	
25.4 x 20.3cm	10 x 8"
12.7 x 10.2cm	5 x 4"

ANGLE OF VIEW	FILM FORMATS					LENS TYPE
	APS	35mm	120 roll film 6 x 6cm	6 x 7cm	sheet film 5 x 4in	
100°	14mm	18mm	—	—	—	Wide-angle
90°	17mm	21mm	38mm	45mm	75mm	Wide-angle
75°	22mm	28mm	55mm	60mm	105mm	Wide-angle
62°	28mm	35mm	65mm	70mm	130mm	Wide-angle
50°	36mm	45mm	80mm	90mm	165mm	Normal
28°	68mm	85mm	150mm	165mm	300mm	Telephoto
24°	80mm	100mm	185mm	210mm	370mm	Telephoto
12°	160mm	200mm	240mm	270mm	—	Telephoto
6°	320mm	400mm	—	—	—	Telephoto

CALCULATING DEPTH OF FIELD

Depth of field scales are not always shown on lenses and it is therefore necessary to calculate the depth of field yourself. To work out the nearest and farthest points that will be in focus, you need to know the aperture (A), the focal length (F), and the focussed distance (D).

Another factor, the "circle of confusion" figure, must also be taken into account. A circle of confusion is a disc of light in the image produced by a lens when a point on the subject is not perfectly brought into focus. An extremely small circle cannot be distinguished by the human eye from a point of light. The maximum size of a circle that appears as a point to the viewer (C) depends on the film format, the amount the picture is enlarged, and the distance at which the picture is viewed. Usually, the figure is 0.036mm for 35mm film, or 0.056 for 120 roll film.

To calculate the nearest point in focus, use this formula:

$$\frac{D \times F \times F}{(D \times C \times A) + (F \times F)}$$

To calculate the farthest point in focus, use this formula:

$$\frac{D \times F \times F}{(D \times C \times A) - (F \times F)}$$

Note: To use these formulas, the unit of measure for each of the factors must be the same throughout, and therefore the focused distance should be measured in millimetres. To convert meters to millimetres you need to multiply by 1,000. Similarly, your calculation will give you an answer in millimetres, so needs to be divided by 1,000 to give you the distance in meters.

CONTRAST FILTERS FOR BLACK AND WHITE FILM

Any relatively strong-colored filter can be used to correct or modify the tonal balance produced by black and white film. For example, filters are particularly useful for bringing out detail in a cloudy sky – dark-red gives the most pronounced effect, and light yellow the mildest. Filters can also be used to increase the contrast between two colors that the film would usually record as nearly the same tone – such as green and red. The table shows the effect of each color of filter.

Filter color	Tones of color made comparatively lighter	Tones of color made comparatively darker
Blue	Blue	Yellow, Orange, Red
Green	Green	Blue, Orange, Red
Yellow	Yellow, Orange, Red	Blue
Orange	Orange, Red	Blue, Green
Red	Red	Blue, Green

APERTURES

Apertures are expressed in f/stops, which are calculated by dividing the focal length of the lens by the diameter of the aperture. Most photographers quickly familiarize themselves with the full stop apertures most commonly used, but the half-stop values are less well known.

FULL STOPS	f/1	f/1.4	f/2	f/2.8	f/4	f/5.6	f/8	f/11	f/16	f/22

HALF STOPS	f/1.2	f/1.8	f/2.5	f/3.5	f/4.5	f/6.7	f/9.5	f/13	f/19

COLOR TEMPERATURE SCALE

The color of a light source is measured in terms of the temperature of a theoretical "black body" heated to the point at which it emits light of that color. This temperature is measured on the Kelvin scale, which has units called of the same size as degrees centigrade. The higher the color temperature, the bluer the light source; the lower the temperature, the more orange the light source.

The table shows the color temperatures for a selection of typical light sources. Color slide films are balanced to record accurately when used with one particular kind of light, usually either daylight or tungsten (ordinary electric light). In most cases, daylight film is balanced at 5,600K, while tungsten film is balanced at 3,500K.

LIGHT SOURCE	COLOR TEMPERATURE
Clear blue sky	10–20,000K
Hazy sunlight	9,000K
Average shaded subject in summer	8,000K
Cloudy sky	7,000K
Sun through clouds at midday	6,500K
Electronic flash	6–6,500K
Summer sunlight (average, 10am–3pm)	5,800K
Morning/afternoon sunlight	4–5,000K
Photoflood bulb	3,400K
Tungsten halogen lamp	3,200K
150 watt light bulb	2,900K
40 watt light bulb	2,600K
Sunrise/sunset	2,000K
Candle light	1,000K

COLOR CORRECTION FILTERS

A wide selection of pale-colored correction filters is available. They are primarily used by professional photographers to match their color films accurately to specific sources of light. The table lists colour correction filters that have a more general use. These filters cut down the overall amount of light reaching the film, although this will usually be allowed for by the camera's built-in through-the-lens meter.

Filter	Use
80A	Blue filter for use with tungsten halogen lighting and daylight-balanced film
80B	Blue filter for use photoflood bulbs and daylight-balanced film
85B	Orange-colored filter when using tungsten-balanced film in daylight
FL-D	Converts fluorescent light more closely to the color temperature of daylight, so that it can be used with daylight-balanced film

SHUTTER SPEED GUIDE FOR MOVING SUBJECTS

Experience will enable you to judge the shutter speed needed to "freeze" a given subject. It is important to remember that the shutter speed not only depends on the speed of the subject, but also on its magnification in the viewfinder, and on its direction of travel. The larger the subject appears in the frame, the faster the shutter speed required. Similarly, if the subject is moving across the field of view you need a faster speed than if the subject is traveling toward the camera. The table gives some typical shutter speed values, to help you to decide what setting you need.

SUBJECT	DIRECTION OF MOVEMENT		
	Toward camera	Diagonal	Across frame
Walking pedestrians	1/30sec	1/60sec	1/125sec
Slow traffic	1/60sec	1/125sec	1/250sec
Sailing boats	1/60sec	1/125sec	1/250sec
Cyclists	1/60sec	1/125sec	1/250sec
Trains	1/125sec	1/250sec	1/500sec
Running athlete	1/250sec	1/500sec	1/1000sec
Motor races	1/500sec	1/1000sec	1/2000sec

COLOR INFRA-RED FILM

Unlike other emulsions, infra-red film should be stored in your freezer (below -10°F or -23°C). For the best results, use a yellow filter over the lens. Rate the film at ISO 200 if you are metering through a filter, or at ISO 100 if you are metering without one in place. It can be a problem finding laboratories to develop infra-red film (Kodak Ektachrome Infra-red 35mm is the only make available) because it must be developed by the E4 process, which has long been superseded by the E6 process for nearly all other color slide films. Following are the addresses of two laboratories that still handle infra-red film and of a company that makes processing kits for those wishing to develop the film at home.
Laboratories: Argentum, 1 Wimpole Street, London W1M 7AA, UK; Rocky Mountain Film Labs, 145 Madison Street, Denver, CO 80206, USA.
Chemical suppliers: Speedibrews Photochemicals, 54 Lovelace Drive, Pyrford, Woking, Surrey GU22 8QY, UK.

NIGHT-TIME EXPOSURE GUIDE

Low-light conditions present the greatest difficulty when measuring exposure because the overall illumination is low but the contrast between the bright lights and the dark shadows is extremely high. This causes problems for any metering system because an average reading is often unhelpful. In most cases, it is the highlights that you want to record accurately, while the shadow areas are allowed to appear pitch black. To reach the slowest shutter speeds, you may have to use the camera's B, or bulb, setting, in which the shutter is kept open as long as your finger remains on the trigger. This table suggests exposure settings for a range of subjects when shooting in low light.

Subject	ISO 100	ISO 400	ISO 1600
Candlelit scenes	1/4sec f/2	1/15sec f/2	1/30sec f/4
Christmas lights indoors	1sec f/4	1/4sec f/4	1/15sec f/4
Brightly lit city streets at night	1/30sec f/2.8	1/60sec f/4	1/125sec f/5.6
Neon signs	1/60sec f/2.8	1/125sec f/4	1/125sec f/8
Shop windows	1/30sec f/2.8	1/60sec f/4	1/125sec f/5.6
Floodlit buildings	1sec f/4	1/2sec f/5.6	1/4sec f/8
Skyline at night	4secs f/2.8	1sec f/2.8	1sec f/5.6
Skyline at dusk	1/30sec f/5.6	1/60sec f/8	1/125sec f/11
Moving traffic (as light streaks)	20sec f/16	20sec f/8	20sec f/4
Stage performances	—	1/15sec f/2.8	1/60sec f/2.8
Stars (as trails of light)	5mins f/4	5mins f/8	5mins f/16
Moonlit landscape	2min f/4	1min f/5.6	1min f/11
Full moon	1/250sec f/8	1/500sec f/11	1/1000sec f/16

ACCESSORIES FOR CLOSE-UPS

A wide range of accessories is available to help you achieve higher image magnifications than are usually possible with a standard lens. The table shows some of the most common types.

Accessory	Maximum magnification (approx)	Description
Standard lens	0.2x	—
Standard lens with teleconverter	0.4x	The main purpose of a teleconverter is to increase the focal length of a lens (it usually doubles it). It fits between the camera body and the lens and achieves this change of angle of view without affecting the minimum focussing distance, so you can increase your close-up capabilities.
Close-up lens	0.5x	Attached like a filter to the front of the lens, this increases the image size in the same way as a magnifying glass. These lenses are available in a range of strengths, measured in dioptres, usually varying from +1 to +4 dioptres.
Reversing ring	0.7x	This adaptor allows you to attach a lens to your SLR so that it is back-to-front, turning the lens into a crude macro lens. These accessories are cheap and give a good level of magnification, but can result in a loss of aperture control with some cameras, and will certainly result in a loss of automatic exposure. Furthermore, focussing must be adjusted by altering the subject distance.
Macro lens	1x	A macro lens can be focussed at any distance from infinity to the point that gives a life-size image. These lenses are specially designed for close-up work, but can also be used for normal photography. Usual focal lengths available for 35mm SLRs are 50mm, 90mm and 100mm. See pages 104–5 for further details.
Extension tubes	1x	This set of three hollow tubes can be used singly, in pairs, or all together to give up to seven different image magnifications. Automatic types are available for some cameras, enabling you to maintain control over aperture settings. The tubes are fitted between the lens and the camera body.
Bellows unit	3x	This is the most flexible macro accessory, and functions like an adjustable extension tube. The bellows, made of plastic or cloth, are extended using a monorail system similar to that found on a large-format camera.

Glossary

Words shown in capitals indicate cross references within the glossary.

Aberration Inherent fault in a lens image. Aberrations include ASTIGMATISM, BARREL DISTORTION, CHROMATIC ABERRATION, COMA, PINCUSHION DISTORTION, SPHERICAL ABERRATION. COMPOUND LENSES minimize aberrations.

Accelerator Alkali in a DEVELOPER, used to speed up its action.

Actinic Light which is able to affect photographic material. With ordinary film, visible light and some ultraviolet light is actinic, while infra-red light is not.

Acutance Objective measure of image sharpness. ADDITIVE COLOR PRINTING. A method of filtration occasionally used in making prints from color negatives. Three successive EXPOSURES of the negative are made, with red, green and blue light respectively. See also SUBTRACTIVE COLOR PRINTING.

Additive synthesis Method of producing full-color image by mixing blue, green and red lights. These colors are called additive primaries.

Aerial perspective Sense of depth in a scene caused by haze. Distant objects appear in gentler tones than those in the foreground and they tend to look bluish. The eye interprets these features as indicating distance.

Air bells Bubbles of air clinging to the emulsion surface during processing, which prevent uniform chemical action. Removed by agitation.

Airbrush An instrument used by photographers for retouching prints. It uses a controlled flow of compressed air to spray paint or dye.

Anamorphic lens Special type of lens that compresses the image in one dimension by means of cylindrical or prismatic elements. The image can be restored to normal by using a similar lens for printing or projection.

Angle of view Strictly the angle subtended by the diagonal of the film format at the rear NODAL POINT of the lens. Generally taken to mean the wider angle "seen" by a given lens. The longer the focal length of a lens, the narrower its angle of view. See also COVERING POWER.

Angstrom unit A unit of length equal to one ten-millionth of a millimeter, generally used to express the wavelength of light.

Anti-halation backing. See HALATION.

Aperture Strictly, the opening that limits the amount of light reaching the film and hence the brightness of the image. In some cameras the aperture is of a fixed size; in others it is in the form of an opening in a barrier called the DIAPHRAGM and can be varied in size. (An iris diaphragm forms a continuously variable opening, while a stop plate has a number of holes of varying sizes). Photographers, however, generally use the term "aperture" to refer to the size of this opening. See also F/NUMBER.

Aperture priority EXPOSURE mode whereby the user sets the aperture manually, and the camera automatically sets the shutter speed for the metered light level. See also SHUTTER PRIORITY.

ASA American Standards Association, which devised one of the two early systems for rating the SPEED of an emulsion. See also DIN and ISO.

Astigmatism The inability of a lens to focus vertical and horizontal lines in the same FOCAL PLANE. Corrected lenses are called "anastigmatic".

B

Back projection Projection of slides onto a translucent screen from behind, instead of onto the front of a reflective screen.

Ball-and-socket head A type of tripod fitting that allows the camera to be secured at the required angle by fastening a single locking screw. See also PAN-AND-TILT HEAD.

Barn doors Hinged flaps for studio lamps, used to control the beam of light.

Barrel distortion Lens defect characterized by the distortion of straight lines at the edges of an image so that they curve inward at the corners of the frame.

Bas relief In photography the name given to the special effect created when a negative and positive are sandwiched together and printed slightly out of register. The resulting picture gives the impression of being carved in low relief, like a bas-relief sculpture.

Beaded screen Type of front-projection screen. The surface is covered with minute glass beads, giving a brighter picture than a plain white screen.

Bellows Light-tight folding bag made of pleated material used to join the lens to the camera body. Found on large studio cameras, and used as an accessory for close-up work with smaller formats.

Between-the-lens shutter One of two main types of shutter. Situated close to the diaphragm, it consists of thin metal blades or leaves that spring open and then close when the camera is fired, exposing the film. See also FOCAL PLANE SHUTTER.

Bleaching Chemical process for removing black metallic silver from the emulsion by converting it to a compound that may be dissolved.

Boom light Studio light attached to a long arm.

Bounced flash Soft light achieved by aiming flash at a wall or ceiling to avoid the harsh shadows that result if the light is pointed directly at the subject. Tungsten light can be bounced in the same way.

Bracketing Technique for ensuring the correct EXPOSURE by taking several photographs of the same subject at slightly different exposure settings. The bracketed sequence is usually taken with exposures at regular STOP intervals.

B setting Setting on the shutter speed dial of a camera at which the SHUTTER remains open for as long as the release button is held down, allowing longer EXPOSUREs than the preset speeds on the camera. The "B" stands for "bulb" for historical reasons. See also T SETTING.

Buffer Alkaline salt, such as sodium carbonate, used in a developer to maintain the alkalinity of the solution in the presence of acids liberated during processing. See also ACCELERATOR.

Bulk loader Device for handling film that has been bought in bulk in a single length and which needs to be cut and loaded into cassettes.

Burning in Technique used in printing when a small area of the print requires more EXPOSURE than the rest. After normal exposure, the main area is shielded with a card or by the hands while the detail (such as a highlight that is too dense on the negative) receives further exposure. See also DODGING.

C

Cable release Simple camera accessory used to reduce camera vibrations when the shutter is released on a camera that is supported on a tripod, particularly when a relatively long EXPOSURE is being used.

Callier effect Phenomenon that accounts for the higher contrast produced by enlargers using a condenser system, compared to those using a diffuser system. This effect, first investigated by André Callier in 1909, is explained by the fact that the light focussed by the condenser onto the lens of the enlarger, is partly scattered by the negative before it reaches the lens. The denser parts of the negative scatter the most light and therefore the contrast is increased. In a diffuser enlarger, on the other hand, all areas of the negative cause the same amount of scattering.

Calotype Print made by an early photographic process from paper negatives. Iodized paper requiring lengthy EXPOSURE was used in the camera. The system was patented by Fox Talbot in 1841, but became obsolete with the introduction of the Collodion Process. Also known as a Talbotype.

Camera movements Adjustments to the relative positions of the lens and the film whereby the geometry of the image can be controlled. A full range of movements is a particular feature of large-format view cameras, although a few smaller cameras allow limited movements, and special lenses are available that do a similar job for 35mm SLRs.

Camera obscura Literally a "dark chamber". An optical system, familiar before the advent of photographic materials, using a pinhole or a lens to project an image onto a screen. One form of camera obscura, designed as an artist's aid, is the ancestor of the modern camera.

Cartridge Plastic container of film such as the old 126 or 110 formats. The film is wound inside the cartridge from one spool onto a second spool.

Cassette Container for 35mm or APS film. After EXPOSURE the film is wound back onto the cassette spool before the camera is opened.

Catadioptric lens see MIRROR LENS.

Catchlights Tiny highlights in the eyes of the subject of a portrait photograph, caused by the reflection of a bright light source.

CdS cell Photosensitive cell used in some light meters, incorporating a cadmium sulphide resistor, which regulates electric current.

Center-weighted meter Type of through-the-lens light meter. The reading is most strongly influenced by the intensity of light at the center of the image.

Characteristic curve Graph of the image DENSITY produced by a given photographic EMULSION against the logarithm of the EXPOSURE. A steep curve indicates a high-contrast material.

Chromatic aberration The inability of a lens to focus different colors on the same focal plane.

Circle of confusion Disc of light on the image produced by a lens when a point on the subject is not perfectly brought into focus. When looking at a photograph, the eye cannot distinguish between a very small circle of confusion (with a diameter of less than a hundredth of an inch) and a true point.

Close-up lens Simple positive lens placed over the normal lens to magnify the image. The strength of the close-up lens is measured in DIOPTERS.

Color analyzer Electronic device that assesses the correct filtration for a color print.

Color conversion filters Camera filters required when daylight color film is used in artificial light, or when film balanced for artificial light is used in daylight.

Color correction filters Filters used to correct slight irregularities in color caused by specific light sources. Also refers to the cyan, magenta and yellow filters that are used to balance the color of prints made from color negatives.

Color negative film Film giving color negatives, intended for printing.

Color reversal film Film giving color positives (called slides or transparencies). Prints can also be made directly from these positives using special paper and chemicals.

Color temperature Measure of the relative blueness or redness of a light source, expressed in KELVIN. The human eye adjusts to differences in color temperature automatically most of the time, but color film is balanced to work with a single color temperature – usually average daylight, or tungsten bulb lighting.

Coma A lens defect that results in off-axis points of light appearing in the image not as points but as discs with comet-like tails.

Compound lens Lens consisting of more than one element, designed so that the faults of the various elements largely cancel each other out.

Condenser Optical system consisting of one or two plano-convex lenses (flat on one side, curving outward on the other) used in an enlarger or slide projector to concentrate light from a source and focus it on the negative or slide.

Contact print Print that is the same size as the negative, made by sandwiching together the negative and the photographic paper when making the print. A whole roll of 35mm film can be contact printed at once onto one sheet of 10 x 8in (25.4 x 20.3cm) paper.

Contre jour Literally "against the light". The term is used to describe photographs taken with the camera pointing towards the sun or another light source.

Converging lens Any lens that is thicker in the middle than at the edges. Such lenses are able to cause parallel light to converge onto a point of focus, giving an image. Also known as a positive lens.

Converging verticals Distorted appearance of vertical lines in an image, produced when the camera is tilted upwards. Tall objects such as buildings, for instance, appear to be leaning backward. Can be partially corrected at the printing stage, or by the use of CAMERA MOVEMENTS.

Converter Auxiliary lens, usually fitted between the camera body and the principal lens, giving a combined FOCAL LENGTH that is greater than that of the principal lens alone. Most converters increase focal length by a factor of two or three. Also known as teleconverters.

Correction filters Color filters used over the camera lens to modify the tonal balance of black and white images. See COLOR CORRECTION FILTERS.

Covering power The largest image area of acceptable quality that a given lens produces. The covering power of a lens is usually only slightly greater than the standard negative size for which it is intended. However, in a lens designed for use with a camera with movements (see CAMERA MOVEMENTS), the covering power must be considerably greater.

Cropping Enlarging only a selected portion of the negative instead of printing the entire area.

Cut film Another name for sheet film.

 D

Daguerreotype Early photographic picture made on a copper plate coated with polished silver and sensitized with silver iodide. The image was developed using mercury vapor, giving a direct positive. The process was introduced by Louis Daguerre in 1839, and was the first to be commercially successful.

Daylight film Color film balanced to give accurate color rendering in average daylight, that is to say, when the COLOR TEMPERATURE of the light source is around 5500 kelvin. Also suitable for use with electronic flash.

Densitometer Instrument for accurate measurement of DENSITY. Used to achieve a precise assessment of negatives, usually for scientific purposes.

Density The light-absorbing power of a photographic image. A logarithmic scale is used in measurements: 50% absorption is expressed as 0.3, 100% is expressed as 1.0, etc. In general terms, density is simply the opaqueness of a negative or the blackness of a print.

Depth of field Zone of acceptable sharpness extending in front of and behind the plane of the subject that is exactly focussed by the lens.

Depth of focus Very narrow zone behind the lens within which slight variation in the position of the film makes no appreciable difference to the focussing of the image.

Developer Chemical agent that converts the LATENT IMAGE into a visible image.

Diaphragm System of adjustable metal blades forming a roughly circular opening of variable diameter, used to control the APERTURE of a lens.

Dichroic fog Processing fault characterized by a stain of reddish and greenish colors. Caused by the use of exhausted FIXER whose acidity is insufficient to halt the development entirely. A fine deposit of silver is formed that appears reddish by transmitted light and greenish by reflected light.

Differential focussing Technique involving the use of shallow depth of field to enhance the illusion of depth and solidity in a photograph.

Diffraction Phenomenon occurring when light passes close to the edge of an opaque body or through a narrow APERTURE. The light is slightly

deflected, setting up interference patterns that may sometimes be seen by the naked eye as fuzziness. The effect is occasionally noticeable in photography, when, for example, a very small lens aperture is used.

DIN Deutsche Industrie Norm, the German standards association that devised one of the old systems used for rating the speed of an EMULSION. On the DIN scale, every increase of 3 indicates that the sensitivity of the emulsion has doubled. See also ASA and ISO.

Diopter Unit of measurement of the strength of a lens, defined as a reciprocal of the FOCAL LENGTH expressed in meters. Used in photography to express the strength of a supplementary lens.

D-max Technical term for the maximum DENSITY of which a given EMULSION is capable.

Dodging Technique used in printing photographs when one area of the print is given less EXPOSURE than the rest. A hand or a piece of card is used to prevent the selected area from receiving the full exposure. See also BURNING IN.

Drift-by technique Processing technique used to allow for the cooling of a chemical bath (in most cases, the developer) during the time it is in contact with the EMULSION. Before use, the solution is warmed to a point slightly above the required temperature, so that while it is being used it cools to a temperature slightly below but still within the margin of safety.

Drying marks Blemishes on the EMULSION resulting from uneven drying. Also residue left on the film after water from the wash has evaporated.

Dry mounting Method of mounting prints onto card using a special heat-sensitive adhesive tissue.

DX codes Silver pattern on a 35mm film canister that can be read by many 35mm cameras. It tells the camera the FILM SPEED, so that this can be set automatically. The code can also communicate the length and EXPOSURE latitude of the film being used.

Dye coupler Chemical responsible for producing the appropriate colored dyes during the development of a color photograph. Dye couplers may be incorporated in the EMULSION, or they may be part of the DEVELOPER.

 E

Electronic flash Type of flashgun that uses the flash of light produced by a high-voltage electrical discharge between two electrodes in a gas-filled tube.

Emulsion In photography, the light-sensitive layer of a photographic material. The emulsion consists essentially of SILVER HALIDE crystals suspended in GELATIN.

Enlargement Photographic print larger than the original image on the film.

Exposure Total amount of light allowed to reach the light-sensitive material during the formation of the LATENT IMAGE. The exposure is dependent on the brightness of the image, the camera APERTURE, and on the length of time for which the photographic material is exposed.

Exposure meter Instrument for measuring the intensity of light so as to determine the correct SHUTTER and APERTURE settings.

Extension tubes Accessories used in close-up photography, consisting of metal tubes that can be fitted between the lens and camera body, thus increasing the lens-to-film distance.

 F

Farmer's reducer Solution of potassium ferricyanide and sodium thiosulphate, used in photography to bleach negatives and prints.

Fast film A film that is more sensitive to light than standard films A film with a FILM SPEED of ISO 400 or above.

Fast lens Lens with a wide maximum APERTURE, relative to its FOCAL LENGTH.

Fill-in Additional lighting used to supplement the principal light source and to brighten shadows.

Film speed The film's sensitivity to light, usually expressed as a rating on the ISO scale.

Filter Transparent sheet usually made of glass or plastic that is used to block a specific part of the light

passing through it or to change or distort the image in some way. See also COLOR CONVERSION FILTERS, COLOR CORRECTION FILTERS, CORRECTION FILTERS and POLARIZING FILTERS.

Fisheye lens Extreme wide-angle lens, with an ANGLE OF VIEW of about 180°

Fixed-focus lens Lens permanently focussed at a fixed distance, usually the HYPERFOCAL DISTANCE. Most cheap cameras use this system, giving sharp pictures from about six feet (two meters) to INFINITY.

Fixer Chemical bath needed to fix the photographic image permanently after it has been developed. The fixer stabilizes the EMULSION by converting the undeveloped SILVER HALIDES into water-soluble compounds, which can then be dissolved away.

Flare Unwanted light reflected inside the camera or between the elements of the lens giving rise to irregular marks on the negative and degrading the quality of the image. This can be overcome to some extent by using a LENS COATING, or a LENS HOOD.

Floodlight General term for an artificial light source that provides a constant and continuous output of light suitable for studio photography or similar work. Usually consists of a 200–500 watt tungsten-filament bulb mounted in a REFLECTOR.

F/number Aperture setting. The number refers to the focal length of the lens divided by the diameter of the APERTURE. Because f/numbers are reciprocals, the bigger the number the smaller the aperture – thus f/32 is smaller than f/8. The f/numbers available with a particular lens and camera generally follow a standard sequence, in which the interval between one STOP and the next represents a halving or doubling in image brightness.

Focal length Distance between the optical center of the lens and the point at which rays of light parallel to the optical axis are brought to a focus. In general, the greater the focal length of a lens, the smaller its ANGLE OF VIEW.

Focal plane Plane on which a given subject is brought to a sharp focus, which is the same as the plane on which the film is positioned.

Focal plane shutter One of the main types of SHUTTER, used almost universally in SINGLE-LENS REFLEX cameras. Positioned behind the lens (but slightly in front of the FOCAL PLANE), the shutter consists of a system of blinds or blades. When the camera is fired, a slit travels across the image area either vertically or horizontally. The width and the speed of travel of the slit determine the duration of the EXPOSURE. See also BETWEEN-THE-LENS SHUTTER.

Format Dimensions of the image recorded on the film by a given type of camera.

Fresnel lens Lens whose surface consists of a series of concentric circular "steps", each of which is shaped like part of the surface of a convex lens. Fresnel lenses are often used in the focussing screens of cameras to help improve the brightness of the image seen through the viewfinder. They are also used in spotlights to concentrate the light beam.

 G

Gamma Strictly, the gradient of the straight line section of the CHARACTERISTIC CURVE. In effect, an expression of the contrast of a given photographic material under specified conditions of development.

Gelatin Material used as a binding for the EMULSION of photographic paper and film.

Grain Granular texture appearing to some degree in all processed photographic materials. In black and white photographs the grains are clumps of particles of black metallic silver that constitute the dark areas of a photograph. In color photographs the silver has been removed chemically but tiny blotches of dye retain the appearance of graininess. The faster the film the coarser the texture of the grain.

Granularity Objective measure of graininess.

Guide number Number indicating the effective power of a flash unit. For a given FILM SPEED, the guide number divided by the distance between the flash and the subject gives the appropriate F/NUMBER to use.

Halation Phenomenon characterized by a halo-like band around the developed image of a bright light source. It is caused by internal reflection of light from the support of the EMULSION (in other words, the paper of the print or the base layer of a film).

Halogens Group of chemical elements, including fluorine, chlorine, bromine and iodine. These elements are important in that they combine with silver to form SILVER HALIDES – the light-sensitive substances found in all photographic materials.

Hardener Chemical used to strengthen the GELATIN of an EMULSION against physical damage.

High-key Picture containing predominantly light tones. See also LOW-KEY.

Highlights Brightest areas of a subject or image. In the negative these are the areas of greatest DENSITY.

Hot shoe Accessory plate on a camera for holding a flashgun in position, and incorporating a live contact for firing the flash when the SHUTTER is fired.

Hyperfocal distance The shortest distance at which a lens can be focussed to give a DEPTH OF FIELD extending to infinity for a given APERTURE. At the hyperfocal distance, depth of field stretches from half the hyperfocal distance to infinity.

Hypo Colloquial name for sodium thiosulphate, which was once used universally as a fixing agent. The term was thus a synonym for FIXER.

Incident light Light falling on the subject. When a subject is being photographed, readings may be taken of the incident light instead of the reflected light.

Infinity A distance so far away from the camera that all rays coming from objects at this distance enter the lens as parallel lines. Marked on lenses using the symbol ∞.

Intermittency effect Phenomenon observed when an EMULSION is given a series of brief EXPOSUREs. The DENSITY of the image thus produced is lower than the image density produced by a single exposure equal to the total duration of the short exposures.

Inverse square law Rule that states that for a point source of light, the intensity of light decreases with the square of the distance from the source. Thus when the distance is double, the light intensity is reduced by a factor of four.

IR (infra-red) setting A mark sometimes found on the focussing ring of a camera indicating the shift in focus needed when using black-and-white infra-red film. Infra-red radiation is refracted less than visible light, and the infra-red image is therefore brought into focus slightly behind the visible one.

Iris See DIAPHRAGM.

ISO Scale introduced by the International Standards Organisation for the measurement of FILM SPEED, which combines the figures previously used in the ASA and DIN scales. The full rating for a medium-speed film is therefore ISO 100/21° — this however is usually abbreviated to ISO 100. The larger the number the faster, and more sensitive, the EMULSION. The scale is arranged so that a film rated at ISO 200 is twice as fast as one rated at ISO 100 – while one rated at ISO 400 is four times as fast.

Kelvin (K) Unit used to measure COLOR TEMPERATURE

Latent image Invisible image recorded on photographic EMULSION after EXPOSURE, but before development by chemicals.

Latitude Tolerance of photographic material to variations in EXPOSURE.

Lens coating Thin coating of metallic fluoride on the air-glass surface of a lens. It reduces reflections at that surface. Most modern lenses are multi-coated, using several layers of this anti-reflective material.

Lens hood Simple lens accessory, usually made of rubber or plastic, used to shield the lens from light coming from areas outside the field of view – thus preventing FLARE.

Lith film Very high contrast film used to eliminate gray tones and reduce the image to areas of pure black or pure white.

Low-key Picture containing predominantly dark tones. See also HIGH-KEY.

Macro lens Strictly, a lens capable of giving an image that is life-size or bigger – a magnification ratio of 1:1 or greater. The term is generally used to describe any close-focussing lens. Macro lenses can also be used at ordinary subject distances.

Magnification ratio Ratio of image size to object size. The magnification ratio is used to judge the capabilities of a MACRO LENS, and can be useful in calculating the correct EXPOSURE for close-ups.

Microprism Special type of focussing screen composed of a grid of tiny prisms, often incorporated into the standard viewing screens of manual-focus SLR cameras. The microprism gives a fragmented image when the image is out of focus.

Mired Acronym for micro-reciprocal degree. Unit on a scale of COLOR TEMPERATURE used to calibrate COLOR CORRECTION FILTERS. The mired value of a light is derived by dividing one million by the color temperature in kelvin.

Mirror lens TELEPHOTO lens of a compact design whose construction is based on a combination of lenses and curved mirrors. Light rays from the subject are reflected backward and forward inside the barrel of the lens before reaching the film plane. Also known as a catadioptric lens. Because of its compact design, a mirror lens can be used as a telephoto lens that is smaller and lighter than its traditionally constructed equivalent.

Montage Composite photographic image made from several different original pictures.

Motordrive Battery-powered camera feature or accessory used to wind the film on automatically after each shot, and to rewind the film at the end of the roll. Fast motorwinds can be used to take several pictures a second, when shooting sport, for example.

Negative Image in which light tones are recorded as dark tones, and vice versa. In color negatives every color in the original subject is represented by its complementary color.

Neutral density filter Uniformly gray filter that reduces the brightness of an image without altering its color content. Used when the light is too bright for the film being used. A graduated neutral density filter (which is gray at the top and clear at the bottom) is used to reduce contrast in landscape photography between a bright sky and a darker foreground.

Newton's rings Narrow multicolored bands that appear when two transparent surfaces are sandwiched together with imperfect contact. The pattern is caused by interference, and can be troublesome when slides or negatives are held between glass or plastic.

Nodal point Point of intersection between the optical axis of a compound lens and one of the two principal planes of refraction. A compound lens thus has a front and a rear nodal point from which its basic measurements (such as FOCAL LENGTH) are made.

Open flash Technique of firing flash manually after the camera SHUTTER has been opened, instead of synchronizing the flash automatically.

Optical axis Imaginary line through the optical center of a lens system.

Orthochromatic Term used to describe black and white EMULSIONs that are insensitive to red light. See also PANCHROMATIC.

Pan-and-tilt head Type of tripod head employing independent locking mechanisms for movement in two planes at right angles to each other. Thus the camera can be locked in one plane while remaining free to move in the other.

Panchromatic Term used to describe black and white photographic EMULSIONs that are sensitive to all the visible colors (although not necessarily equally to each of them). Nearly all modern films are panchromatic. See also ORTHOCHROMATIC.

Panning Technique of moving the camera during EXPOSURE to follow a moving subject, giving an impression of speed. A relatively slow shutter speed is used, so that the background is more blurred than the subject.

Panoramic camera Any camera that is capable of producing an image whose width is significantly wider than its height.

Parallax error The difference between what is seen through the viewfinder and what is recorded on the film. It occurs in non-SLR cameras where the viewfinder and the lens have slightly different viewpoints. It becomes a problem when shooting close-ups.

Pentaprism Five-sided prism used in the construction of eye-level viewfinders for SLR cameras, which ensures that the image seen in the viewfinder is the right way round and the right way up. In practice the pentaprism often has more than fives sides, as unnecessary parts of the prism are cut off to reduce its bulk.

pH value A scale used to measure the acidity or alkalinity of a substance. Pure water is neutral at pH 7; a smaller pH value than this indicates an acid, whilst a higher number indicates an alkali.

Photoflood Bright tungsten filament bulb used as an artificial light source in photography. The bulb is over-run (to increase the brightness, more current passes through the filament than would in a standard bulb running for a longer period) and it therefore has a short life.

Photogram Photographic image produced by arranging objects on the surface of a sheet of photographic paper or film, or so that they cast a shadow directly onto the material as it is being exposed. The image is thus produced without the use of a lens.

Photomicrography Technique of taking photographs through the lens of a microscope.

Pincushion distortion Lens defect marked by the bending of the lines at the edge of the image so that the lines are convex toward the center. See also BARREL DISTORTION.

Pinhole camera Simple camera that employs a very small hole instead of a lens to form an image.

Polarized light Light whose electrical vibrations are confined to a single plane. In every-day conditions, light is usually unpolarized, having electrical (and magnetic) vibrations in every plane. Light reflected from shiny non-metallic surfaces is usually polarized and can be controlled using a POLARIZING FILTER.

Polarizing filters Thin transparent filters used as a lens accessory to cut down reflections for certain shiny surfaces (such as glass and water), or to intensify the color of a blue sky (by reducing the amount of light reflected by the sky). Rotating the filter will vary the proportion of the polarized light that is blocked. There are two types of polarizing filter – linear and circular. Circular polarizing filters are constructed in a different way from linear polarizers so that they do not interfere with the exposure and autofocus systems of some cameras, and are therefore necessary when using autofocus SLRs.

Positive Image in which the light tones correspond to the light areas of the subject, and the dark tones to the dark areas. In color photography, it refers to an image in which the colors correspond to those of the original subject. See NEGATIVE.

Posterization Technique of drastically simplifying the tones of an image by making several negatives from an original each with different densities and contrasts, and then sandwiching them together and printing them in register. The effect can also be achieved electronically.

Primary colors Red, green and blue light. See ADDITIVE SYNTHESIS.

Process film Slow, fine-grained film of good resolving power used for copying work.

Programmed exposure Exposure mode in which the camera sets both APERTURE and shutter speed automatically for the metered light level. Some program modes are designed to give the highest shutter speed possible for the prevailing light conditions, while others aim to set the smallest aperture possible. Some cameras will change motorwind, autofocus, and metering modes for a particular program setting. It is not uncommon for a modern SLR to offer about six program modes.

Pushing Technique that increases the effective SPEED of a film by extending its normal development time.

Rangefinder Optical device for measuring distance, sometimes coupled to the focussing system of a camera lens. A rangefinder displays two images, showing the scene from slightly different viewpoints, that must be superimposed one on the other to establish the subject's distance.

Reciprocity law Principle according to which the DENSITY of the image formed when the EMULSION is developed is directly proportional to the duration of the EXPOSURE and the intensity of the light. However, with extremely short or long exposures, and with unusual light intensities, the law fails, leading to unpredictable results – hence the term reciprocity failure. See also INTERMITTENCY EFFECT.

Reducer Chemical agent used to reduce the DENSITY of a developed image either uniformly over the whole surface (leaving the contrast unaltered) or in proportion to the existing density (thus decreasing contrast). The best known is FARMER'S REDUCER.

Reflector Sheets of white, gold or silver material employed to reflect light into shadow areas.

Reflex camera Generic name for types of camera whose viewing systems employ a mirror to reflect an image onto the viewfinder screen. See TWIN-LENS REFLEX and SINGLE-LENS REFLEX.

Refraction Bending of a ray of light traveling obliquely from one medium to another; the ray is refracted at the surface of the two media.

Resin-coated (RC) paper Photographic printing paper coated with synthetic resin to prevent the paper base from absorbing liquids during processing. Resin-coated papers can be washed and dried more quickly than untreated papers.

Resolving power Ability of an optical system (or an EMULSION) to distinguish between objects that are very close together.

Reticulation Fine, irregular pattern appearing on the surface of an EMULSION that has been subjected to a sudden and severe change in temperature.

Reversal film Photographic film that gives a positive image when processed. A film intended for producing slides, rather than negatives.

Reversing ring Camera accessory that enables the lens to be attached back to front. Used in close-up photography to achieve a high magnification ratio.

Ring flash Type of electronic flash unit that fits around the lens to produce flat, shadowless lighting. It is particularly useful in close-up work.

Rising front One of the principal CAMERA MOVEMENTS. The lens is moved vertically in a plane parallel to the film. Particularly important in architectural photography, as it allows the photographer to include the top of the building without causing CONVERGING VERTICALS to appear.

Sabattier effect Partial reversal of the tones of a photographic image resulting from a secondary EXPOSURE to light during development. Sometimes also know as SOLARIZATION or, more correctly, pseudo-solarization. A special effect usually carried out at the printing stage.

Safelight Darkroom lamp whose light is of a color (usually red or orange) that will not affect certain photographic materials. Can be used with black and white printing paper, and ORTHOCHROMATIC film. Color materials must be handled in total darkness.

Saturated color Pure color, free from any mixture with gray.

Shading Alternative term for DODGING.

Shutter Camera mechanism that controls the duration of the EXPOSURE. The two main types of shutter are the BETWEEN-THE-LENS SHUTTER and the FOCAL-PLANE SHUTTER.

Shutter priority EXPOSURE mode in which the user sets the shutter speed manually, and the camera automatically sets the APERTURE for the metered light level. See also APERTURE PRIORITY.

Silver halide See HALOGENS.

Single-lens reflex (SLR) One of the most popular types of camera design. Its name derives from its viewfinder system, which enables the user to see an image that is produced by the same lens as the one used for taking the photograph. A hinged mirror reflects this image onto a viewing screen, where the picture may be composed and focussed. When the SHUTTER is released the mirror flips out of the light path, so that the film can be exposed. See also TWIN-LENS REFLEX.

Slave unit Photoelectric device used to trigger electronic flash units in studio work. The slave unit detects light from a primary flashgun linked directly to the camera, and fires the secondary flash unit to which it is connected.

SLR Abbreviation for SINGLE-LENS REFLEX.

Snoot Conical lamp attachment used to control the beam of a studio light.

Soft focus Slight diffusion of the image achieved by use of a special FILTER or similar means, which softens the definition of the image. The effect is usually used to give a romantic haze to a photograph.

Solarization Strictly, the complete or partial reversal of the tones of an image as a result of extreme overexposure. Often used to refer to the SABATTIER EFFECT, which produces results similar in appearance.

Speed The sensitivity of an EMULSION to light. See ISO.

Spherical aberration Lens defect resulting in an image that is not sharp, caused by light rays passing through the outer edges of a lens being more strongly refracted than those passing through the central parts. Not all rays, therefore, are brought to exactly the same focus.

Spot meter Special light meter that takes a reading from a very narrow ANGLE OF VIEW. In some TTL METERS the reading may be taken from only a small central portion of the image in the viewfinder.

Spotting Retouching a print or negative to remove blemishes.

Standard lens Lens of FOCAL LENGTH approximately equal to the diagonal of the negative format for which it is intended. In the case of 35mm cameras the standard lens is a 50mm, for the 6 x 6cm (2 ¼ x 2 ¼ in) format it is an 80mm lens.

Stop Alternative name for an APERTURE setting, or F/NUMBER.

Stop bath Weak acidic solution used in processing as an intermediate bath between the DEVELOPER and the FIXER. The stop bath serves to halt the development completely, and at the same time to neutralize the alkaline developer, thereby preventing it lowering the acidity of the fixer when it is added.

Stopping down Term used for reducing the APERTURE of a lens.

Subminiature camera Camera using 16mm film to take negatives measuring 12 x 17mm (½ x ¾ in).

Subtractive color printing Principal method of filtration used in making prints from color negatives. The color balance of the print is established by exposing the paper through a suitable combination of yellow, magenta or cyan filters, which selectively block the part of the light giving rise to an unwanted color cast. See also ADDITIVE COLOR PRINTING.

Synch speed The fastest usable shutter speed which can be used with flash for a particular camera.

Telephoto Lens (or lens setting) with a long FOCAL LENGTH and a small ANGLE OF VIEW.

Test strip Print showing the effects of several trial EXPOSURE times, made in the darkroom to assess the correct exposure time.

TLR Abbreviation of TWIN-LENS REFLEX camera.

Tone separation Printing technique similar to POSTERIZATION, used to strengthen the tonal range in a print by printing the highlights and the shadows separately.

Toner Chemical used to alter the color of a black and white print.

Transparency A photograph viewed by transmitted, rather than reflected, light. When mounted in a rigid frame, the transparency is called a slide.

T setting Abbreviation of time setting. A setting available on some cameras for giving very long EXPOSUREs. When the SHUTTER release is pressed, the shutter remains open until the release is pressed a second time. See also B SETTING.

TTL meter Through-the-lens meter. Built-in EXPOSURE meter that measures the intensity of light in the image produced by the main camera lens. Principally found in SINGLE-LENS REFLEX cameras.

Twin-lens reflex (TLR) camera Type of camera whose viewing system employs a secondary lens of FOCAL LENGTH equal to that of the main "taking" lens. A fixed mirror reflects the image from the viewing lens up onto a ground glass screen. Twin-lens reflex cameras suffer from PARALLAX ERROR, particularly when focussed at close distances. See also SINGLE-LENS REFLEX camera.

UV filter Filter used over the camera lens to absorb ultraviolet radiation, which is particularly prevalent on hazy days. A UV filter enables the photographer to penetrate the haze to a certain extent.

View camera Large-format studio camera whose viewing system consists of a ground-glass screen at the back of the camera on which the picture is composed and focussed before the film is inserted. The front and back of the camera are attached by a flexible bellows unit, which allows a full range of CAMERA MOVEMENTS.

Viewfinder Window or frame on a camera showing the scene that will appear in the picture.

Wetting agent Chemical that has the effect of lowering the surface tension of water, often used in the final rinse (particularly of film) to promote even drying.

Wideangle lens Lens of FOCAL LENGTH shorter than that of a standard lens. A wideangle lens, or lens setting, has a short focal length and a wide ANGLE OF VIEW.

Working solution Processing solution diluted to the strength at which it is intended to be used. Most chemicals are sold in concentrate form, to save space.

Zone focussing Technique of presetting the APERTURE and focussing of the camera so that the entire zone in which the subject is likely to appear is covered by the DEPTH OF FIELD. This technique is particularly useful in areas of photography such as sport and photojournalism in which there is not enough time to focus the camera more accurately at the moment of taking the photograph.

Zone system System of relating EXPOSURE readings to tonal values in picture-taking, development and printing, popularized by the American landscape photographer Ansel Adams.

Zoom lens Lens with a variable FOCAL LENGTH, where the FOCAL PLANE remains unchanged while the focal length is being altered.

Index

Italic page numbers refer to picture captions.

Acknowledgments

The author and publisher would like to thank the following people and organizations for their help in preparing this book:

The Austrian Tourist Board · The Dutch Tourist Board

Great Yarmouth Stadium · The Isle of Man Tourist Board

The Icelandic Tourist Board · The Jersey Tourist Board · Christine Church

Rosie Church · Ben, Henry and Siena Carter · Eric Edwards

Daniel Fairclough · George Fowley · Xaver Hajdu · Stella of Jurby

Justo James · P Sam Jefferson · Mrs K Lockwood · Alexandra Mackintosh

Jenny Mackintosh · Elaine Winkworth